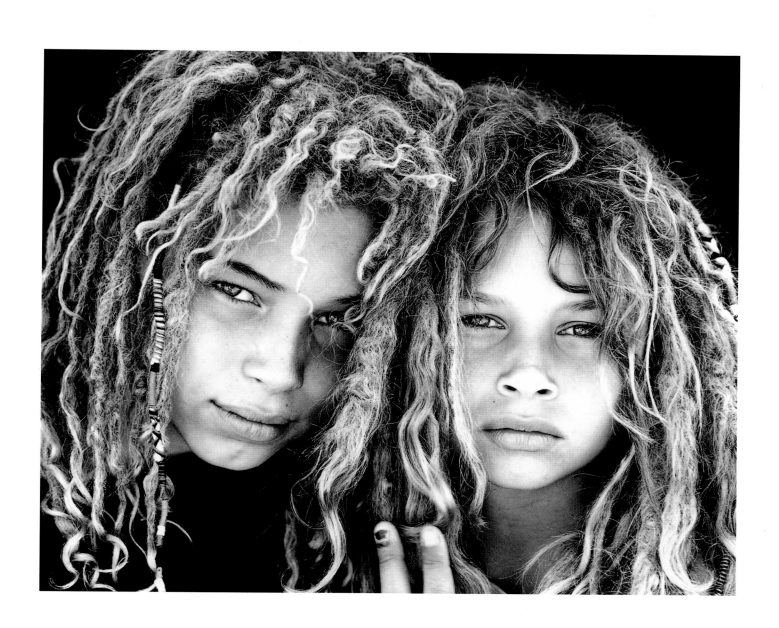

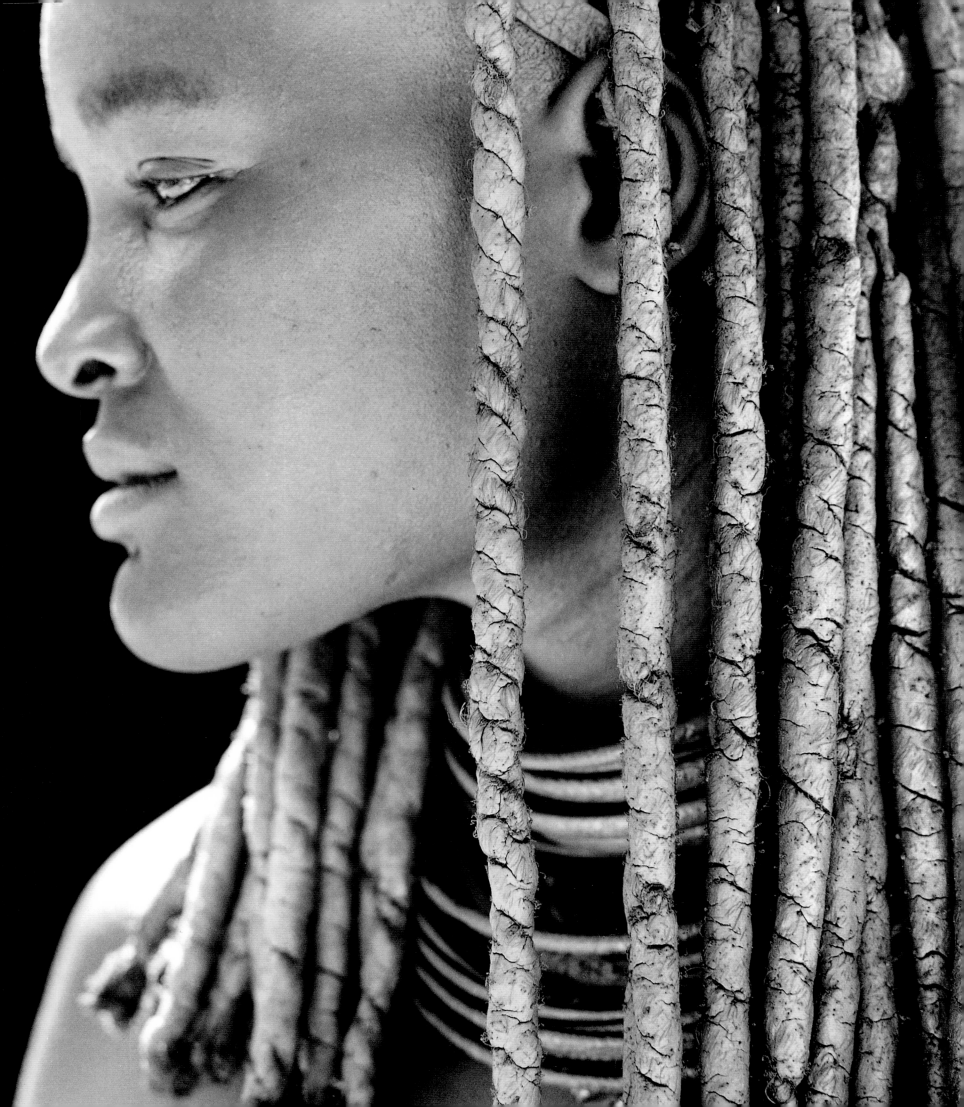

DREADS

FRANCESCO MASTALIA

and

ALFONSE PAGANO

introduced by

ALICE WALKER

ARTISAN | NEW YORK

Published in 1999 by Artisan
A Division of Workman Publishing Company, Inc.
708 Broadway, New York, New York 10003–9555
www.workman.com

Designer: Susi Oberhelman

Library of Congress Cataloging-in-Publication Data

Mastalia, Francesco.
Dreads / by Francesco Mastalia and Alfonse
Pagano ; introduced by Alice Walker.
 p. cm.
 ISBN 1-57965-134-8 (hardcover). —
 ISBN 1-57965-150-X (paperback.)
 1. Portrait photography. 2. Dreadlocks
Pictorial works. 3. Hairstyles in art. 4. Mastalia,
Francesco. 5. Pagano, Alfonse.
I. Pagano, Alfonse. II. Title.
TR680.M348 1999
779'.93915—dc21 99–32436
 CIP

SECOND PRINTING

10 9 8 7 6 5 4 3 2

Printed in Hong Kong

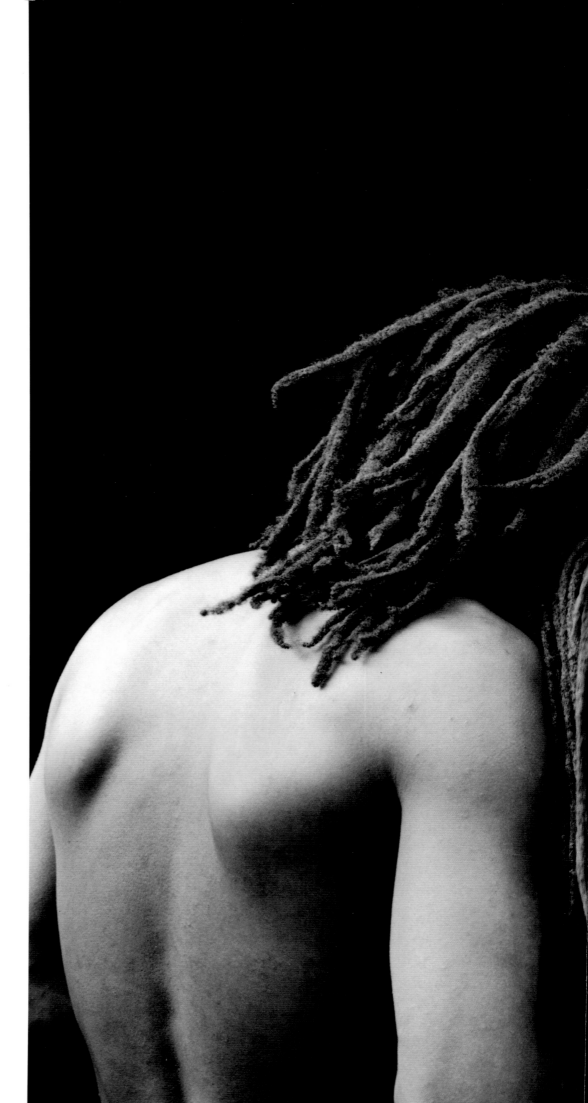

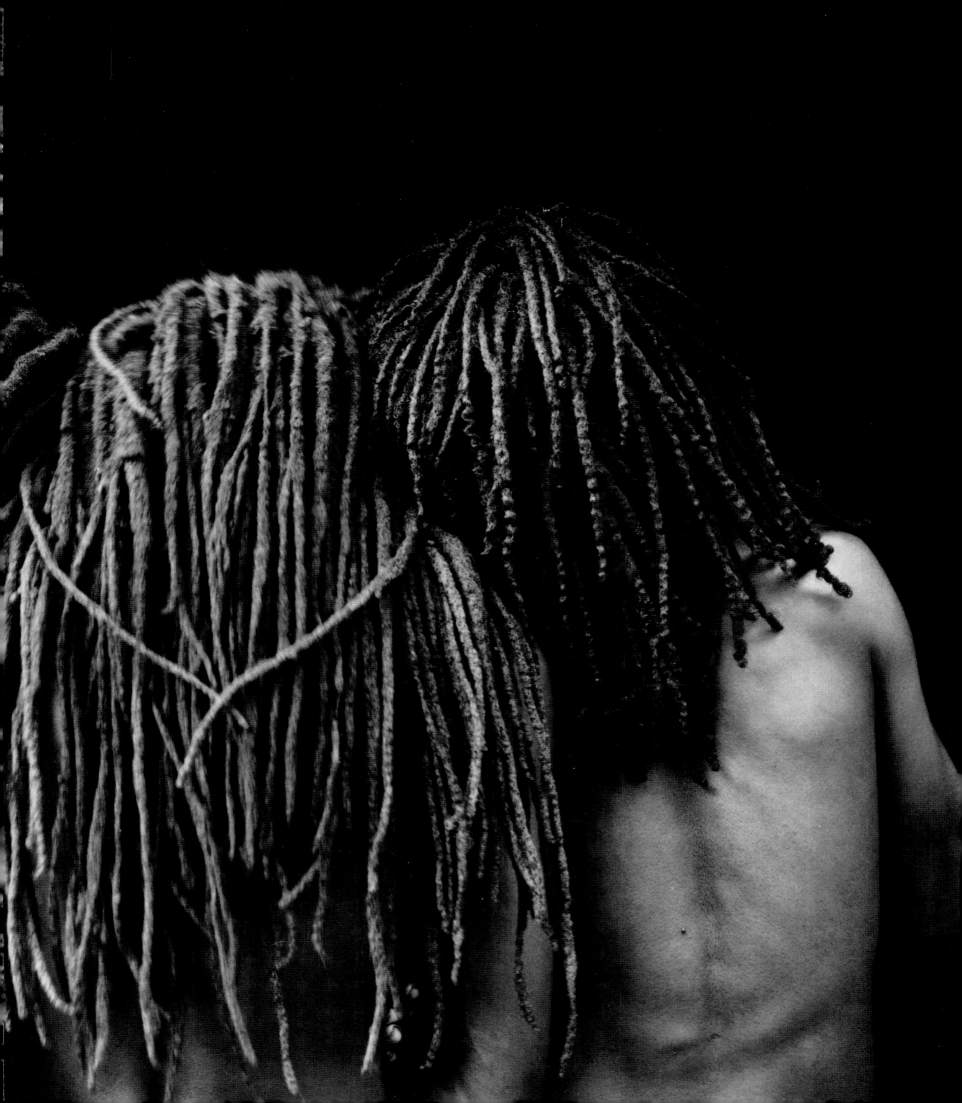

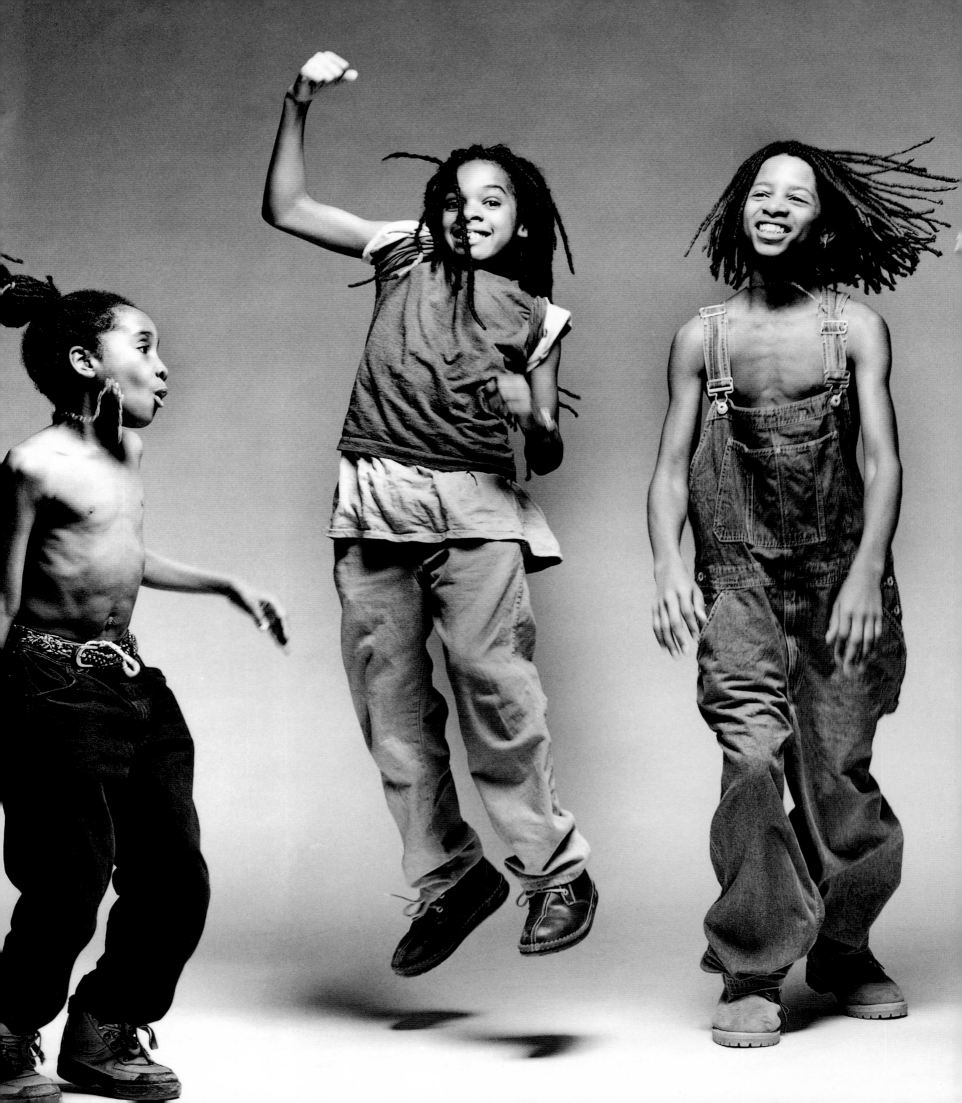

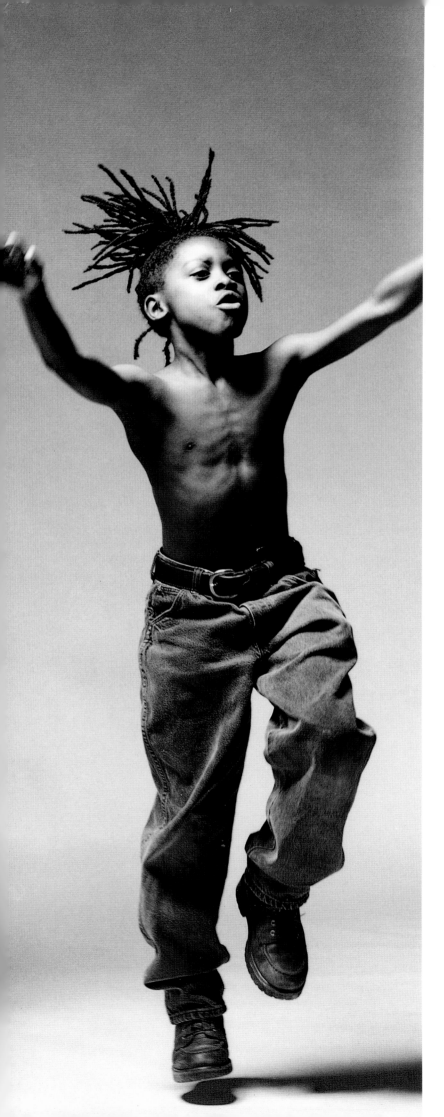

CONTENTS

It has been over ten years since I last combed my hair. When I mention this, friends and family are sometimes scandalized. I am amused by their reactions. During the same ten years they've poured gallons of possibly carcinogenic "relaxer" chemicals on themselves, and their once proud, interestingly crinkled or kinky hair has been forced to lie flat as a slab over a grave. But I understand this, having for many years done the same thing to myself.

Bob Marley is the person who taught me to trust the Universe enough to respect my hair; I don't even have to close my eyes to see him dancing his shamanic dance onstage, as he sang his "redemption songs" and consistently

DREADS

poured his heart out to us. If ever anyone truly loved us, it was Bob Marley, and much of that affirmation came out of the way he felt about himself. I remember the first time I saw pictures of Marley and of that other amazing rebel, Peter Tosh. I couldn't imagine those black ropes on their heads were hair. And then, because the songs they were singing meant the ropes had to be hair, natural hair to which nothing was added, not even a brushing, I realized they had managed to bring, or to reintroduce, a healthful new look, and way, to the world. I wondered what such hair felt like, smelled like. What a person dreamed about at night, with hair like that spread across the pillow. And, even more intriguing, what would it be like to make love to someone with hair on your head like that, and to be made love to by someone

with hair on his or her head like that? It must be like the mating of lions, I thought. Aroused.

It wasn't until the filming of *The Color Purple* in 1985 that I got to explore someone's dreads. By then I had started "baby dreads" of my own, from tiny plaits, and had only blind faith that they'd grow eventually into proper locks. It was during a scene in which Sofia's sisters are packing up her things, as she prepares to leave her trying-to-be-abusive husband, Harpo. All Sofia's "sisters" were large, good-looking local women ("location" was Monroe, North Carolina), and one of them was explaining why she had to wear a cap in the scene instead of the more acceptable-to-the-period head-rag or straw hat. "I have too much hair," she said. Besides, back then (the 1920s) nobody would have been wearing dreads. Saying this,

ALICE WALKER

she swept off her roomy cap, and a cascade of vigorous locks fell way down her back. From a downtrodden, hardworking Southern Black woman she was transformed into a free, Amazonian goddess. I laughed in wonder at the transformation, my fingers instantly seeking her hair.

I then asked the question I would find so exasperating myself in years to come: "How do you wash it?"

She became very serious, as if about to divulge a major secret: "Well," she said, "I use something called shampoo, that you can buy at places like supermarkets and health food stores. I get into something called a shower, wet my hair, and rub this stuff all over it. I

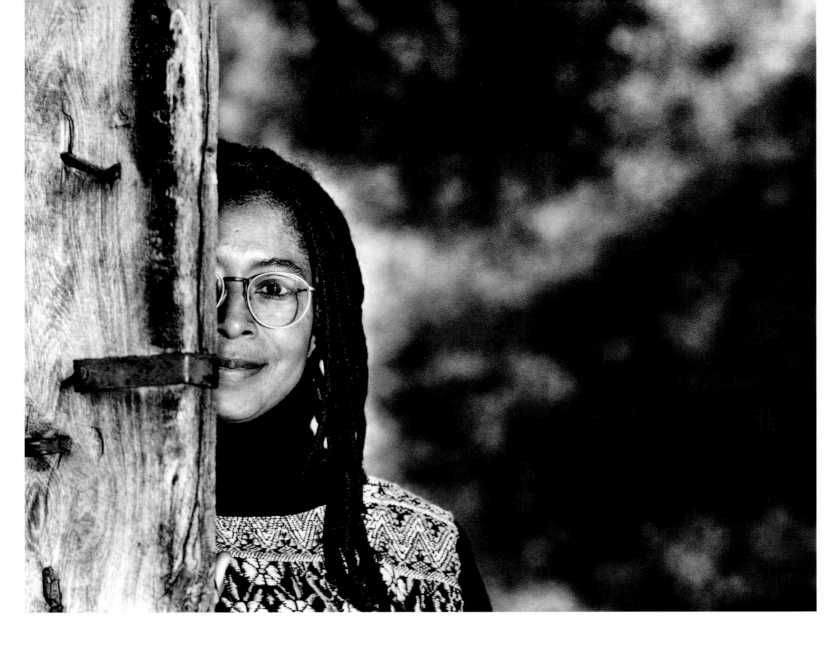

stand under the water and I scrub and scrub, working up a mighty lather. Then I rinse." She smiled suddenly, and I realized how ridiculous my question was. Through the years I would find myself responding to people exactly as she had, delighting in their belated recognition that I am joking with them.

The texture of her hair was somehow both firm and soft, springy; with the clean, fresh scent of almonds. It was warm black, and sunlight was caught in each kink and crinkle, so that up close there was a lot of purple and blue. I could feel how, miraculously, each lock wove itself into a flat or rounded pattern shortly after it left her scalp—a machine could not have done it with more precision—so that the "matting" I had assumed was characteristic of dreadlocks could more accurately be described as "knitting." How many Black people had any idea that, left pretty much to itself, our hair would do this, I wondered. Not very many, I was sure. I had certainly been among the uninformed. It was one of those moments that was so satisfying, when I felt my faith in my desire to be natural so well deserved, that it is not an exaggeration to say there is a way in which I was made happy forever. After all, if this major mystery could be discovered right on top of one's head, I thought, what other wonders might not be experienced in the Universe's exuberant, inexhaustible store?

The Rastafarian religion has its roots in the Universal Negro Improvement Association, a Pan-Africanist organization founded in the late twenties by the Jamaican-born Black nationalist leader Marcus Garvey. A devout Christian, Garvey incorporated his religious beliefs into his political ideology. He advocated the liberation of Blacks in America, and identified Africa as the motherland. In fact, Garvey was one of the first figures of the early civil rights movement to claim that Jesus Christ himself was a Black man. Branded an incendiary and imprisoned for labor disputes, Garvey was ultimately deported from the United States. He continued his work back in Jamaica.

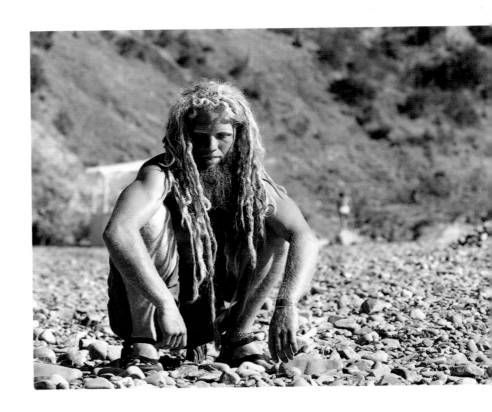

SACRED RITES

OF THE NATURAL HAIR REVOLUTION

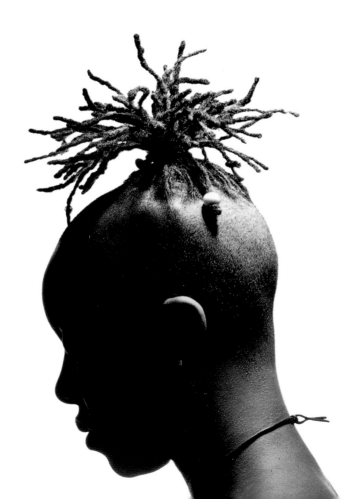

In contemporary American history, Garvey is regarded primarily as a political proponent of Black equality and economic independence, but his legacy in his native land is something altogether different: Garvey is viewed by many Jamaicans as John the Baptist reincarnate, a prophet appointed to announce the coming of a messiah, an Abyssinian king descended from David, as foretold in the Book of Revelations. In November of 1930, when Ras Tafari, an African prince with ancient lineage, was crowned Emperor Haile Selassie I of Ethiopia, many considered the prophecy fulfilled.

Bahatowie priests of the Ethiopian Coptic Church had been locking their hair since the fifth century. During the invasion of Ethiopia

by Italy in 1935, the emperor was forced into exile, and guerrilla warriors, under the command of Ras Abebe Aregai, swore not to cut their locks until Haile Selassie, "the lion of Judah," was reinstated to the throne. Rastafarianism was born.

At roughly the same time, newspapers around the world published photographs of Kikuyu freedom fighters, dreadlocked to project a fierce, frightening appearance during the Mau Mau rebellion in Kenya. In addition to the impact of the conflicts in Ethiopia and Kenya, as well as in Uganda, Jamaicans may have also been exposed to dreadlocks by way of India: At the end of the nineteenth century, East Indians were imported to Jamaica by the British as cheap field labor, to farm sugar, coffee, and cocoa. Among these immigrants was a small population of *sadhus*—nomadic Hindu holy men who lock their hair.

JAMAICA

Slavery formed the backbone of Jamaica's economy for two hundred years. Under British occupation (beginning in 1655, when the territory was seized from Spain), the island accommodated the intense slave trade of the sixteenth and seventeenth centuries, trafficking Africans to the United States. But by the middle of the nineteenth century, concurrent with the American Civil War and resulting from the unwitting influence of Baptist missionaries, Jamaica's oppressed Negro population began to rebel. Under the rule of George V and, subsequently, Elizabeth II, the monarchy forcibly put down numerous insurrections. Jamaica did not attain its status as an independent state until 1962.

Rastafarianism denounced the British regime as Babylonian, promoted repatriation to Africa, and proclaimed the divinity of an

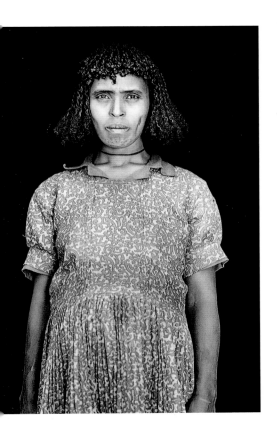

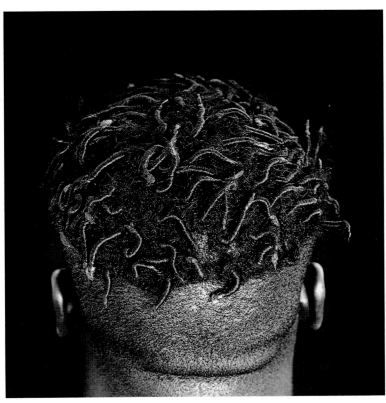

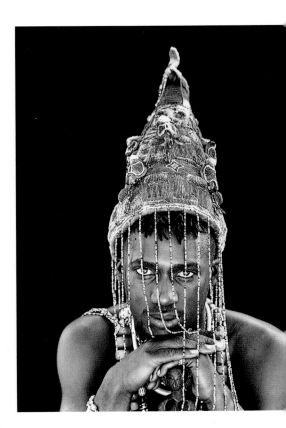

Ethiopian emperor. Much to the dismay of the orthodoxy, the burgeoning religion found validation of its doctrines in the Bible—specifically the Books of Daniel, Isaiah, Deuteronomy, Leviticus, Numbers, and Revelations. Rastafarians equated the scattering of the twelve tribes of Israel with the African Diaspora, and the return of the Jews to the promised land with repatriation. From a political perspective, mane of locks, British imperialists saw their worst nightmare manifest—the African primitive, unleashed. To avoid total anarchy, the authorities sought to suppress these beasts. Kingston shantytowns were raided and razed. If weapons were uncovered in the search, the owners were executed. Policemen arrested street-corner proselytizers and charged them with sedition and blasphemy. Many more

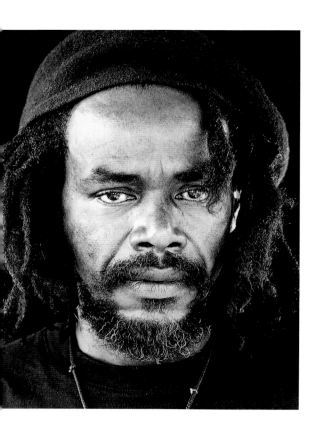 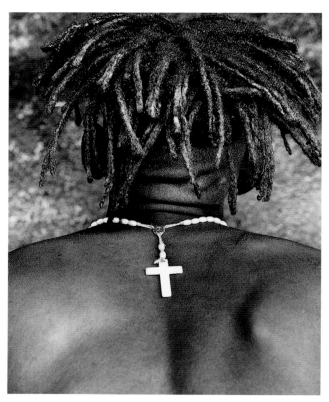 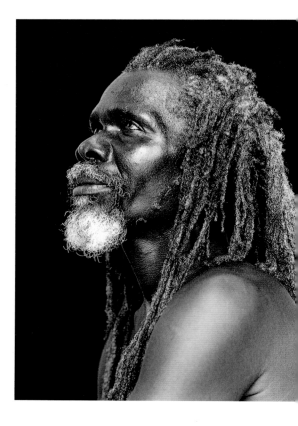

the tenets of Rastafarianism resonated with the radical ideologies of the day: socialism, which emphasized cooperative action; Marxism, with its exploiter/exploited dialectic; Black power, as embodied by Marcus Garvey; and nationalism, focused on a free Jamaican state. Marked as a threat to both Christianity and colonialism, the movement came under attack by the establishment.

Rastas emphatically advocate nonviolence. Regardless, in the Rastaman's lion's

Rastas were imprisoned for possession and consumption of an illegal substance, ganja.

Regarded by the brethren as biblically sanctioned, the marijuana plant holds mythic powers. Rastas often profess its medicinal properties by quoting Revelations 22:2: "The leaves of the tree were for the healing of the nations." A holy herb integral to worship, cannabis is inhaled, ingested, and applied topically. For Rastas, a burning pipe of ganja is a sweet, sacrificial cup, akin to the Christian

communion chalice. Before smoking the weed, Rastas recite a blessing. The mild state of euphoria induced by the drug heightens awareness and promotes enlightenment.

THE SEPARATE ONES

Rastas considered it their calling to expose the corruption of the colonial system, and accepted persecution as their plight as prophets of Jah (God). Redemption was to be found in the pursuit of peace and the embrace of self as a chosen one. "I-and-I" refers to the intimate relationship between a Rasta and his Creator: There are no intermediaries, the union is absolute. For the same reason, the concept of original sin does not exist in Rastafarianism. How could a child of God be anything but innocent? A sense of shame would only serve to perpetuate the imposed feeling of inferiority that has plagued Africans in exile.

Like the Nazarites of biblical days, Rastafarians regard themselves as "the separate ones." Dedicated to pure and holy living, Nazarites vowed not to cut their hair, and so were recognized by the mass of knotted locks upon their head:

"All the days of the vow of the separation, no razor shall pass over his head. Until the day be fulfilled of his consecration to the Lord, he shall be holy, and shall let the hair of his head grow."—Numbers 6:5

The single most identifying mark of a Rasta is his or her dreadlocks. According to Father Joseph Owens, author of *Dread: The Rastafarians of Jamaica*:

"The locks especially are considered to be a vital link with anciency, since they symbolise man's yearning to return to the unsophisticated

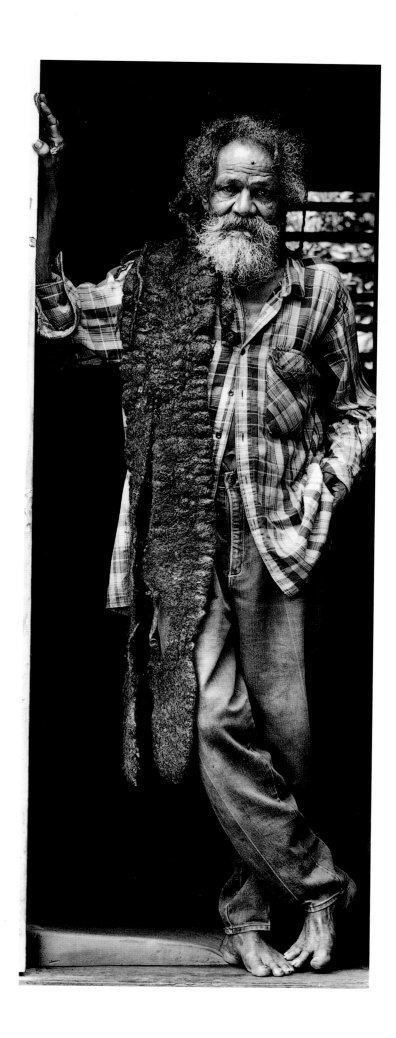

ways of 'creation-living' . . . The locks and the beard are the sign of the ancient covenant between God and his people. They symbolise the Rastas' refusal to depart from the ancient, natural way."

Confronted with the uncontrollable tresses of Rastafarian men, the conservative segment of Jamaican society deemed the look not just disgusting, but downright frightening—hence the term "dreadlock." Intended as an insult, the name was eventually reclaimed by the Rastas. Reggae musicians in particular are largely responsible for popularizing the label and spreading the dreadlock look. Bob Marley, with his plaintive songs for freedom, brought the peaceful philosophy of Rastafarianism to the world stage. Indubitably the most influential dread ever, Marley singlehandedly spread the gospel of Rastafarianism to every corner of the globe.

Today, the wearing of dreadlocks has transcended racial and religious barriers. No longer necessarily a reflection of ancient traditions or cultural identification, locks are just as often a simple fashion statement. Actress Whoopi Goldberg, singer Lauryn Hill, boxer Lennox Lewis—several prominent Black entertainers have made dreads part of their image. Dread-heads represent a cross-section of society, and the reasons for letting hair lock are as diverse as the wearers themselves.

RASTA-BUDDHISTS
AND TOKYO TRENDSETTERS

In Japan, Rasta-Buddhists subscribe to the belief systems of both ancient Buddhism and modern Rastafarianism, two philosophies vastly different in origin but strikingly similar in outlook.

Unlike Zen monks, who shave their heads to indicate purity and simplicity, Rasta-Buddhists let their hair lock as a sign of their acceptance of nature's divine order.

Separate from the Rasta-Buddhists, mainstream trendsetters in Tokyo pay thousands of yen to have their poker-straight strands literally drilled into dreads. Hair is coated in a chemical concoction, then grouped into thick sections which are attached one at a time to a toothed, rotating apparatus that twists the "insta-lock" up to its roots. Each freshly coiled section is clipped in place and left to dry. In extreme cases, glue is added to help the hair clump. The average price for this procedure is $500. That the young and hip now go to such extremes to imitate what was originally a statement against artificiality proves the growing popularity of dreads.

MAORI WARRIORS

Urban areas of New Zealand offer unexpected pockets of cosmopolitan dreadlock communities, with wearers whose ropelike hair primarily serves a sartorial purpose. Contrarily, Maori gang members—indigenous cohabitants of the same country—see their locks as an external manifestation of their anti-socialism and general rebellion. In rural neighborhoods south of Auckland, towns are populated almost exclusively by members of gangs with such names as the Mongrel Mob, the Brotherhood, and Black Power. Warriors in thought and act, Maori men typically greet each other by locking arms, staring eye to eye, pressing nose to nose, and vigorously sniffing to inhale the essence of their opponent.

Ta Moko—full facial tattooing—is perhaps

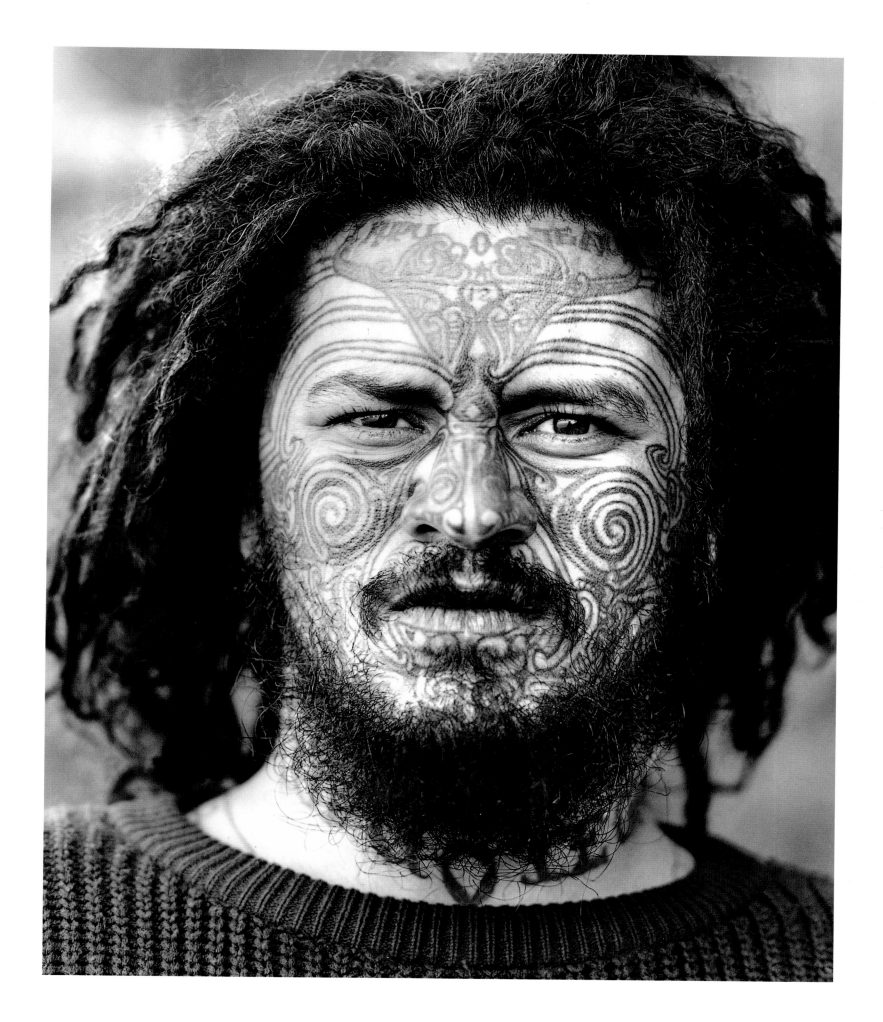

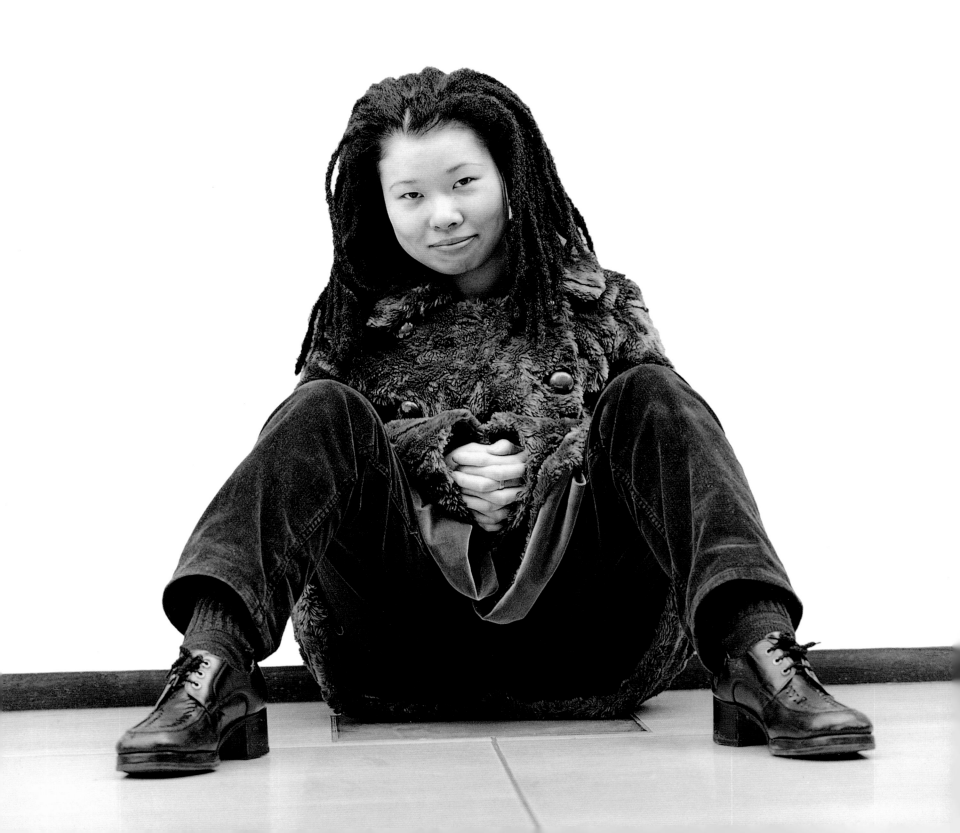

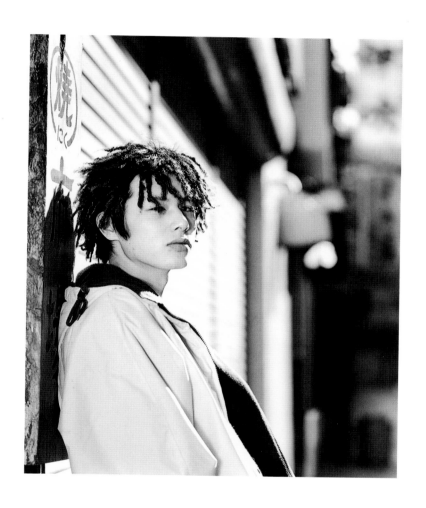

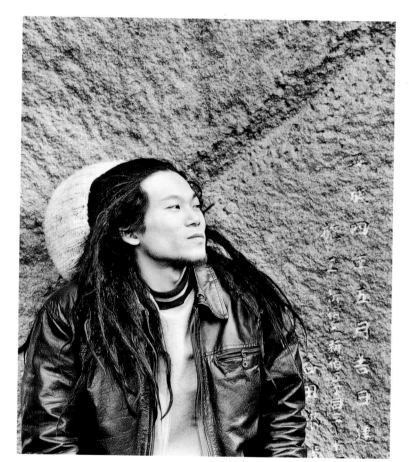

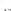

the most alarming aspect of Maori appearance. Traditionally, the markings indicate economic and marital standing within the society. Gang members, however, have substituted such designs with obscenities, slogans, and anti-government propaganda. Combined with full-body tattoos and dreadlocks, the effect is genuinely shocking.

THE AFRICAN-AMERICAN
DREADLOCK LIBERATION

Many African-Americans consider dreadlocks to be an authentic and attractive hairstyle choice. After decades spent chemically straightening

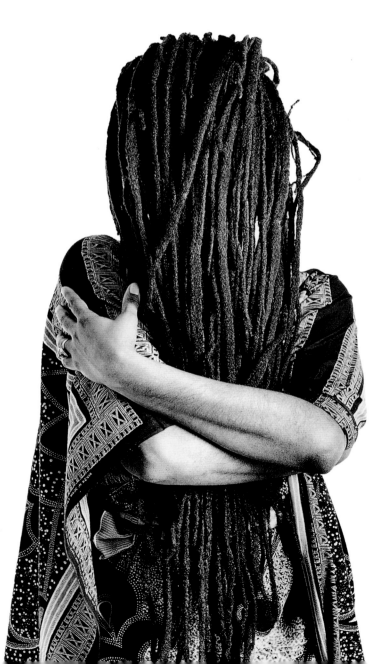

(or "conking") their naturally kinky hair in an attempt to assimilate, Blacks began to regard dreadlocks as a way of freeing themselves both figuratively and literally from the dictates of Western European fashion. The Afro gained popularity as part of the so-called counterculture of the sixties and seventies, when social standards, sexual mores, and political attitudes were liberated. At the same time, as both reggae music and word of the Rastafarian struggle reached the United States, American Blacks were exposed to the phenomenon of dreadlocks. Empathizing with the Jamaican fight for independence and its economic aftermath, African-Americans gradually began to adopt the hairstyle in solidarity. Dreadlocks represented an embrace of ethnicity, a way of communing with the homeland. Moreover, they proved that Black hair was beautiful when left to its own devices.

Considering the prevalence of dreadlocks today and their twentieth-century Jamaican roots, it's tempting to view them as just another outgrowth of multiculturalism, a blatant badge of membership in the global village. But the current craze for dreadlocks can be deceptive: In fact, the style dates back to the dawn of civilization. The Old Testament recounts the tale of Samson and Delilah, in which a man's potency is directly linked to the "seven locks" upon his head. Jesus of Nazareth would have returned from his forty days in the desert with matted hair.

SADHUS, SIKHS,
AND SINHALESE

India's sadhus (and *sadhvis*, the female counterpart)—mendicant mystics of the Hindu faith—have been locking their hair for pre-

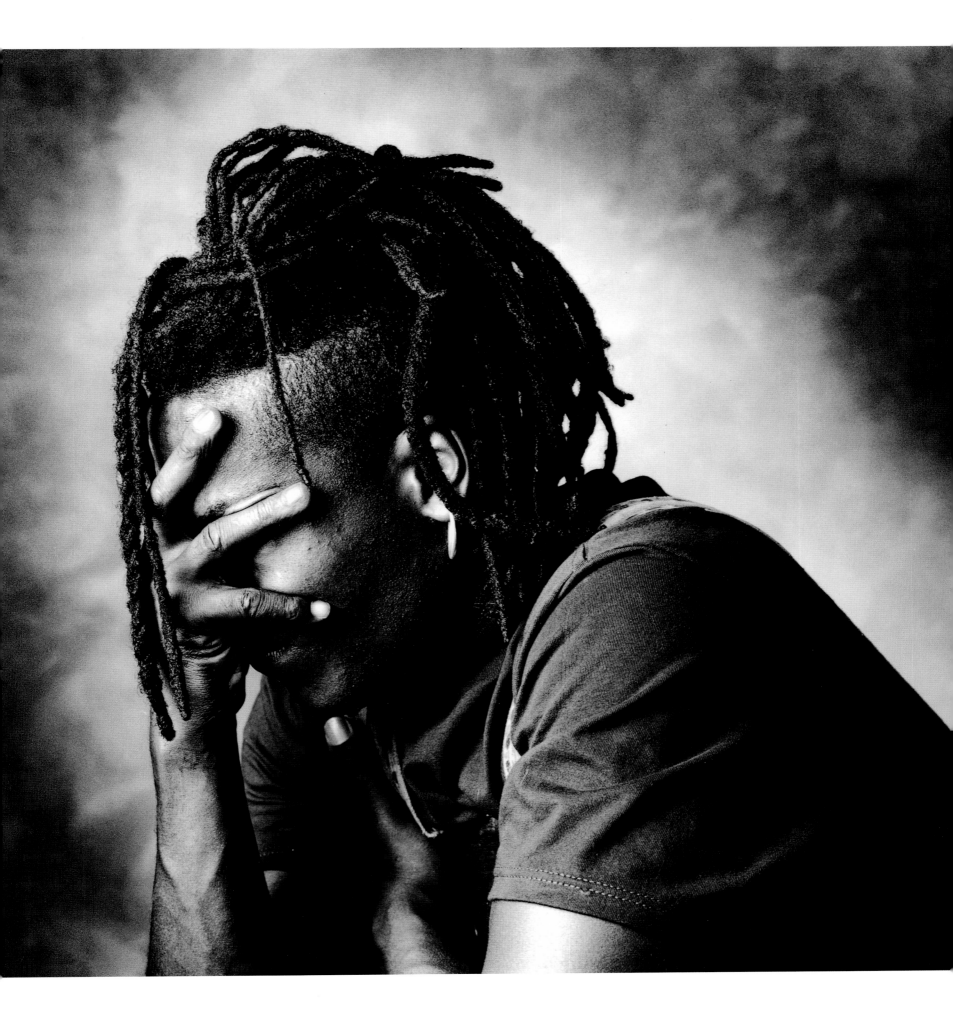

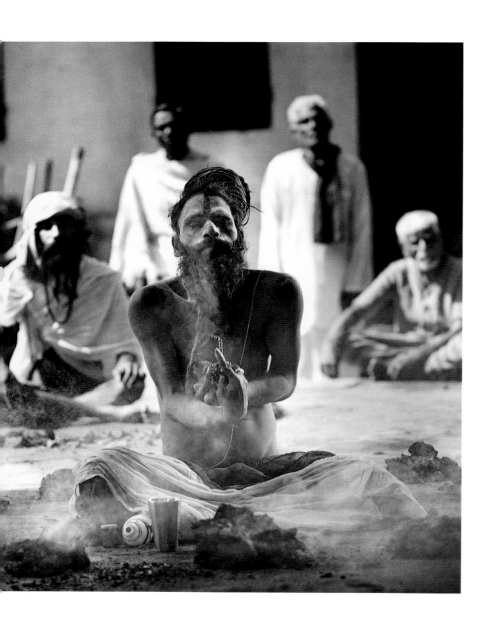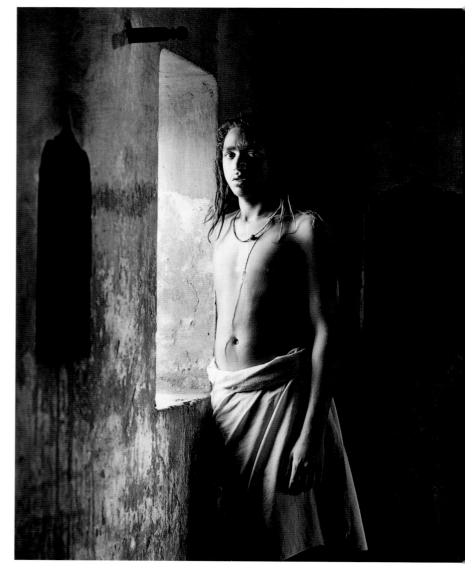

Christian centuries. *Jatta* announces that its wearer adheres to the strict spiritual and sexual practices, including poverty and celibacy, outlined over two thousand years ago in the Naradaparivrajaka Upanishad. A divine directive descended from Upanishadic creation mythologies, matted locks are considered symbolic of a covenant between the sadhus and Shiva, the god of destruction and regeneration. Hindu legend tells of Ganga, the river goddess, abandoning the people of the plains to hide in the Himalayas. Desperate for water, a sadhu performs extraordinary feats of devotion. In answer to his prayers, Ganga agrees to return and relieve the suffering. But Shiva, fearing that the force of the river will drown everything in its path, allows the Ganges to flow gently onto the land through his magical locks.

Today, in the sacred city of Varanasi, thousands of believers gather on the banks of the Ganges. The faithful arrive from all corners of India, and for many the sole goal of their pilgrimage is to die. To be cremated along the ghats is to attain a karmic promotion, skipping several stages in the caste system and moving that much closer to nirvana. From temple to temple, the various sects of sadhus can be distinguished by the way they wear their jatta. Tresses are roped in emulation of the deities: Skanda, depicted with six locks—one for each of his faces; Huniyan, marked with five—three in his demonic incarnation. Locks may fall freely to the ground, or may be coiled—*jatta mukta*—like a crown on top of the head. *Chelas*—novitiates—neglect their hair until it is a filthy, lice-infested mass: The torment it inflicts is thought to humble the newly holy men. But jatta are a tonsorial option, not a religious dictate. A

Hindu ascetic does not have to lock his hair.

The length of jatta roughly relates to the number of years a sadhu has been committed to his ascetic career—although he does have to cut his hair when his guru dies. Upon initiation into his sect, the chela receives a new name from his guru, which includes either *Das* (slave) or *Muni* (sage) as a suffix—although neither label signifies rank, and both are seemingly assigned at random. To announce his pending entry into another life, one in which all ties with family, clan, or caste are abandoned, the neophyte's head is shaved three days before his baptism: *Shaivas*—followers of Shiva—are shorn bald as babies. *Vaishnavas*—followers of Vishnu—leave a small tuft of hair, the *shikha*, on the back of the head. Along with his fellow apostles, the sadhu undergoes a funerary ceremony on the banks of the river. The gurus shave the shikhas, the group bathe in the river, then rub their bodies with cremation ashes. Symbolically, every sadhu dies from his earthly existence and is reborn into divinity. His former life is irrelevant, and he measures his age from his new birthdate.

Joining a brotherhood is akin to traveling back in time to become part of an itinerant tribe of the pre-agrarian age. Sadhus, like Rastafarians, reject the technological morass of modernity, and subscribe instead to a lifestyle that revolves around the most basic of behaviors. To celebrate the connection between heaven and Earth, to extract the spiritual essence inherent in all things organic, sadhus engage in many rituals. By burning pieces of wood or cakes of dried cow dung, Shaivas maintain a *dhuni*—sacrificial fire. Seated around their humble altars, they smoke a mixture of tobacco

and hashish. The *chilam*, or pipe, represents Shiva's body; the *charas*, or hashish, his mind; the smoke, his presence. The high induced is regarded as an act of self-realization, a moment of union with the deity. Prior to taking the first puff, Shaivas invoke the "Lord of Charas," and as a closing gesture, they annoint their foreheads with the chilam ashes. They may even ingest some, as the ashes are considered *prasad*—nourishment—from Shiva.

To complete the primitive image of the sadhu, he is often *digambar*—"sky-clad"—with the exception of a *langoti*, or loincloth. Naked, ash-covered, with hair in matted strands, the sadhu is simultaneously Earthbound and otherwordly. As translated from the Rigvedic hymn 10.136:

"The longhaired sage carries within himself fire and elixir and both heaven and earth. To look at him is like seeing heavenly brightness in its fullness. He is said to be light himself."

In many other groups throughout India, matted hair signifies that the wearer is touched by the spirit—a mystic or madman, a shaman or saint. Certain sects of Sikhism, for example, have rules directly related to *kesh*. Long hair indicates harmonious living, while short or shorn hair is seen as an act of disobedience, a questioning of God's will. Interestingly, dreadlocks—an injurious term concocted by British imperialists in Jamaica—are referred to as beauty marks—*palu*—by the Sinhalese of Sri Lanka.

HERMETIC PRIESTS, PROLIFIC GODDESSES

African cultures have always utilized the body as a vehicle for expression. Hairstyles can signify everything from tribal affiliation to religious denomination. The Yoruba, Akan, and Mende, for example, associate the head with both physical and spiritual well-being. In other African societies, people with tangled, unkempt hair are regarded as wizards or witches—agents of the netherworld. Among the Ibo of Nigeria, those with dreadlocks are called *dada*, and are viewed as shamans. Oral history recounts cases of such chosen ones being born with a full head of hair. One of their deities, Uhammiri Ogbuide (Mammy Waters, the Lake Goddess), is depicted with thick, twisted locks. The extraordinary length of her tresses symbolizes her fecundity; the twists tell of a wild, natural beauty beyond civilized control.

Both hermetic and prophetic orders of Bahatowie priests have been locking their hair for hundreds of years. The meditative sect secludes itself in caves surrounding Coptic monasteries in Ethiopia, coming out only to collect scraps of food left behind by devotees. Conversely, the prophetic sect wanders the open countryside, preaching to all who will listen. Draped in vermilion robes decorated with jeweled amulets, carrying sceptres topped with Coptic crosses, they are an awe-inspiring sight. The Oromo, Amhara, and Tigre of Ethiopia also wear locked hair for traditional tribal reasons.

INITIATION RITES OF THE HIMBA

For the Himba of Namibia and Angola, dreadlocked hair is related to rights of passage that serve to establish social and marital status within the tribe. Himba girls shave their hair, except for a small patch on top of the head. The shorn tresses are made into plaits—*ozondato*—that are woven into the patch and

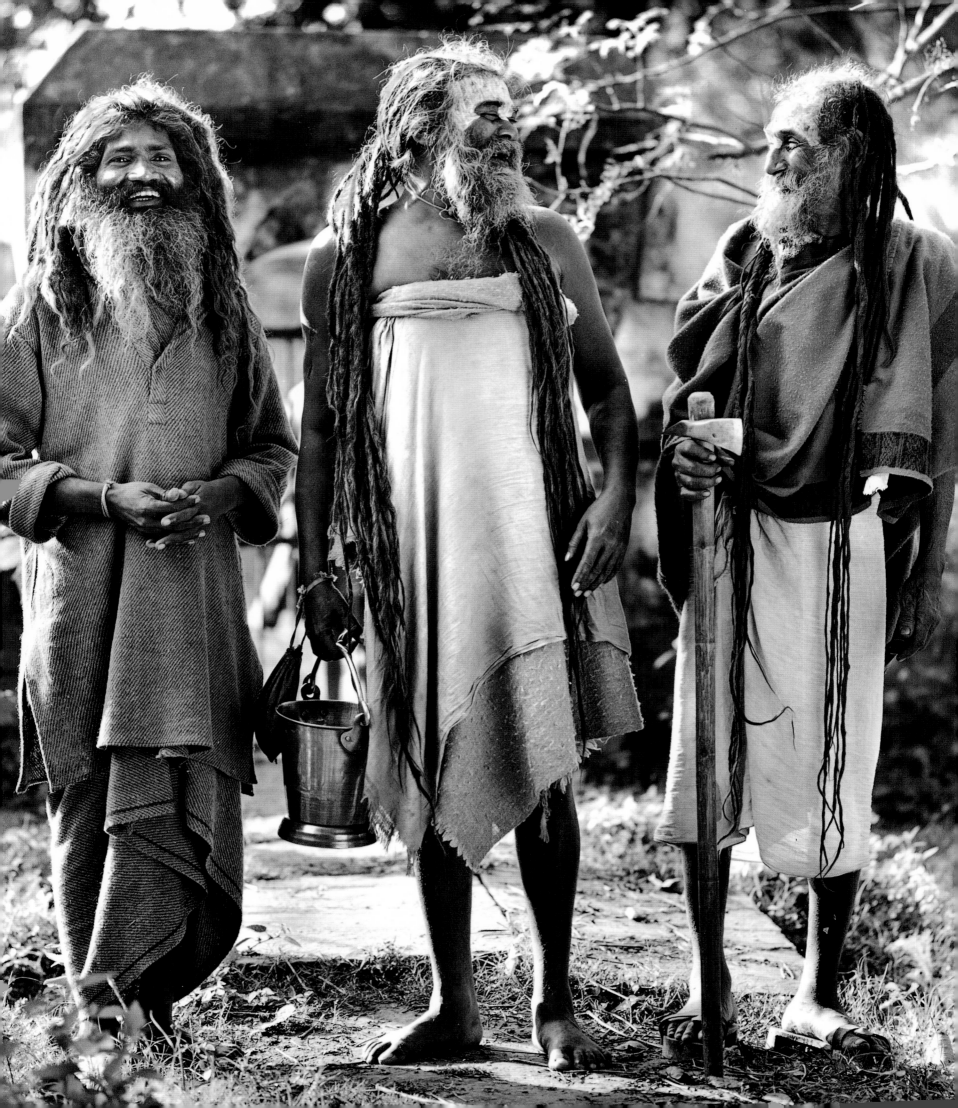

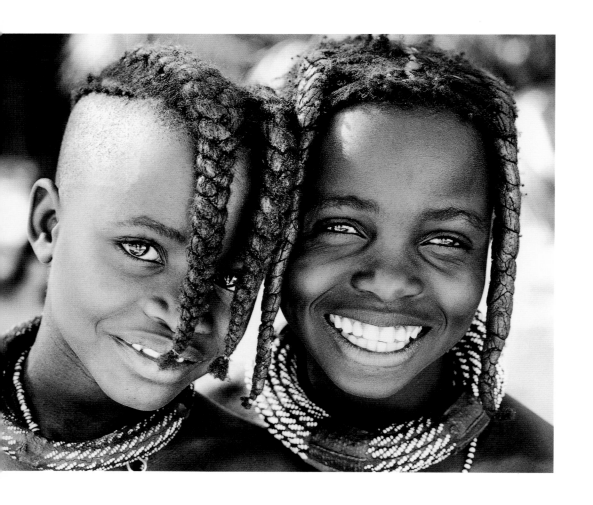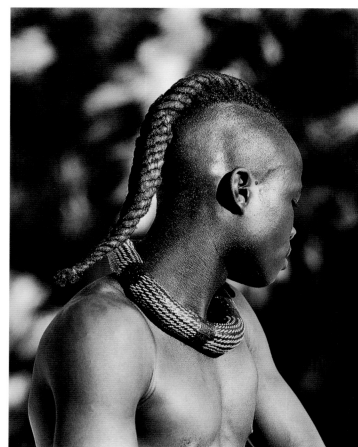

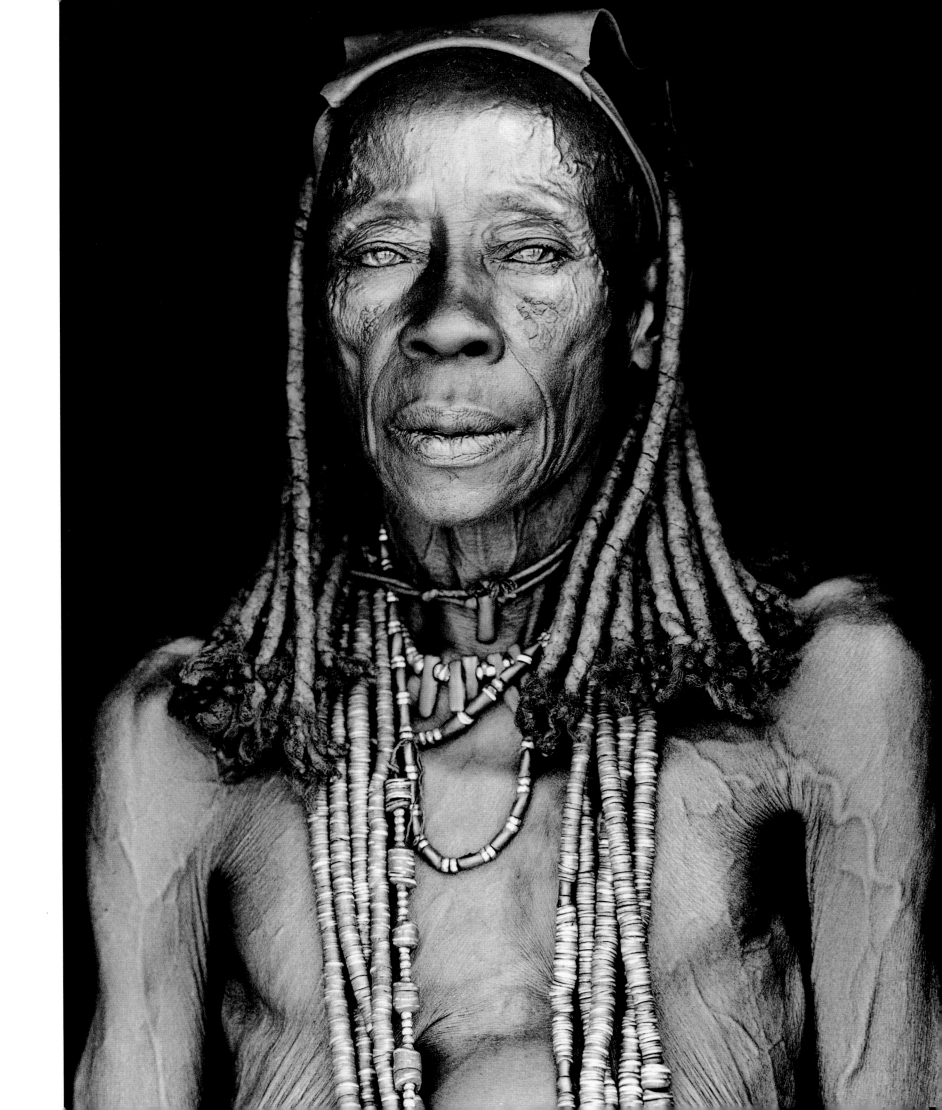

worn in two large, twisted braids in front of the face. At the onset of puberty, the ozondato are unraveled and arranged in smaller, looser sections across the forehead and over the eyes. Only after menstruation and its corresponding ceremonies can a young woman wear her locks to the back and sides of the head, to indicate that she has reached marriageable age. As part of her initiation into adulthood, she receives an *ekori* headdress, made of tanned

THE TURKANA, MASSAI, ### AND SAMBURU OF KENYA

Different tribes resident in Kenya plait their hair for similar cultural reasons. From the age of fourteen, Samburu and Massai men maintain locks in very thin strands, then braid and weave these sections with decorative ornaments. Within the warrior class, the Morani, hair indicates rank. When his first child is born, a warrior's head is shaved in declaration of the completion of his

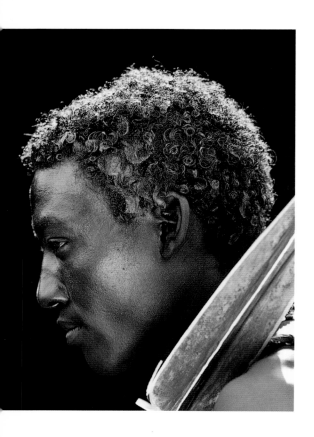 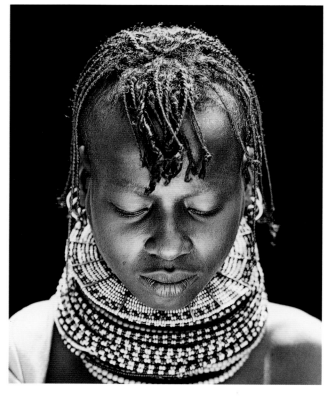 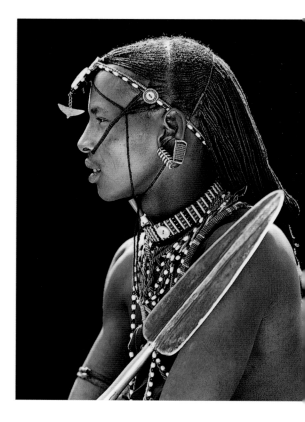

sheep- or goatskin decorated with iron beads.

Adolescent boys adhere to a similar system, but theirs is a single, braided lock—*ondato*—kept to the back of the head. After ritual circumcision, the lock is divided in two. A married man is required to fasten his locks on top of his head and cover them with a cloth or leather cap. He can remove this *ombwiya* only on the occasion of a death in the family.

military service: By the age of twenty-five, he is, for all practical purposes, an old man.

Samburu and Massai females shave their heads, but in the Turkana tribe, women wear the dreads. The sides of their heads are shorn, and locks crop out from the top. As with the Morani, Turkana dreadlocks denote societal status, but are also worn by the women for purely fashionable purposes.

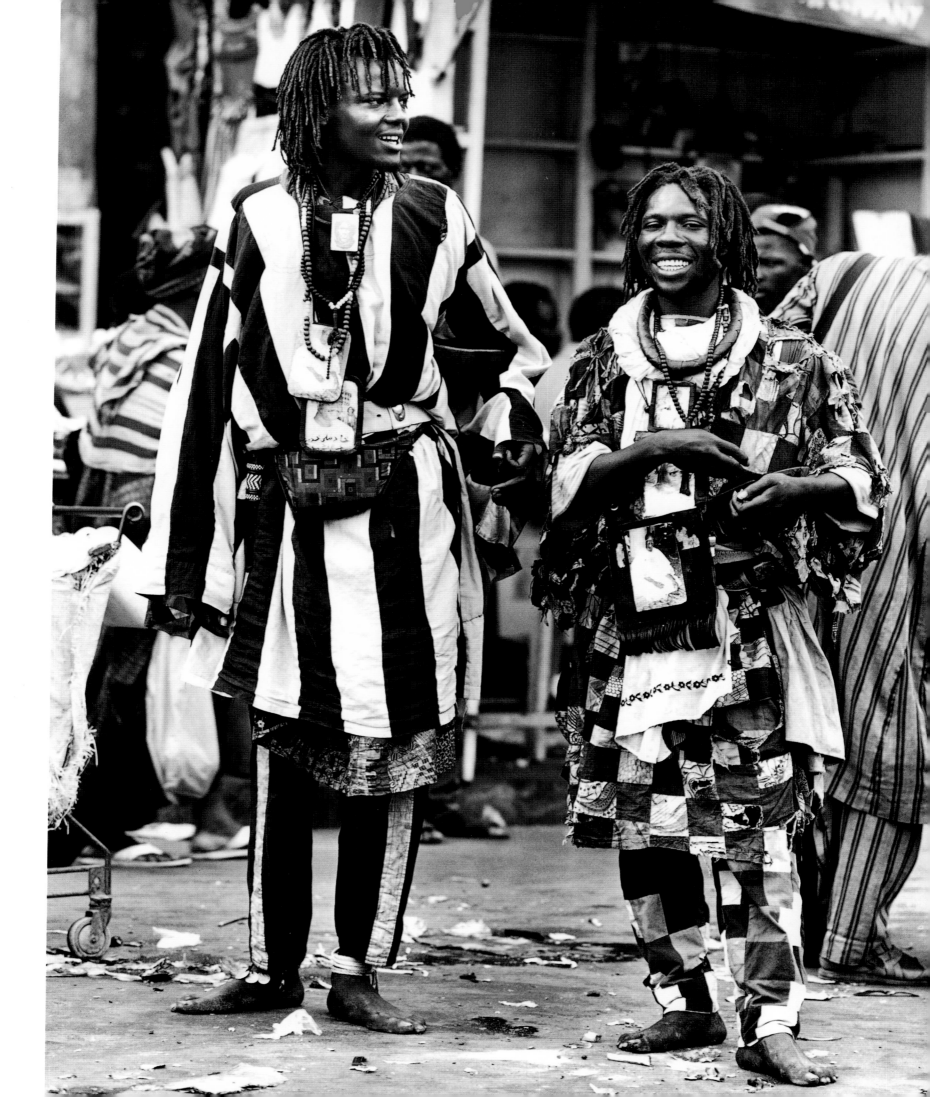

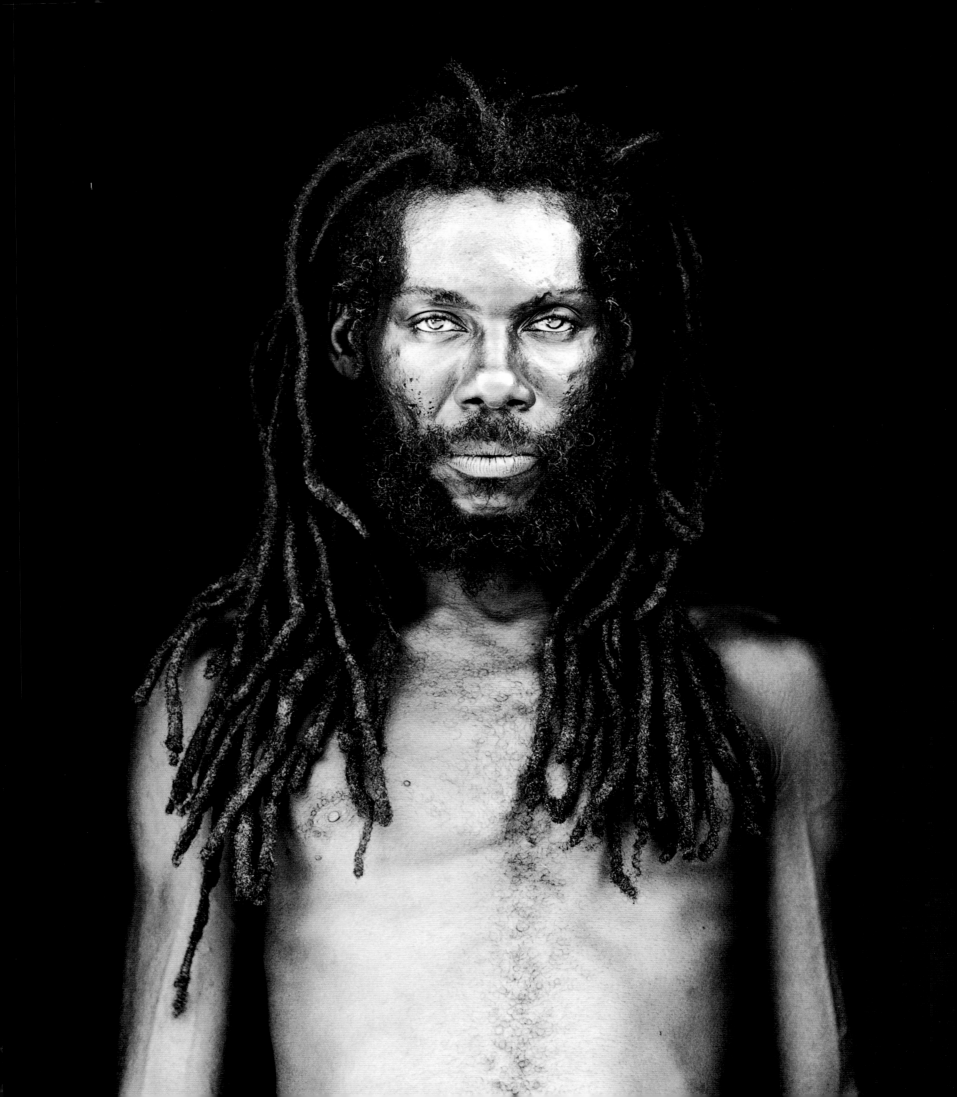

BAMBA'S BLESSING

Along the streets of Dakar, dreadlocked men dressed in patchwork robes and carrying begging bowls approach all who pass to ask for food or money. These are the Baye Fall, followers of the Mouride movement, a sect of Islam indigenous to Senegal. They wear their dreadlocks—*ndiagne*—in imitation of Ibrahim Fall, chief disciple of the spiritual guide Cheik Amadou Bamba. Baye can be translated as "Father."

By combining elements of African paganism, Wolof nationalism, and Sufism, Bamba created Mouridism. The philosophy of the movement emphasizes a personal relationship with God, who is seen not as an omnipotent ruler, but as a friend and confidant. Such intimacy is achieved through submission to a spiritual guide.

A scholar, scribe, and miracle worker, Bamba is considered as important a personage to the Mouride movement as Jesus is to Christianity or Moses to Judaism. Fall, his disciple, was granted special dispensation by the prophet. He did not fast, or pray five times a day. Instead, he devoted his entire existence to the care of his guide. He begged in the streets, and gave the offerings to Bamba. He harvested crops and chopped wood to feed and warm Bamba. He attended to his guide's every comfort, and neglected his own, to the point that he had no will, no life, but Bamba's.

Mouride mythology holds that Fall, in supplication, once turned his hands toward Bamba's face. In response, the elder spit in his servant's palms. Fall wiped his hands over his head and vowed never to wash the offering from his hair for as long as he lived. Coated in spittle, the strands clumped into ndiagne. To this day, when a member of the Mouride brotherhood enters or leaves the presence of a respected elder, after a blessing or prayer, the guide will spit on the palms of the supplicant.

THE LEGEND OF
THE GOLDEN THRONE

In modern-day Ghana, besides beggars, only priests of the native African religions wear their hair in locks: The majority of the population now embraces some form of Christianity or Islamism. But during the era of the Ashanti federation, some three hundred years ago, dreads held pride of place in the cultural mythology. The empire was founded by two men, the ruler Osei Tutu and his strategist and advisor, Akofo Anokyi. Anokyi developed and disseminated the legend of the golden stool, a throne that fell from the heavens so that, sitting upon it, Tutu could unite the clans and overthrow the ruling Denkyira. Anokyi wore his hair in long locks. Such regal associations are a far cry from the current state of affairs: In Kumasi, Accra, and other crowded cities, many mentally ill homeless have dirty dreads due to their unfortunate circumstances. As a result, Ghanaians see locks as a sign of slovenliness and spiritual corruption.

AN ORGANIC EXPLOSION

Dreads. Jatta. Ndiagne. Palu. Natty, knotted, ropelike locks. Curly knobs, tiny plaits, intricate weaves. Dreadlocks are a modern phenomenon with multicultural roots. From a nappy-topped newborn to a Rastafarian elder with hair roped around his waist, dread-wearers rejoice in the essence of the individual, set free by an organic explosion of hair.

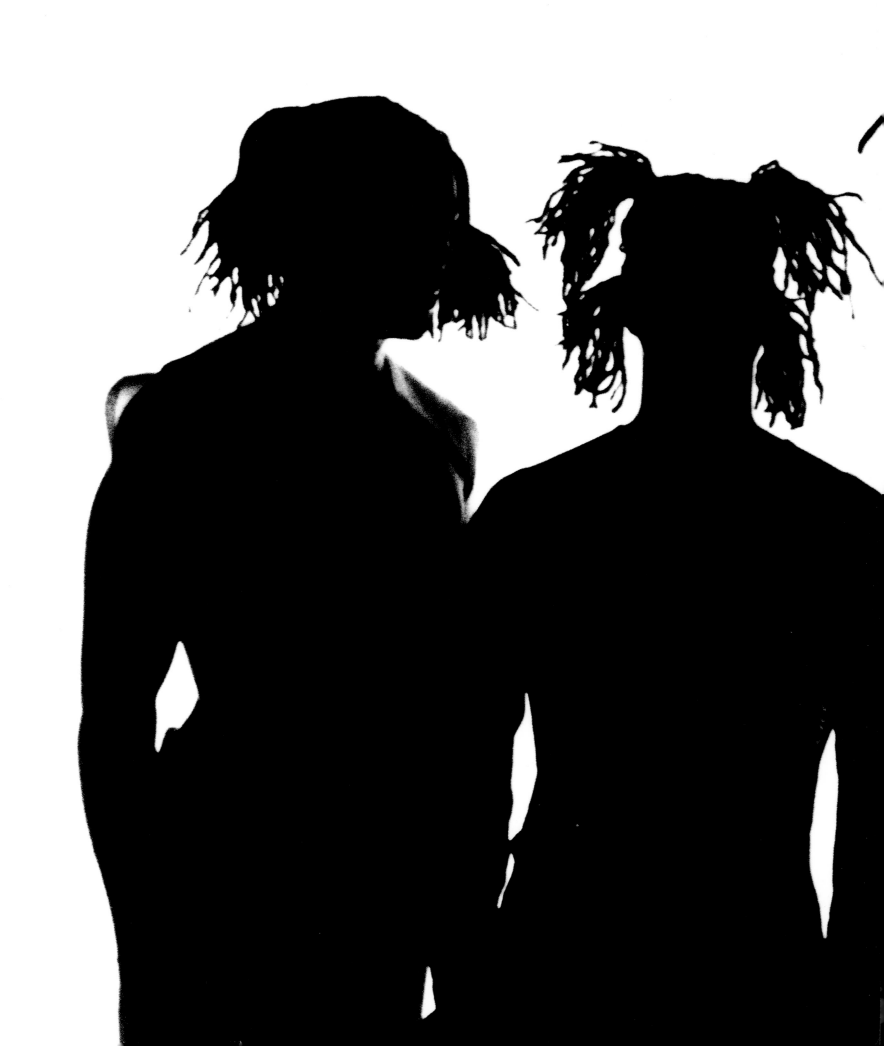

PORTRAITS

I STOPPED BRUSHING MY HAIR WHEN I WAS TEN

I was ten years old and didn't like
brushing my hair, so I stopped.
I love my hair, I just hate
brushing it. I didn't even know
what dreadlocks were. My mom
hated them and gave me lots
of grief, but my dad loved them,
and to this day still does.

ANA LISA DORAN

BARTENDER NEW ZEALAND

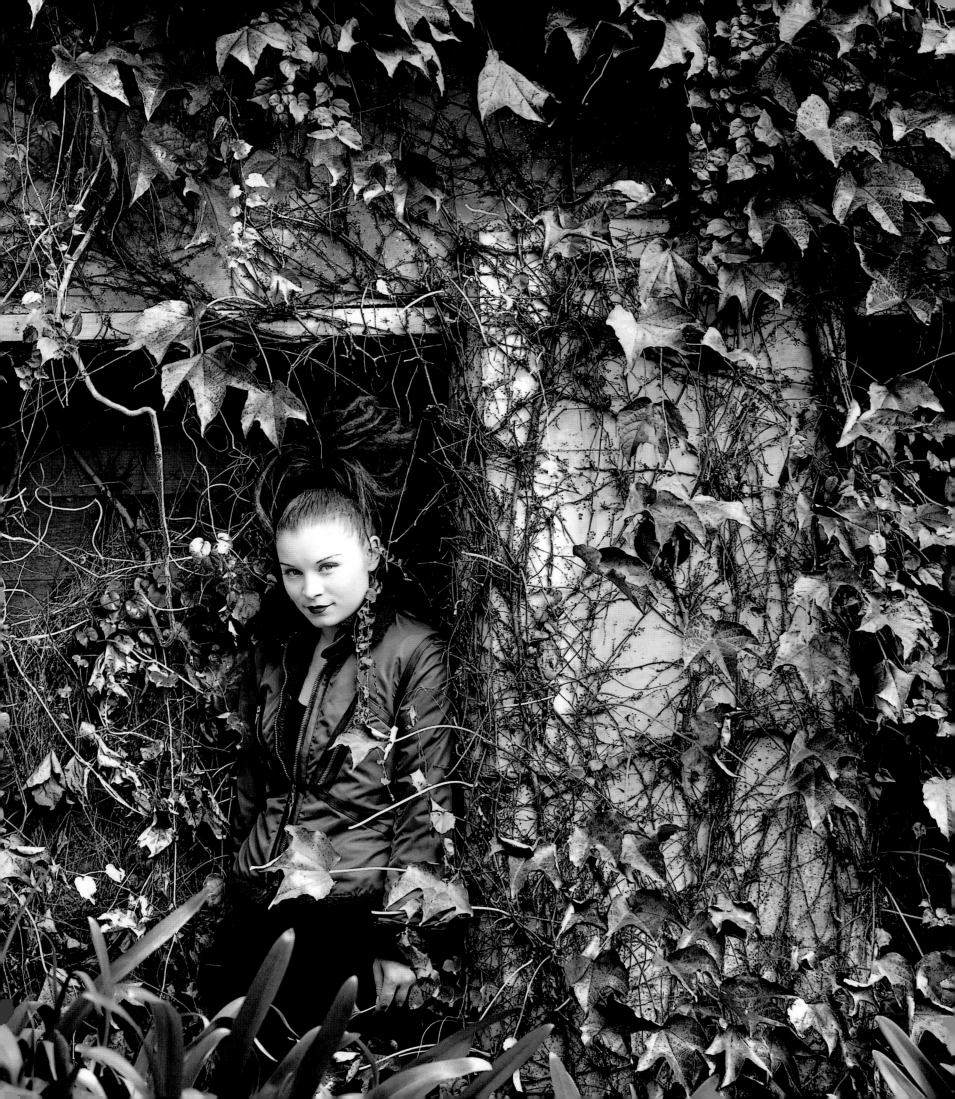

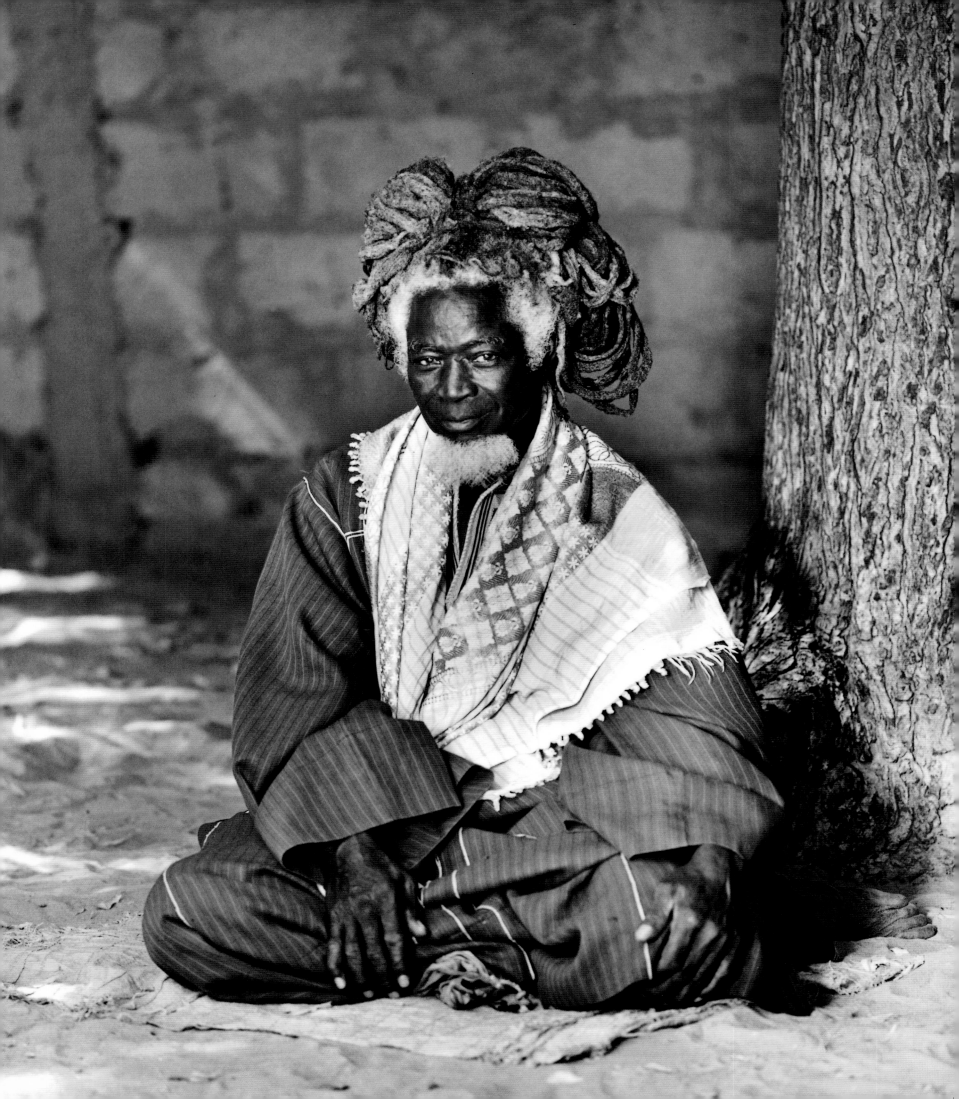

The Fulani of Senegal were among the first to lock their hair. Shepherds who lived in the bush, they never cared much for conventional notions of grooming. They were also among the first to hear the word and follow Bamba.

If you are Baye Fall, you are a Mouride first, an African Muslim. You give yourself body and soul to your spiritual guide. Such sacrifice guarantees that the guide will deliver you to paradise.

As a disciple, Ibrahim Fall was given special favor by Amadou Bamba. He was not required

to pray five times a day, nor did he need to follow any dietary laws. Instead, he dedicated himself completely to the caretaking of Bamba. In this way he earned his entrance into paradise.

Ndiagne are not meant to set the Baye Fall apart. On the contrary, our hair represents our lack of concern with the material, just as the clothing we wear represents a vow of poverty and a lack of concern with vanity. Both are symbolic of our status as servants of Cheik Amadou Bamba.

MAMADOU DIOF NDIANGE

BAYE FALL ELDER SENEGAL

My visual vocabulary as a painter is informed by my multiethnicity, which has its roots in the country of my birth. I was born in Kingston and raised in the British colonial tradition until 1962, when Jamaica earned its independence.

Jamaica was settled by the Ashanti, a tribal people from the country now known as Ghana who were brought to the island as slaves. Seventeen million lost their lives in the great passage, the African Diaspora, and the blood of the survivors runs in my veins. I am African, Jamaican, English,

LOCKS CONNECT ME TO THE LAND OF WOOD AND WATER

American. These combined cultures influence my art-making.

A visit to my homeland in 1989 inspired the introduction of dread-locks into my physical presentation. I wanted to maintain a bond with the country of my birth. Dreads signify a covenant between me and Mother Africa—specifically Ethiopia, the cradle of humanity. Locks highlight my African heritage via the Rastafarian tradition. They are the glue that keeps me connected to the land of wood and water.

PETER WAYNE LEWIS

PAINTER | NEW YORK CITY

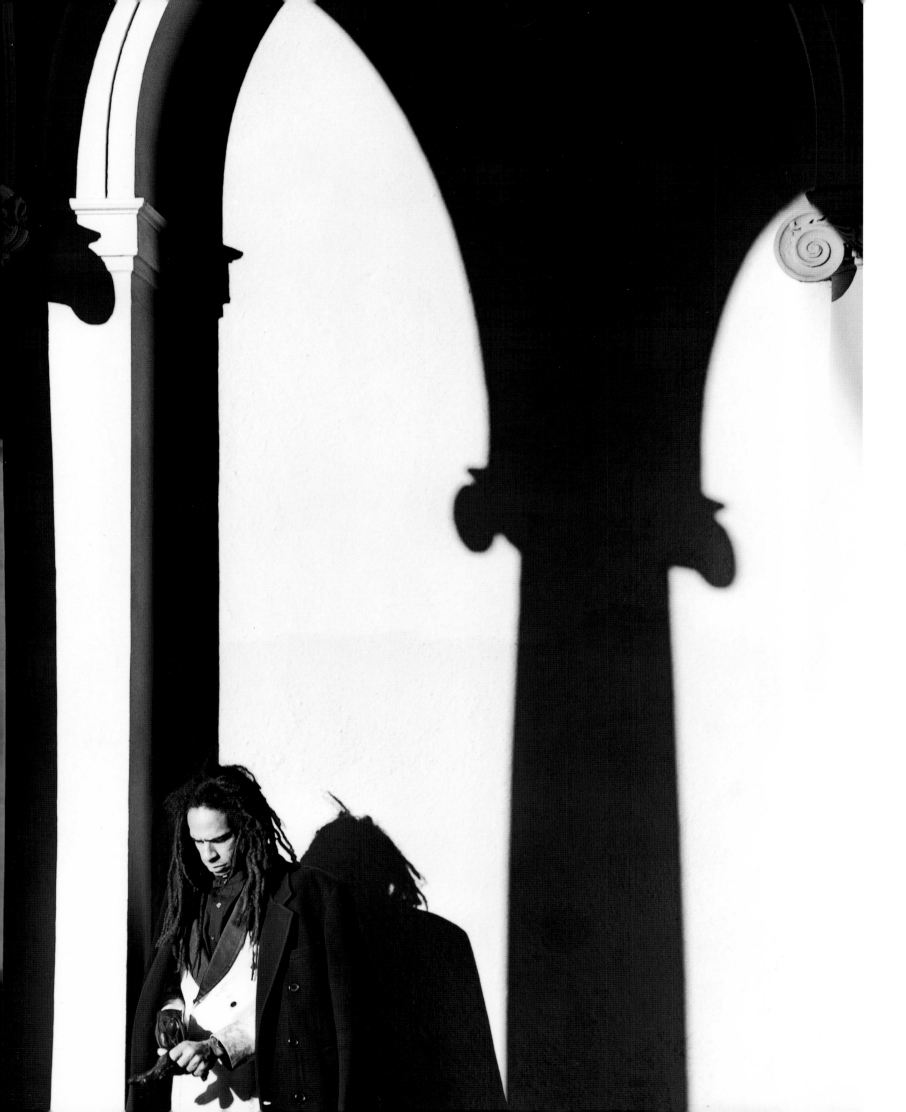

When the Father created the man,
He didn't create the comb. Man
created the comb. To create a differ-
ent beauty. Man started to comb
out his hair, because your hair
is your beauty, and a different hair-
style projects a different identity.

Dreadlocks are ancient, from
Ethiopia, the cradle of civilization.
People are going back to them now
without even knowing why. When
they first saw the Rasta, they called
him dirty-head, mop-head, all kinds
of derogatory terms. Today, they
are wearing the dreads and bearing
the red, green, and gold of Africa.
Tell me, who are the heathens?

But I cannot take offense at
what others do. I can only account
for myself. I wear my hair in locks
because I love and live Jah
Rastafari. It is a natural way of life
that most are born into. But they
are confused, and take systems
unto themselves. Some watch
television, see many things and
think them all true, try hard to lead
that type of life. Most don't know
about culture. They are more
interested in what the system has
to offer. People are trying hard
to get nothing. Life is worth more
than material goods.

FATHER CREATED THE MAN: MAN CREATED THE COMB

Now is the time of famine.
There is famine in the world,
lack of food. But there is an even
greater famine, for the word.
Rasta has the power of the word.
He will not go hungry.

JIMMY MCGHAN

RASTA JAMAICA

38

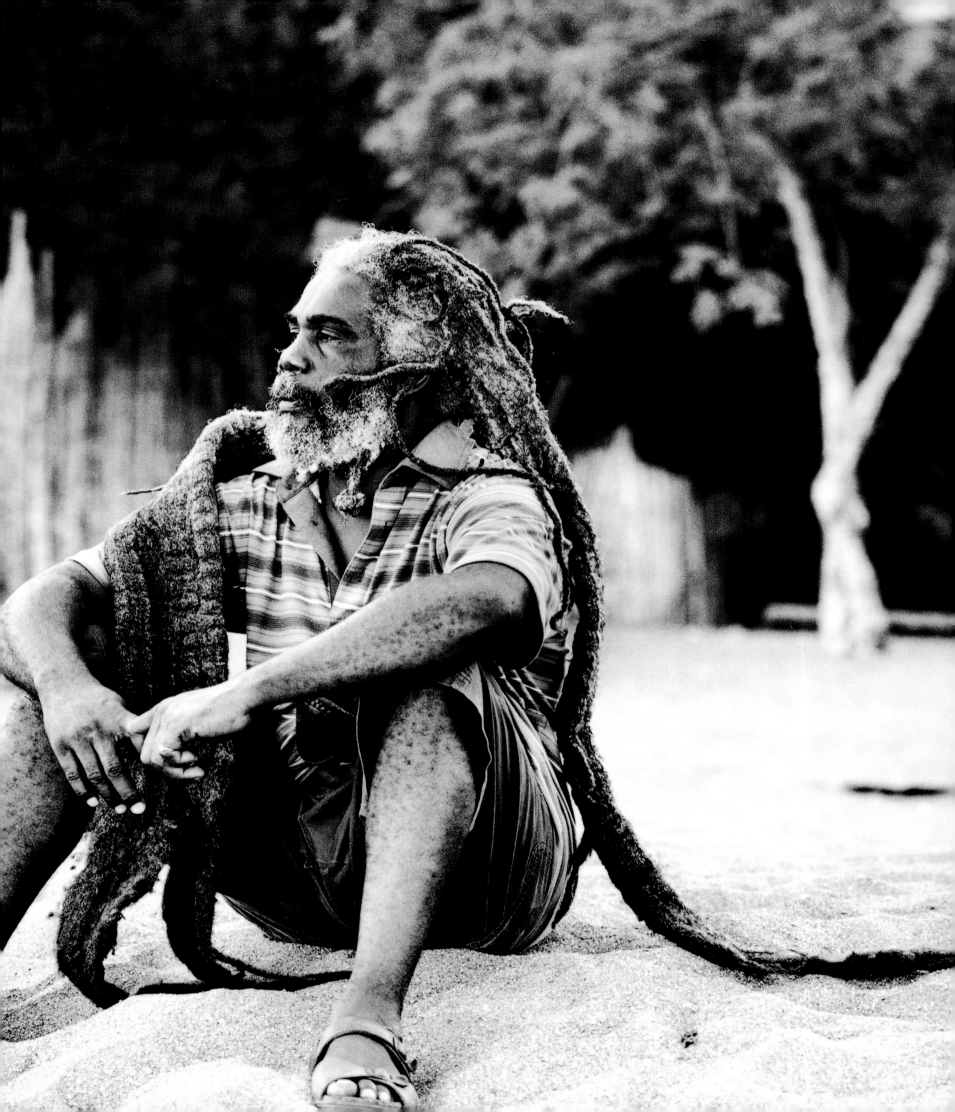

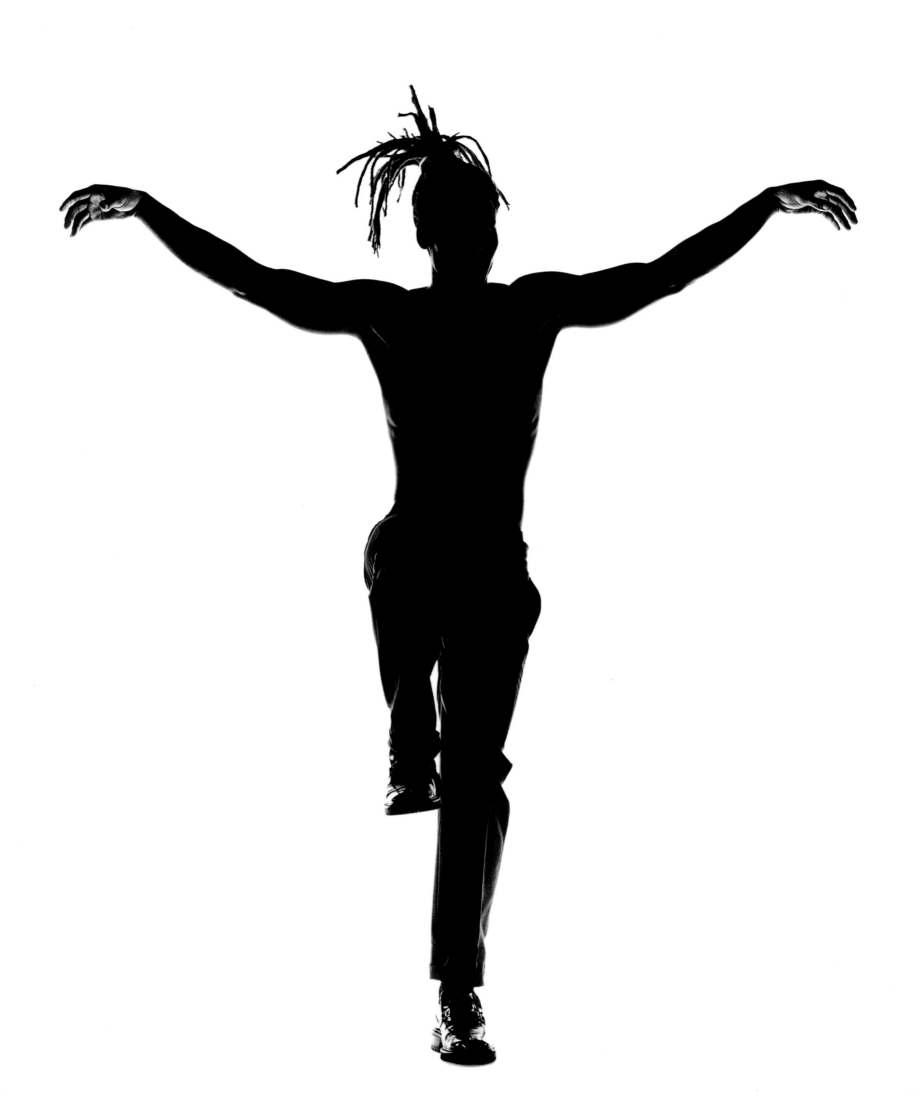

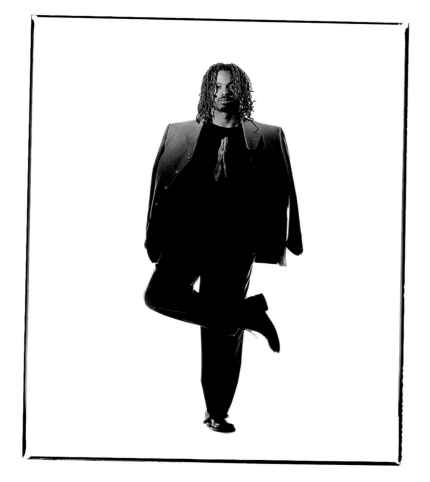 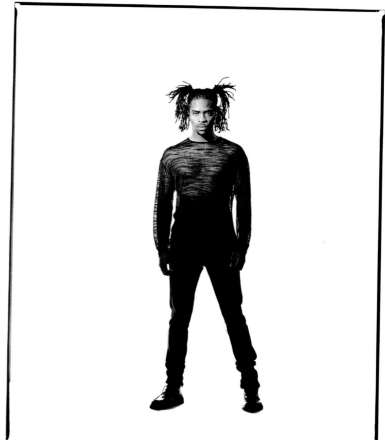

In my heart, I am Baye Fall, although I was born and raised Catholic. At university, I was involved in the Mouride movement along with most of my friends. We took trips to Touba to meet with the *Serigne*—spiritual leaders. We spoke with the guide who is the son of Bamba. (All sons of Bamba have become spiritual guides.) But I never formally converted to Islam. I didn't have to. I just follow the philosophy of the movement. The core of all religions is the same. There are no borders, only one river of truth flowing through all forms of faith.

Although I'm native Senegalese, I didn't grow dreadlocks until I came to New York. Of course, I'd had them to a lesser extent before, but in New York . . . the city was such a mix, so overwhelming, that I felt the need to

DREADS REAFFIRM MY STATUS AS A CHOSEN ONE,

maintain a connection to my culture. Dreads reaffirm my status as a chosen one, a child of Africa.

The spiritual source of ndiagne among Baye Fall is different from that of dreads among Rastas, but the basic belief is the same—although Baye Fall carried locks long before Rastas. A Baye Fall has surrendered his will to God. He is a slave. Nothing belongs to him anymore. He cannot even cut his hair, because hair is God's creation.

Baye Fall are like the birds. They know God will provide. They go out each day and beg only for enough to eat. They ask nothing more.

In Senegal, you will see religious people, spiritual leaders, when meeting or parting, say a blessing, a prayer, with palms raised in supplication, then spit in each other's hands and wipe them through their head. It's a common ritual, even in New York's Muslim community. It's like sending God's spirit, His essence, from body to mind. If, like the disciple Ibrahim Fall, I had the spit of Bamba in my hair, I would not cut it either.

We can't really control how we evolve. Many people today wear dreads for purely fashionable purposes. Regardless, it is still the work of God. Either way, the truth is forthcoming.

A CHILD OF AFRICA

PIERRE THIAM

CHEF SENEGAL

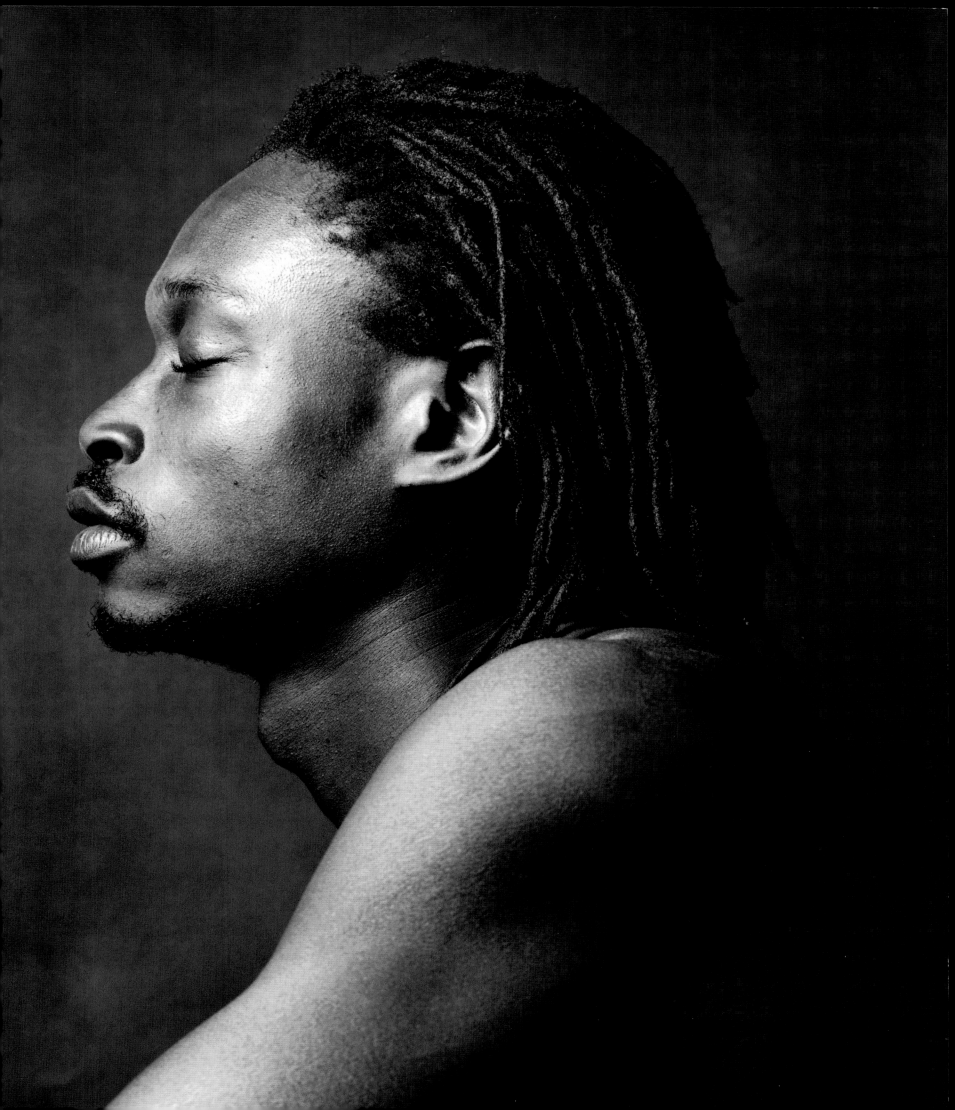

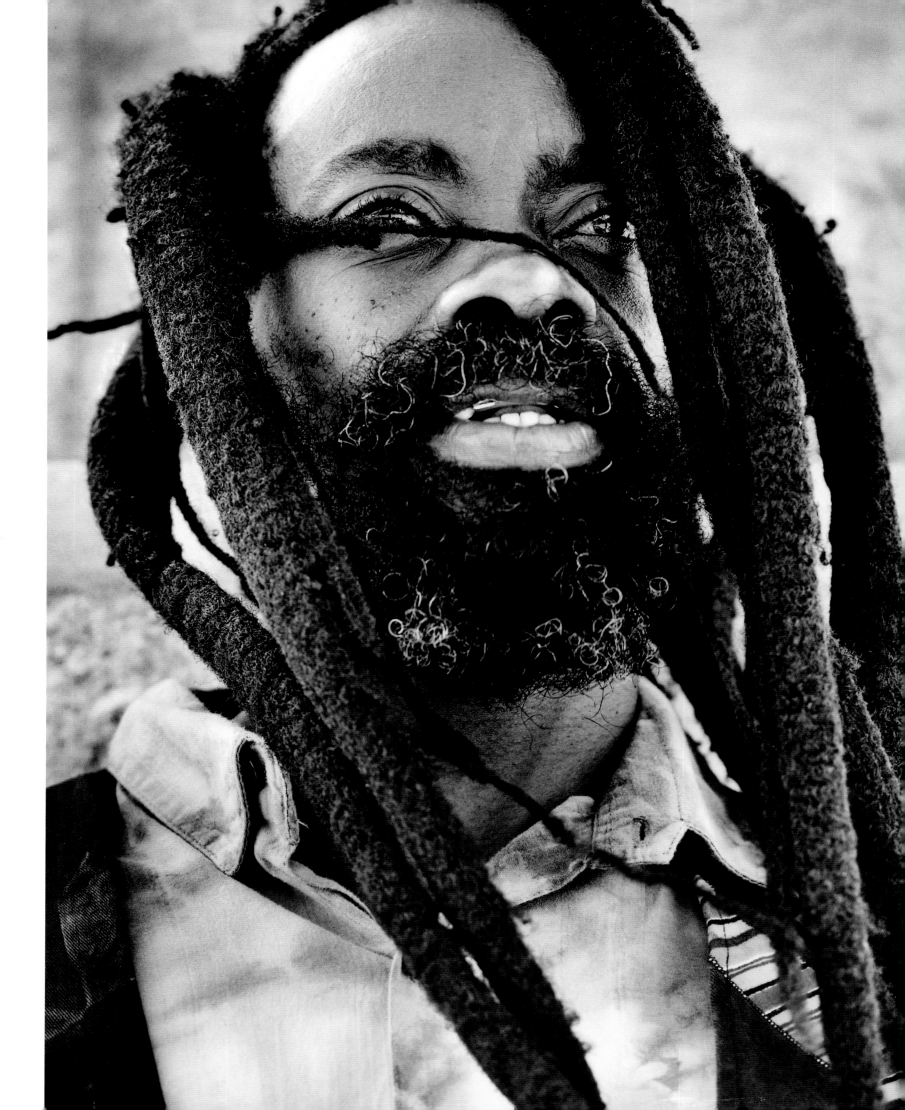

MY DREADS CANNOT BE IGNORED,

My dreads are a signpost declaring to all who wish to see and hear my commitment to my culture and to a spiritual, natural way of life. Rasta elders paid the price of persecution and tribulation for that commitment.

Because of my dreads, I cannot be ignored, thus my message cannot be ignored.

Freedom, rebellion, love, nature: Dreads speak these truths for many peoples around the world.

MY MESSAGE CANNOT BE IGNORED

CHINNA SMITH

MUSICIAN JAMAICA

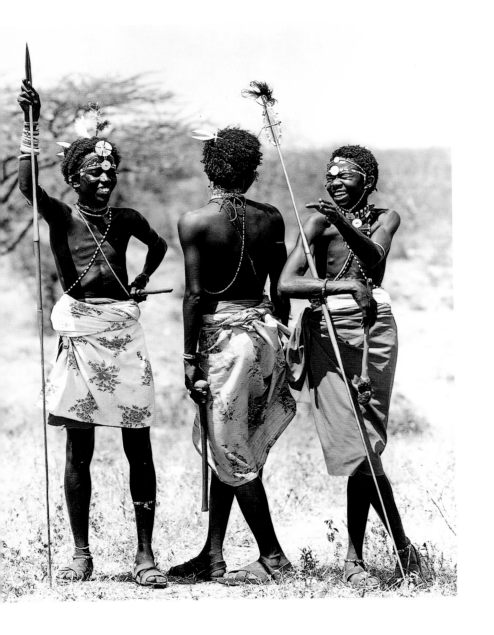
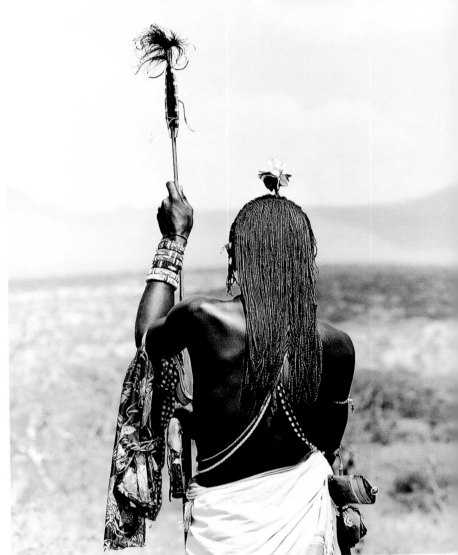

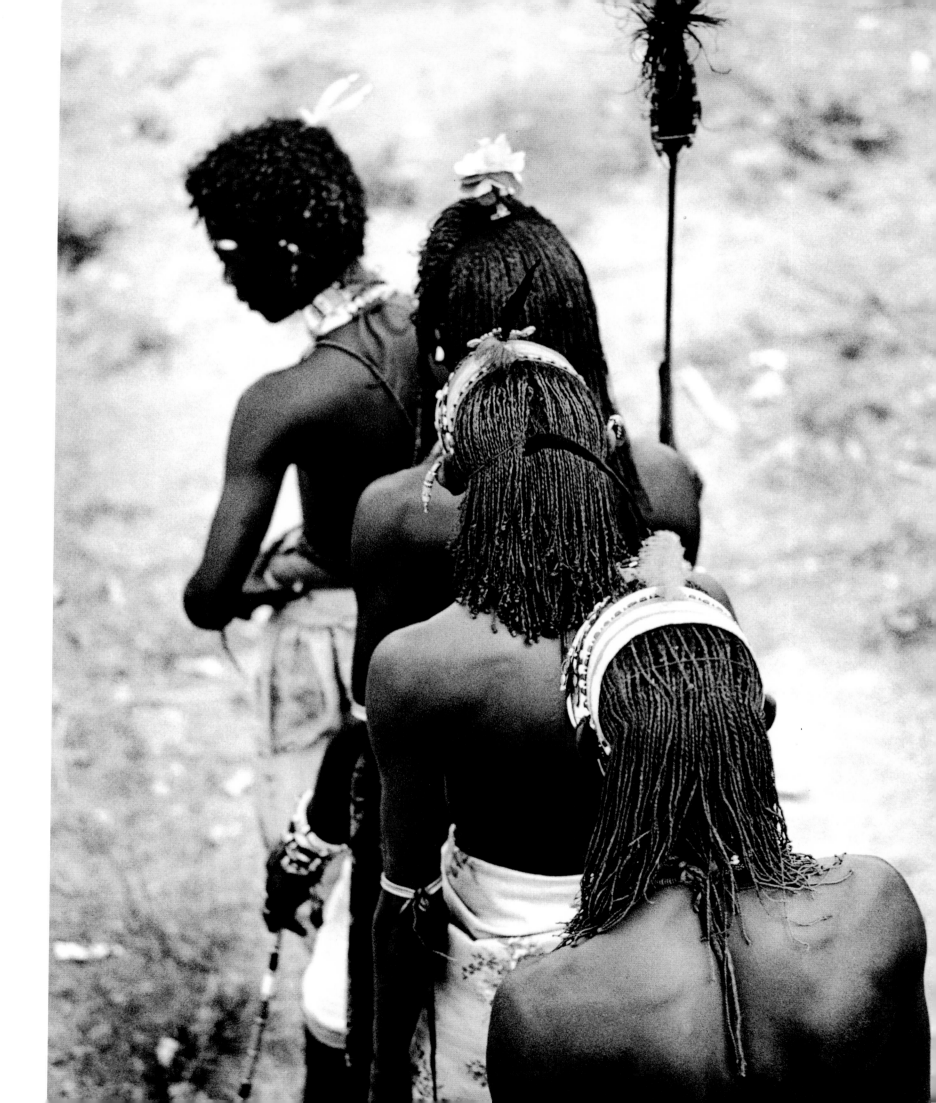

In the sixties, like every other all-American Black kid, I was brought to the barber to have my hair cut short. By the seventies, Afros were in style, so you didn't have to cut your hair, just comb it out. But I was tender-headed and never liked brushing, so I mostly looked like a nappy mess. By the time I was old enough to choose, I wanted to find a happy medium.

After ten years, locks have become such a part of my essence, it's difficult to imagine myself without them. Although I know that different groups consider dreads to be a statement against vanity, mine are very much an outward manifestation of who I am. I admit it. At the risk of sounding arrogant, I think dreads, when worn with pride, give a man a regal bearing. The image is a powerful one, like that of the lion and his mane.

Television and film are visual mediums: When it comes to type-casting, a line exists between what's considered exotic as opposed to just plain ethnic. When my hair was short and kinky, I couldn't get jobs. Directors didn't know where to put me: My readings placed me up for

ception was "Now *this* is a Black man who looks like *more* than a Black man." I spent three years as a main character on a top daytime drama (*All My Children*), and my storyline involved a romance with a non-Black woman. I often wonder if the audience would have been as accepting if my hair had been shorter—in other words, if I had been more ethnic, less exotic.

Overall, though, it's a positive thing, and I hope I'm pushing the envelope a bit, challenging preconceptions. It's important to use a position of prominence responsibly.

When you look at the African-American pastiche, any individual who succeeds in empowering his people is automatically regarded as a pariah. Look at the Muslims: Whether or not you agree with them, they've had a unifying effect on urban Blacks. When they present a united front, with men in matching bow ties and brims, it frightens the establishment.

Dreadlocks have much the same effect. They connect Black men to something bigger than themselves. And those who don't understand it want to suppress it.

I don't know if dreads will ever be unconditionally accepted.

Still, it's incredible how African culture gets appropriated and subsequently removed from its rightful origins. I was at the gym once, I'd finished my workout and was reading at the juice bar when I felt a tug. I turned around to find a woman touching my hair.

"It's very beautiful," she said. She had an accent, she was Scandinavian, maybe, but she was speaking English. I thanked her and went back to my paper. But she continued to stare, so eventually I asked, "Can I help you?"

"It's not real, is it?"

"Yes, it's real," I responded.

Unconvinced, she started to ask the guy across the bar, then declared: "It's not real."

"Okay, it's not real."

"Is it?"

"Yes."

"But can you wash it?"

"No," I answered, sensing an out, "In fact, it's filthy, so I wouldn't touch it if I were you."

That kept her quiet for about half a minute. I tried again to resume my reading, but I could feel her standing there. Finally she states, with all the wisdom of an elder: "You're probably not old enough to remember, but twenty years ago, Bo Derek was the first person to wear her hair like that."

lead roles, my look said I should be in commercials selling burgers. After I locked my hair, attitudes began to shift. Suddenly, the per-

KEITH HAMILTON COBB

ACTOR NEW YORK CITY

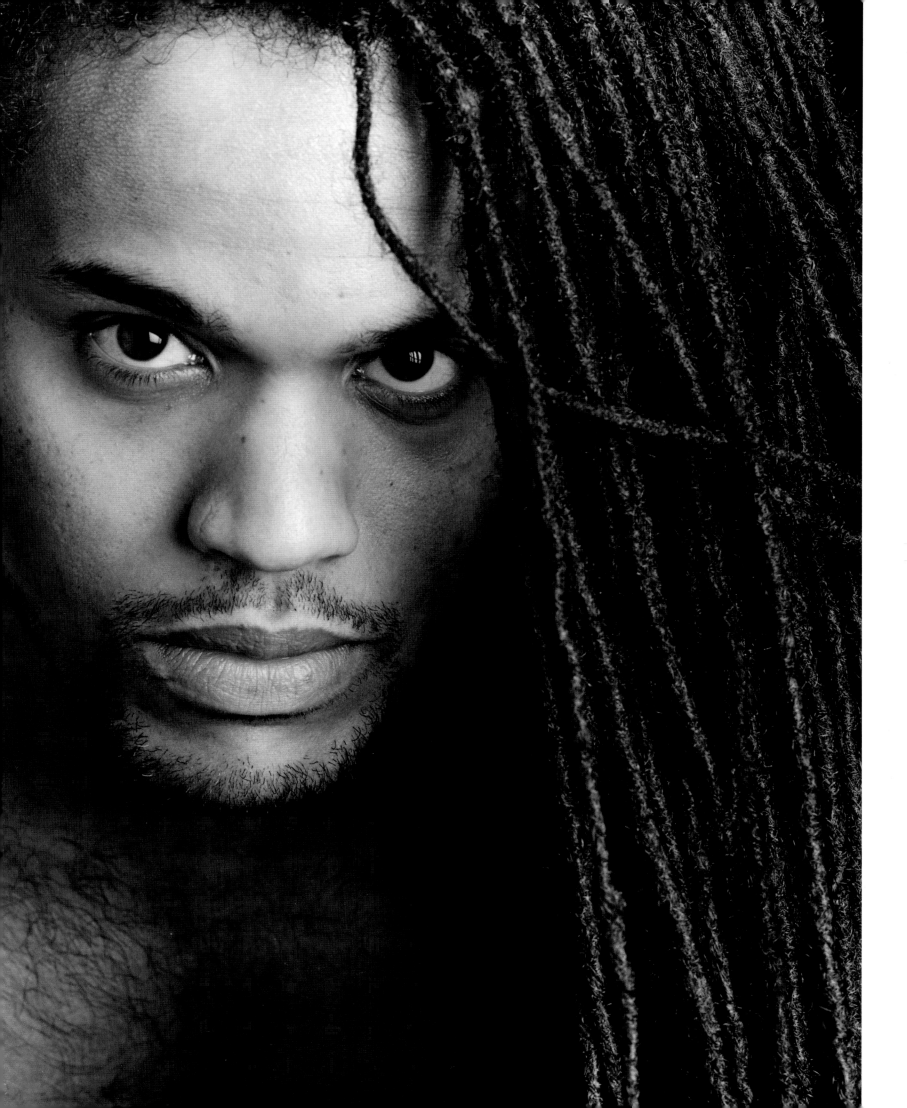

As a sadhu, I have dedicated my
life to Shiva. I have not seen
my family since my rebirth, and
I will never return to them. I have
renounced my former life. I
have no wife, no children. Jatta
represents this renunciation.

Shiva is the god of destruc-
tion and the god of creation.
The power of his jatta controls
the goddess Ganga, incarnated
on Earth as the river Ganges.
The energy of the river comes
from Shiva's jatta, and this energy
flows through all of India.

Understand, if you are a
judge, you must wear the black
robe. If you are a student, you
must wear the school tie. If you
follow Shiva, you must wear the
uniform of Shiva—jatta!

A sadhu spends his life prac-
ticing meditation through yoga.
He meditates sixteen hours,
eighteen hours a day. A true sadhu
adds nothing artificial to his
body: no soap, no shampoo, no
clothes. He covers himself in ashes.
His hair naturally goes to jatta.

SHITAL DAS PER VENS

SADHU INDIA

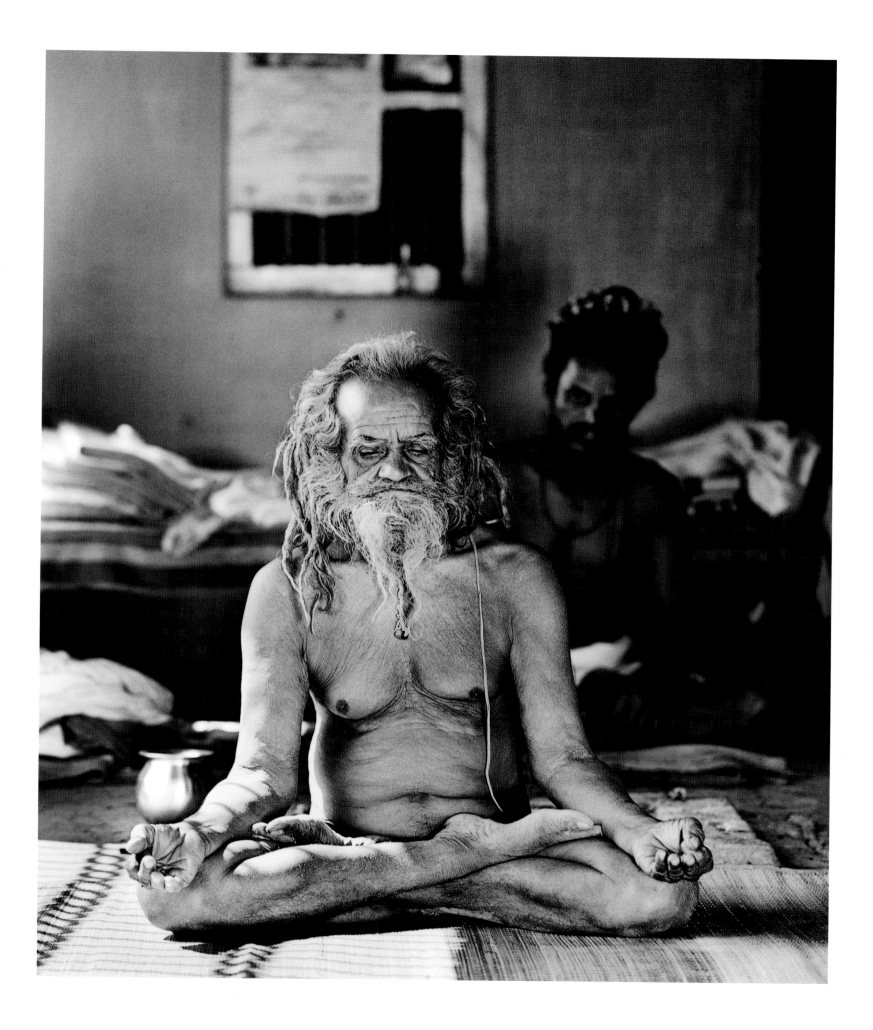

Dreadlocks are man's natural production. They come out of him naturally. They are part of man being himself, and it would be best for us all if men would just be themselves.

It is normal for a man of sound mind and body to wake in the morning and take care of his functions. But I find with dreadlocks that I use more shampoo and conditioner than the average! So there is humor in having dreads, and reconciling the organic with the hygenic.

My body is my temple, I must maintain it in order to exist within this time. Dreadlocks attest to my self-confidence and sanity. The

man who maintains himself and his crown has become obscure, almost extinct. He has become a spectacle. But he is at rest, the man who preserves his originality. He who cuts his locks does it to achieve some societal end. He forsakes naturalness to increase his value within the system. But the institutions are unbalanced: Why discriminate the herbs of the Earth and incriminate the citizens of the Earth? What is the just cause? It goes against the will of the One.

The Earth put forth all things. It continues to unfold in the presence of all elements. All that is, what is.

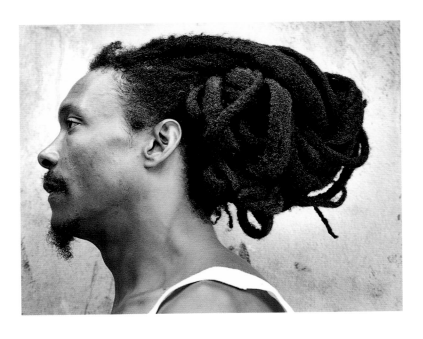

One part of the one,
All together, the fullness of life.
Life brings it forth, more life.
Like the members of the
* human body,*
They make a whole body.
Now, what should the mouth
* say to the eye?*
I bind you to do my duty?
Or should the eye become
* envious of the mouth,*
For the tastes the mouth
* experiences?*
Now I say to the judge,
And I say to the jury:
Have you fathomed the depths
* of creation?*

TONY MOSES

DISC JOCKEY JAMAICA

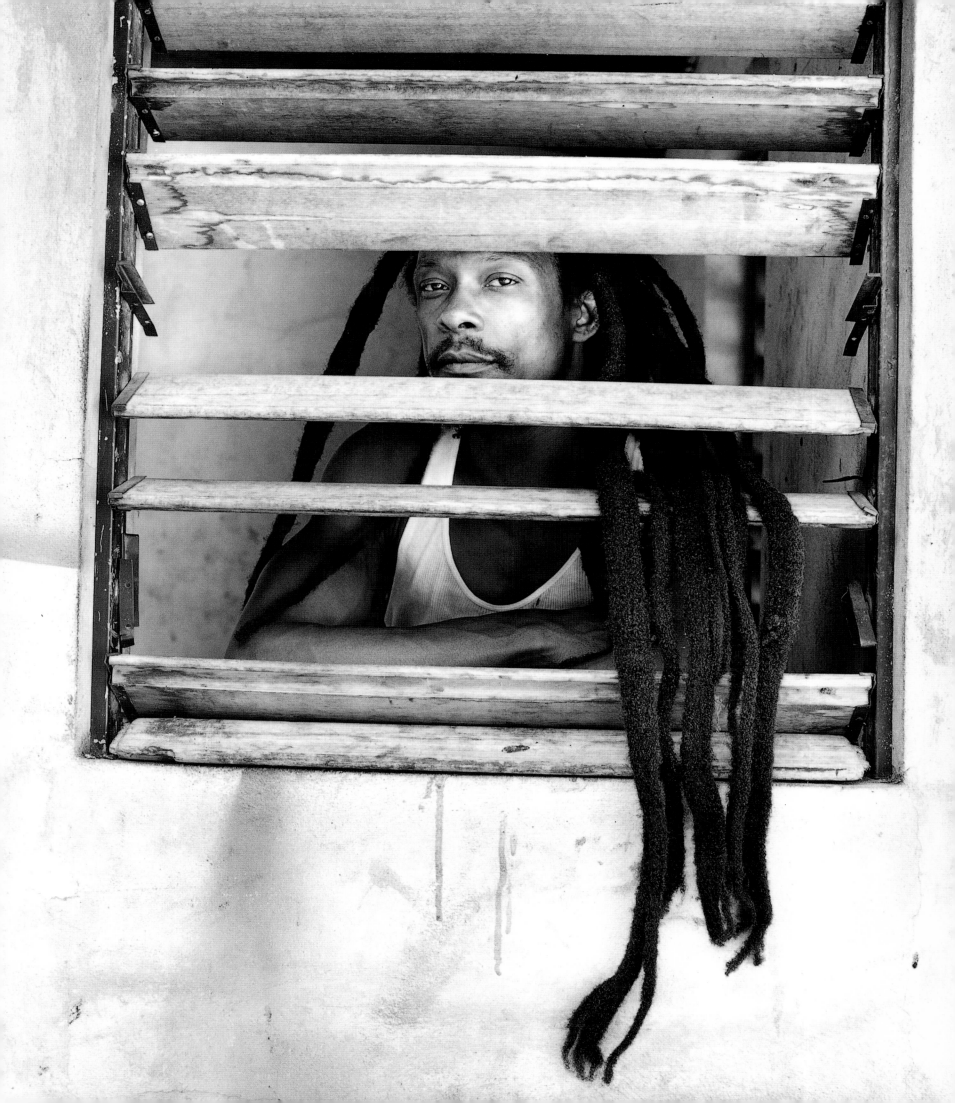

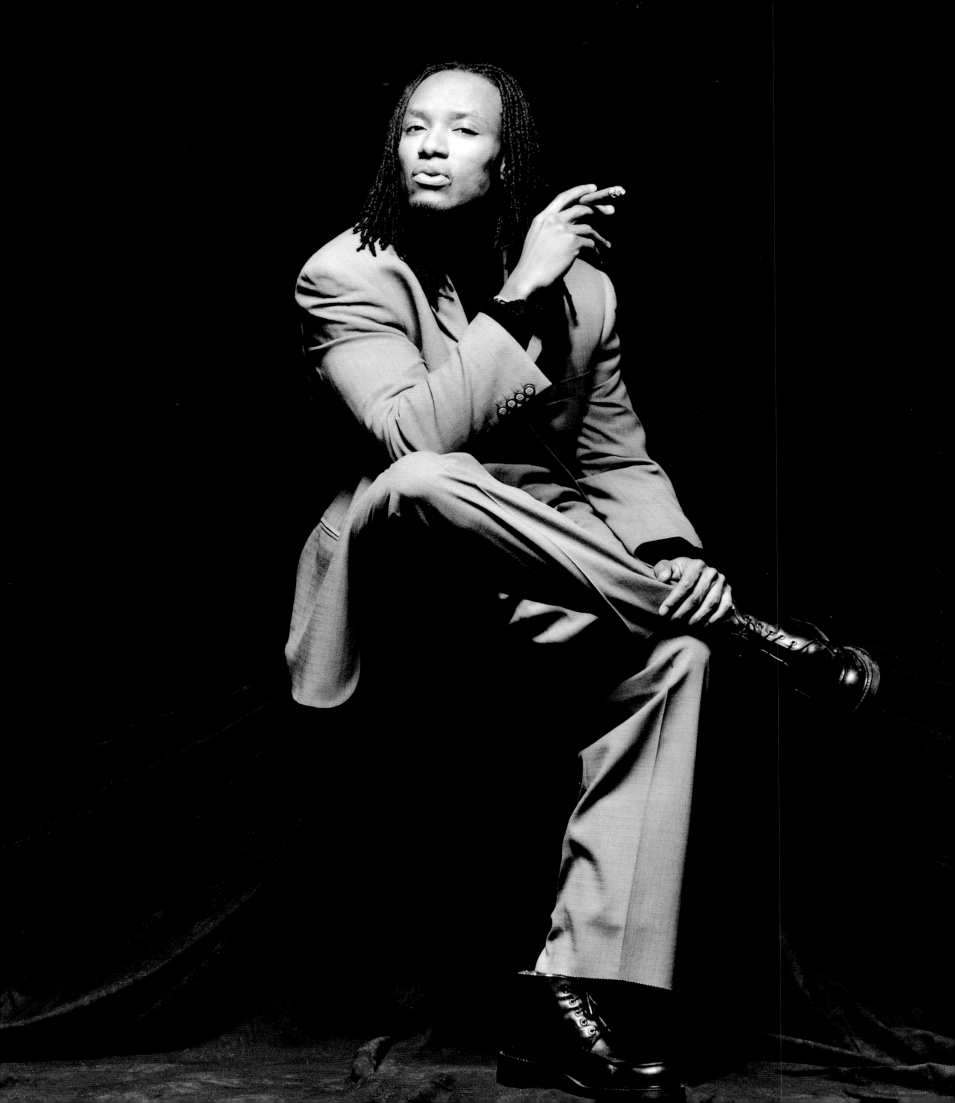

Dreadlocks originated with the Mau Mau in Kenya. They wore them as a sign of resistance against White colonists. In Jamaica, Rastafarians looked to the Mau Mau for inspiration. I looked to Bob Marley. He took the world by storm, became a modern-day saint. I also respect the ideology of

YOU CANNOT ESCAPE THE TRUE MEANING OF DREADS

the Garvey movement and the work of the UNIA (Universal Negro Improvement Association).

No matter how else you dress or decorate yourself, you cannot escape the true meaning of dreads. As beautiful as locks may be, they still stand for something: ethnic pride. When you carry dreads, you demand a second look. People are intrigued, they wonder "What's behind all that hair?"

I am happy to be nappy.

ADRIAN "SUMMIT" DELANEY

ACTOR | NEW YORK CITY

REJOICE, RASTAFARIANS!

As it says in Numbers 6:5: "No razor shall pass over his head until the day be fulfilled of his consecration to the Lord. He shall be holy, and shall let the hair of his head grow."

I am a Havasupai Indian, but the day I threw away my comb, I became a Rastaman. I don't see a contradiction between my Havasupai culture and my Rastasfarian religion. Both are about force of spirit.

The Sioux and Havasupai peoples painted canyon and cave walls with images that foretold the future. One spoke of the coming of a seer, a reincarnation of Chief Crazy Horse as a Black man. He would invoke the fourth apocalypse to liberate the downtrodden Red man. Like "Anancyskiaunk," the mythical wise spider, he would breed dissension. I believe Bob Marley was that prophet, sent to free us from mental slavery.

The work has been done already: redemption, repatriation, unification of the Ethiopian congress. Rejoice, Rastafarians! Babylon is surely falling away.

My dreads bring me dreams. I hear through them telepathically. The Aruba tribe told me that hair is sacred. It is part of your dignity. It is part of your identity, from the last day to the first.

BABYLON IS SURELY FALLING AWAY

DAMON WATAHOMIGIE

MUSICIAN ARIZONA

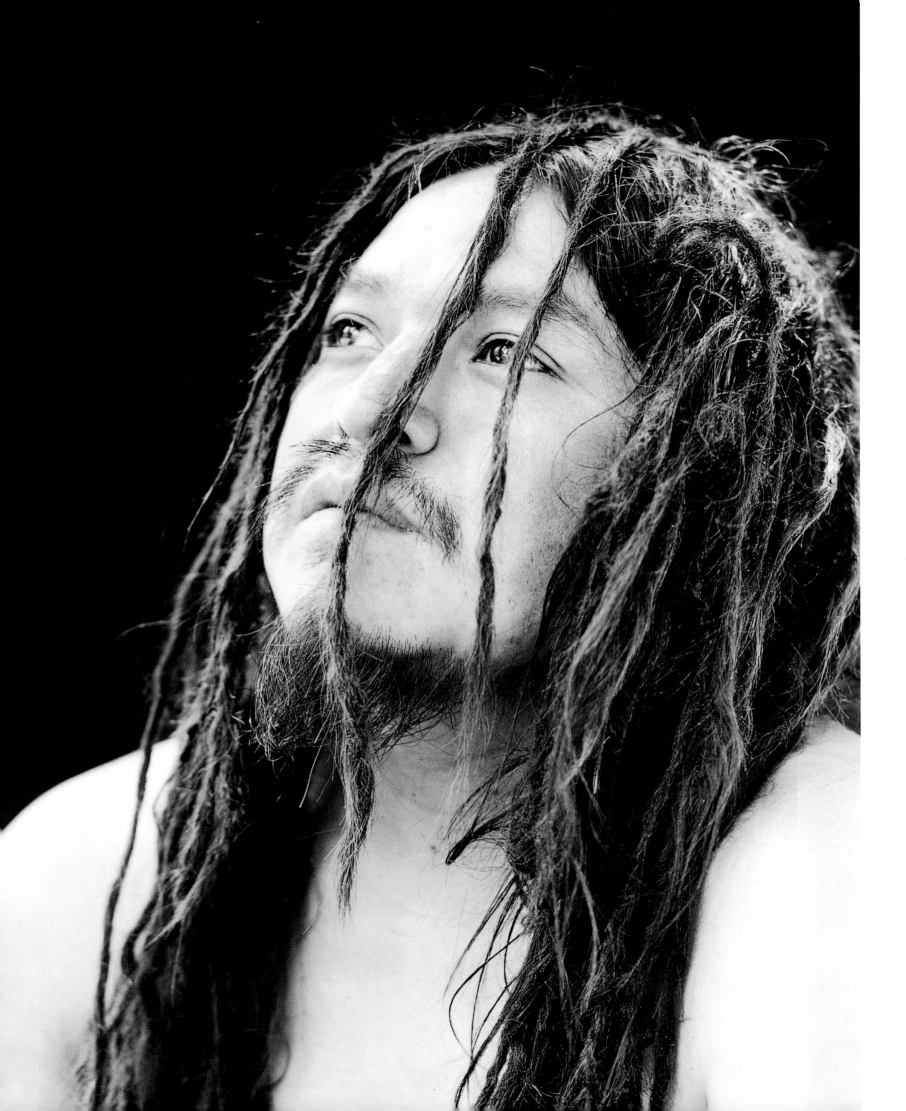

I am a *tyagis,* a renouncer; a believer in Vishnu, the sun-god, the merciful warrior-king.

My guru gives me knowledge. I follow the ways of my teacher. I wear jatta in the custom of the guru.

The guru is going to heaven. When he dies, I will cut off my hair. I will cut off my hair and the nails on my hands and feet.

When the child is born, then the hair comes.

RAMCHANDER DAS

SADHU INDIA

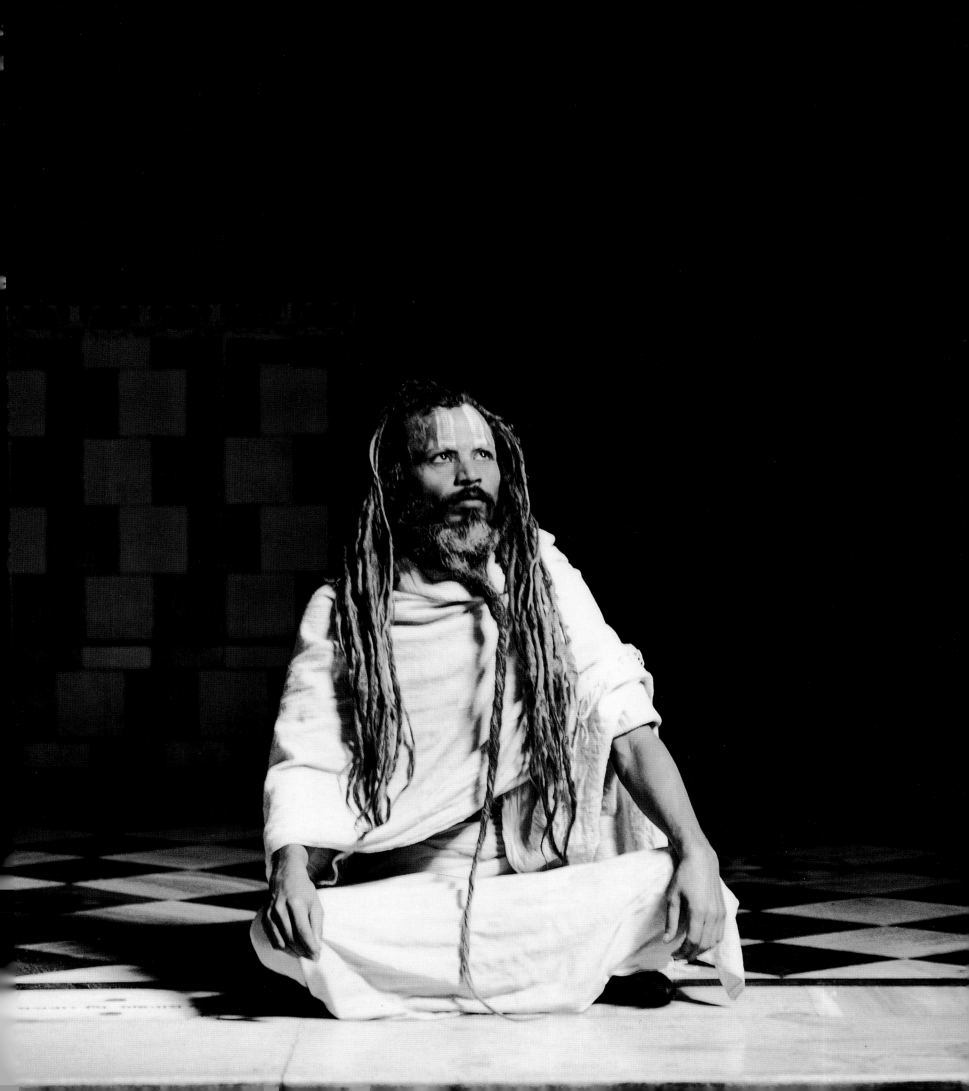

It's my understanding that dreads
originated in ancient Egypt,
and that, in more recent history,
they were worn by the Nyabingi
of Kigezi, Uganda, in opposition to
Black-on-Black oppression and
British imperialism. Many different
cultures in Africa lock their hair,
and I think they—primarily
the Nyabingi, the followers of Haile
Selassie in Ethiopia, and the
Mau Mau of Kenya—inspired the
Jamaican Rastafarians.

YOU DON'T HAVE TO HAVE STRAIGHT HAIR TO BE BEAUTIFUL

I locked my hair in order to
identify with my African culture.
I've had my locks for almost
five years. I discovered that you
don't have to have straight hair to
be beautiful. Locks are about a
deeper love, a self-respect. Living
in Brooklyn, where a lot of
Black women have dreads, has
been a major inspiration to me.

CHERYL BROWNE

MODEL NEW YORK CITY

I RELATE TO RASTA:

I am not a Rasta, but when people
speak the name, I acknowledge
the call. Rastafarianism, like most
religions, is male-dominated. It
really doesn't correspond to my
spirituality. If the men were willing
to admit that my grandmother was
a goddess, just as Haile Selassie
was a god, then I might reconsider.
But I relate to Rasta. I relate to the
concepts of I-and-I, unity and love.

Dreadlocks are a natural
expression of my African heritage.
I grew up with a comb in my hair,
and always hated it. In the sixties,
I wore an Afro. I dreaded my hair
in the early eighties.

In Native American cultures,
long hair represents maturity.
My locks are a sign of my wisdom.

I RELATE TO I-AND-I

SAIYDA STONE HAUGHTON

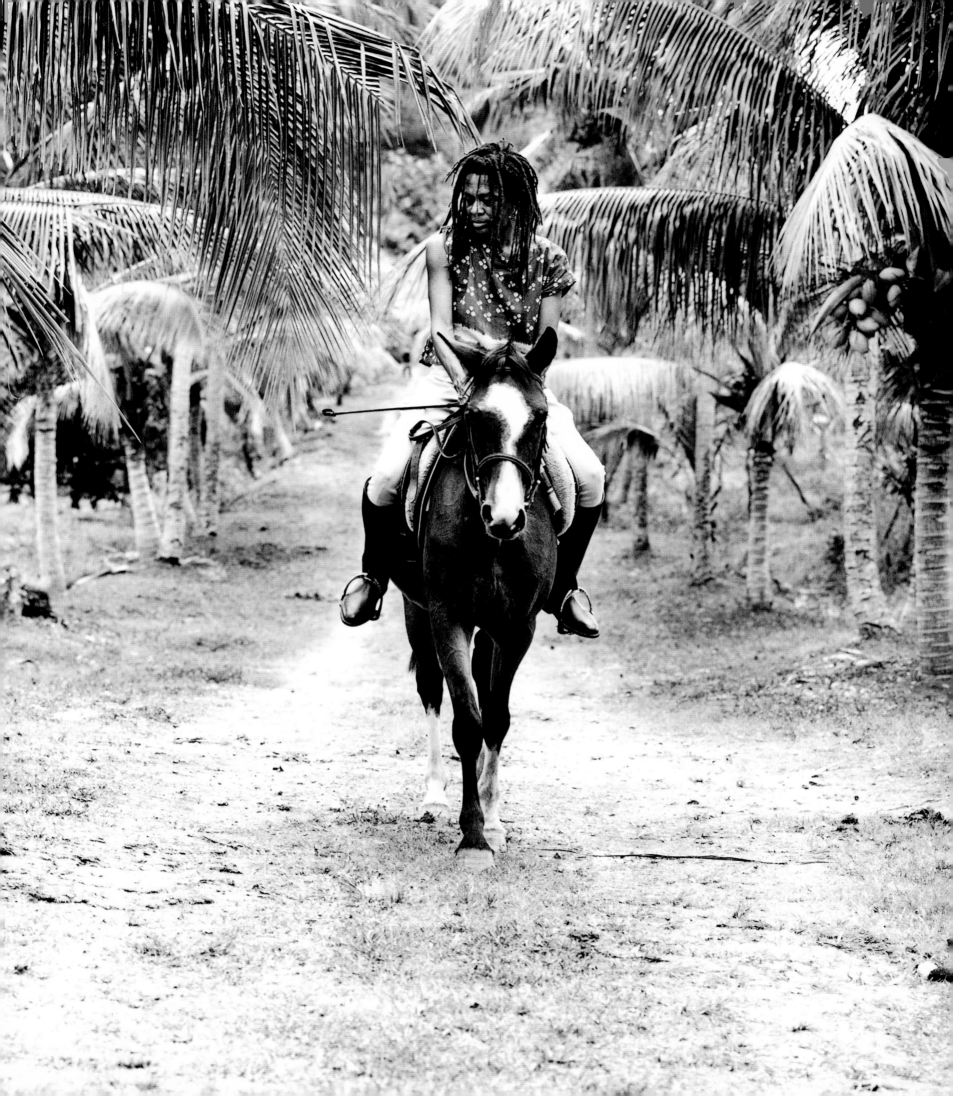

And I thought, "Yeah! I might try that." But that set of dreads didn't roll tightly, they weren't well formed. I kept them for a couple of years. Eventually, I brushed them out.

Third time, let's see: I had dreads, but I went to live in Vanuatu, where I caught head lice, so I cut them off yet again.

Once I tried to go straight. Bought a brush and comb and raked my head daily. But I still hated it, hated my stupid, slutty mess.

The moral of the story being, I never did get into brushing my hair.

SHE HAD THE SCISSORS IN HER HAND,

The first time I had dreads, I was a kid, about eight years old. I had long hair, but I hated brushing it. The concept was foreign to me. One day my mother warned me that if she didn't see it brushed the following morning, she'd cut it all off. Of course, I forgot until the minute my mother looked at me the next day. I rushed out of the room and quickly brushed my hair back into a ponytail, to no avail. When I returned, she had the scissors in her hand, and she cut my hair clean off.

The second time I locked my head was in my late teens. I had long hair again, but I still hated brushing it. At the time, I was traveling with a band, and we were up north in a small town where there was a population of Maori. One guy in particular had great dreads, and I asked him how I could get my hair to look like his.

He said, "You've got to sort your locks, hang out in the sun, and smoke lots of ganja."

For me, dreads are about freedom. My hair locks naturally. I've tried every other way. I've had these dreads for about ten years now.

Ours is such a consumeristic, product-oriented culture: shampoo and conditioner and gel and mousse and permanent waves and blow-dryers. I've got better things to do than style my hair.

SHE CUT MY HAIR CLEAN OFF

KARA DODSON

DESIGNER | NEW ZEALAND

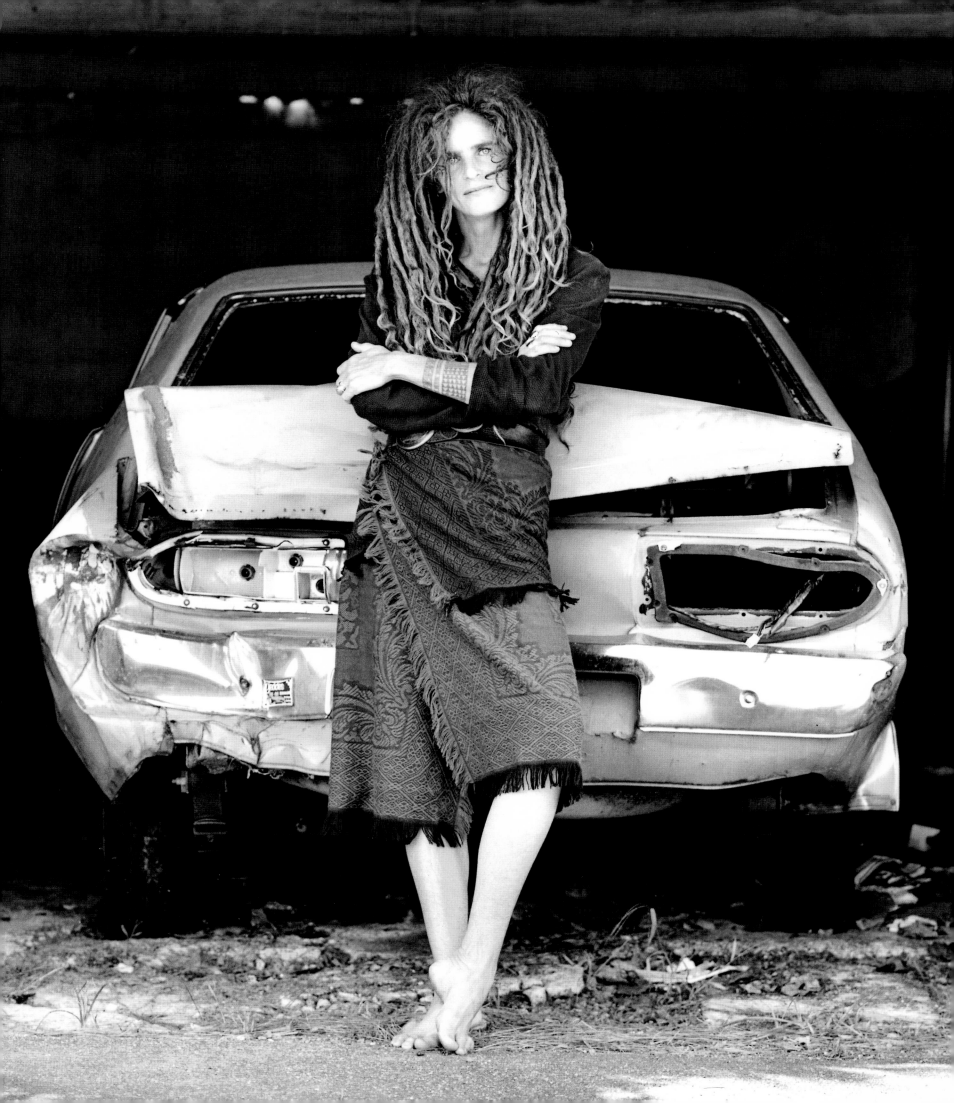

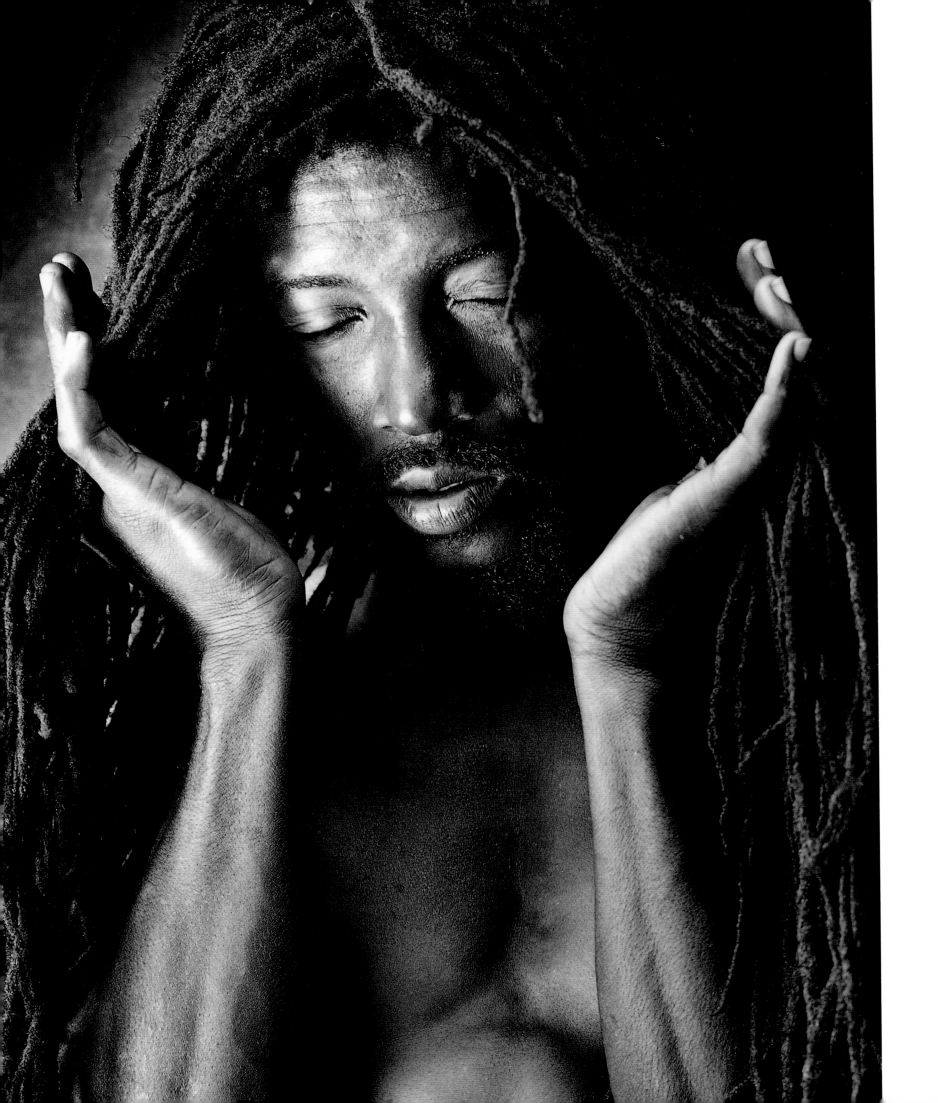

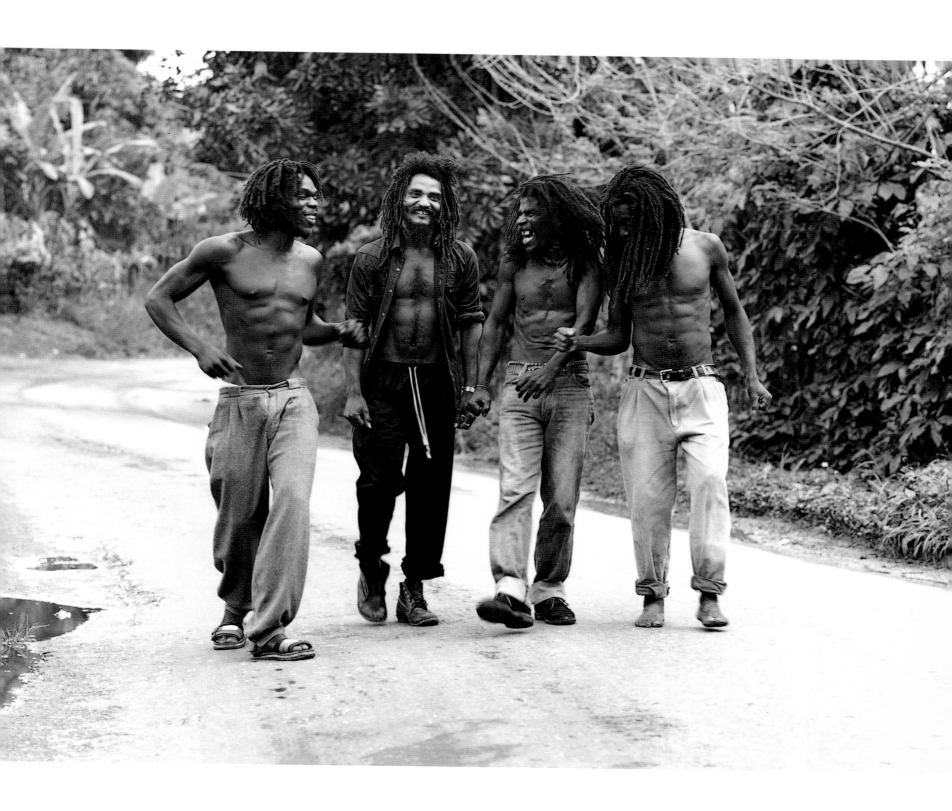

On a basic level, the beauty of my dreads is that I can wake up in the morning and not have to worry about my hair. Speaking seriously, my locks mean less to me in terms of Rastafarianism, and more in terms of personal freedom. In most countries where dreadlocks are present, there's a reason behind them—political, spiritual— and a responsibility attached to them. You cannot be careless about dreads. Some amount of consciousness is inseparable from the act of growing locks.

Dreads are about being Black. The information you receive through American television, for example, tells you that you have to have straight blonde hair. Imagine the impression those images make on a fragile, impressionable, little Black boy growing up in Jamaica. In America, Blackness doesn't count. Society is not geared toward giving us confidence—it's geared toward keeping us in our place.

TOWARD GIVING US CONFIDENCE

MAXINE WALTERS

FILM PRODUCER JAMAICA

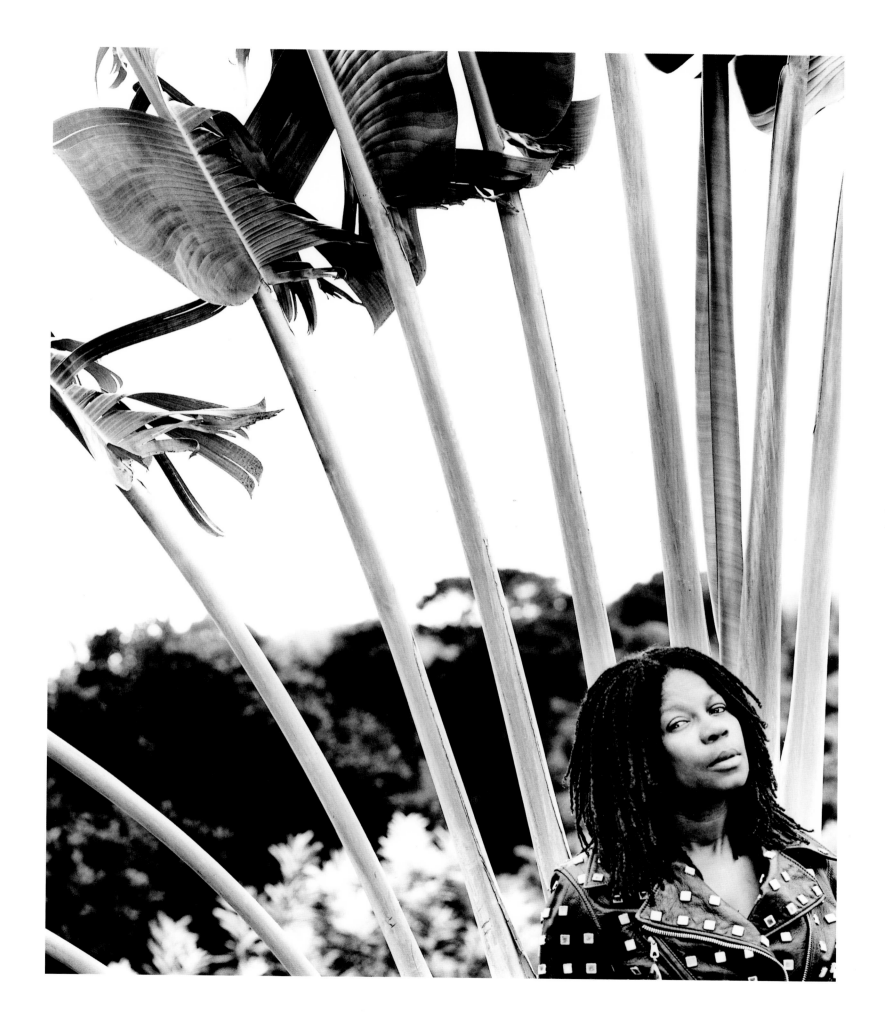

I'm what you would call a twenty-first-century Renaissance man. I don't categorize too easily. As a computer scientist, I was on the forefront of virtual-reality technology, and today that work bridges other fields—neuroscience, physics—as I try to figure out how a digital view of the universe might affect science as a whole. I work as an analyst and a consultant, and have written extensively on the subject of computers as they relate to the average American worker.

I'm also involved in the arts, primarily as a composer. I work in both the Western classical tradition and in modern jazz. I recently completed a symphonic piece on commission for the St. Paul (Minnesota) Chamber Orchestra, and in 1998, I headlined at the Montreux Jazz Festival. I'm also an established graphic artist.

But I'm terrible at basketball.

In the business world, I'm an anomaly. I think I may be the first person with dreadlocks to have testified before Congress, and I know I'm the first to have consulted with the Department of Defense.

My hair had a mind of its own. It always wanted to dread, even when I was a kid. My parents, especially my mom, fought the good fight, but nature was against them. By my teens, I'd decided to let it dread. Periodically, I would beat it back, but eventually I gave in.

I grew up in southern New Mexico, where I had absolutely zero contact with any kind of African Diaspora, including Jamaican culture. I'd never heard reggae music. The world of Mexican-Americans and Indian-Texans is a different world indeed. It wasn't until I went off to college that I was exposed to other groups. The origin of my hair is genetic, not cultural.

My mother is from Vienna. While visiting there once, I spotted some kids with dreads hanging around the train station, so I went up to talk with them, my own kind, White kids with locks. Turned out they were Jewish, like me. From the encounter I surmised that there is some small, little-recognized strand of genetic dreadheads in the Viennese Jewish community. My fantasy is that some Falasha rabbi made his way north many years ago and partook of some hanky-panky!

Even though I'm a scientist, I admit I haven't really researched what makes hair dread. People constantly ask me how I do it, and I always have to tell them that not only have I not done anything to create dreads, I've tried many times to destroy them! I've been accused of cultivating dreads in order to affect a gurulike persona. A rather oily gentleman in Los Angeles once offered to buy my locks, but I never bothered to find out exactly how much they were worth. It's only hair! I find myself having these conversations on a daily basis, and, frankly, it's beginning to get annoying. I'm considering having a card printed up with an explanation.

When I run across Rastafarians, they assume I am either a White-skinned Jamaican or at least a person who is informed about their culture, so they address me as a fellow Rasta. But I'm actually not that familiar with the ideology, and I never know how to respond. On occasion, I'm perceived as trying to assert a Black identity or to usurp Black traditions. I can understand the reaction. Race is an ambigious and deeply personal issue.

In Rastafarian and other Afrocentric cultures, much is taken from Jewish symbology—interpretations of the Old Testament, of Babylon, Judah, and Zion, for example. As a Jew, I've always found that flattering.

Religion and race aside, it occurs to me that I look much as I would if I were a wild animal. Take away my clothing, and the fact that I'm well nourished, and I look like a nonsocialized Homo sapiens. I like that. My dreads acknowledge what I would be were it not for all the things my brain has been taught to do. They're primal, a token of origin.

JARON LANIER

SCIENTIST/ARTIST NEW YORK CITY

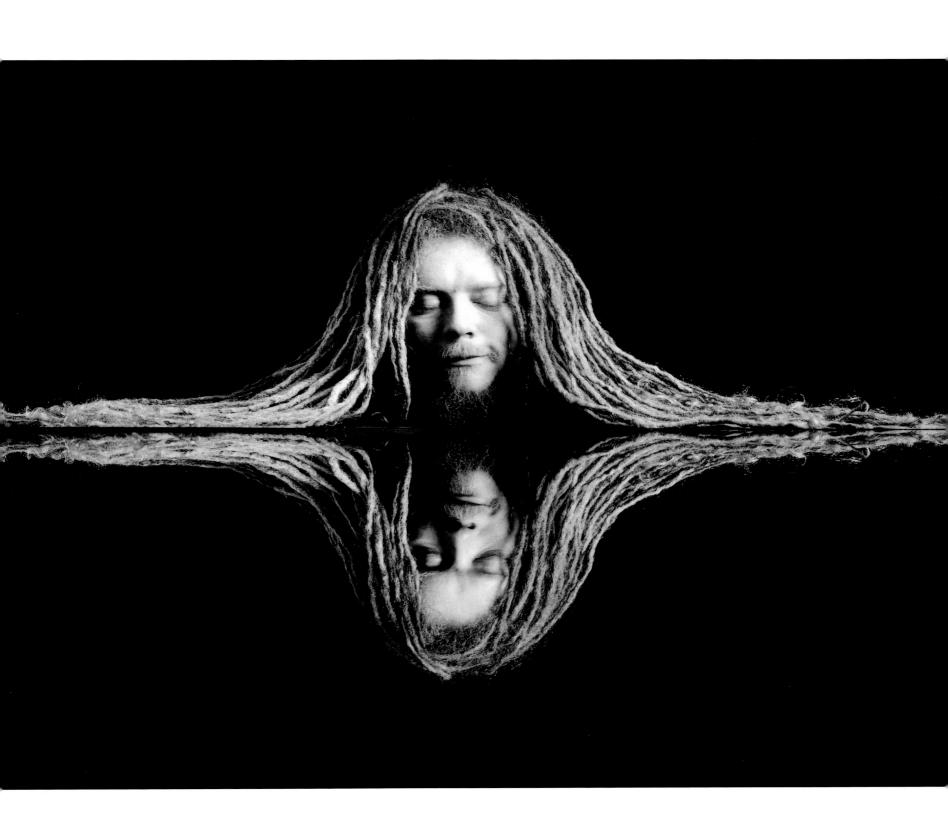

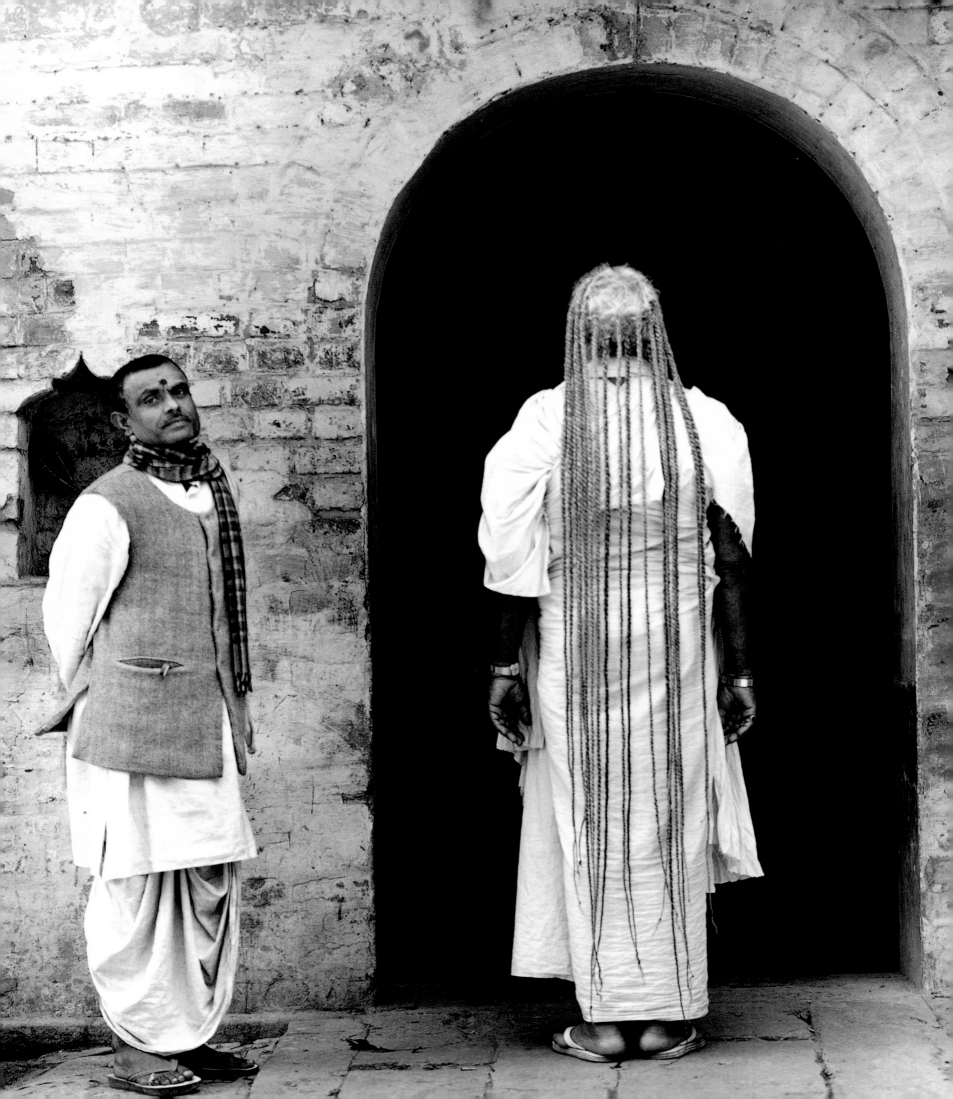

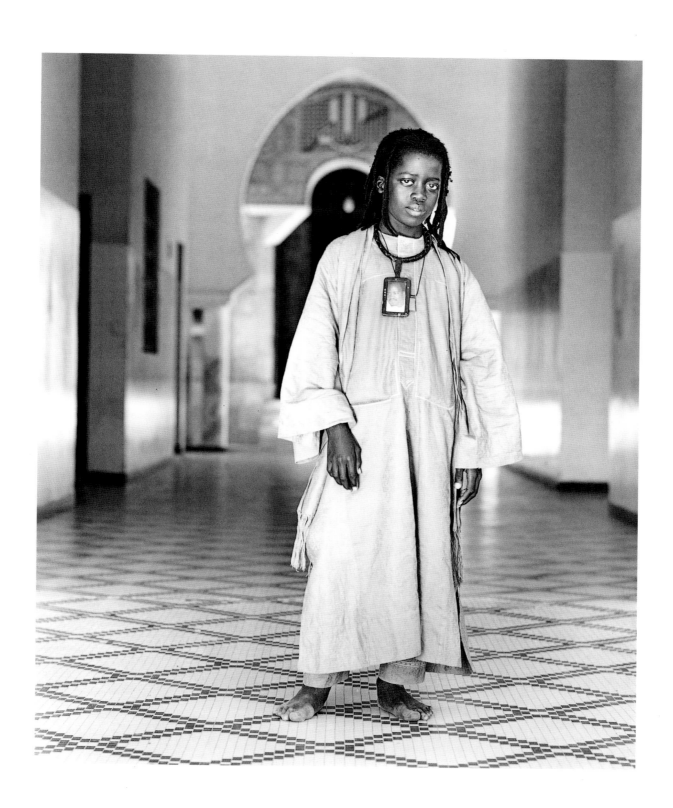

When I was nineteen, I was in a reggae band. Everyone in the group had natty dreads, so I started growing mine. People began to call me "Rasta woman," and I wasn't ready for the title, so I ripped out my locks, pulling them apart with conditioners. Six times I did that, over

THIS IS NOT ABOUT VANITY,

the course of four years, locking and unlocking my hair. I finally committed to dreads when I was twenty-three, when my father was dying of cancer.

I never intended my dreadlocks to be a fashion statement. To me, they represent rebellion and self-respect. But today, dreadlocks are considered quite stylish: When I returned to New York, the reaction was "Wow! Where did you get your locks done?" Done? I grew them in the bush in Jamaica!

These days, dreadlocks have practically become acceptable. Recently, I visited a large record company, and half the staff must have had them: graphic designers sitting behind computers, A&R people, account executives. Not so long ago, you couldn't get a job if

you had dreadlocks. Now you probably could run for mayor.

In the United States, dreadlocks don't necessarily hold any religious significance, as they do elsewhere. In American cities, so many different citizens from different cultures now carry dreads that some of the spiritual reasons behind them have been lost.

Sometimes, it's not so cool being a female with locks. It's not so cool because a lot of hip-hop gangstas are carrying them too, and they're also carrying guns. These kids have only sprouted dreads for the attention—the same reason I did when I was their age, but, since then, my hair has taken on so much more meaning for me. No matter. I'm attracting twenty-one-year-old dreadlocked boys who think my 'do is righteous.

I'm actually offended when people compliment my dreads. This is not about vanity, this is a way of life. My locks are my strength, a constant reminder of the vow I made to stay on the path of spiritual cleanliness and creativity.

THIS IS A WAY OF LIFE

JIVANA

ARTIST NEW YORK CITY

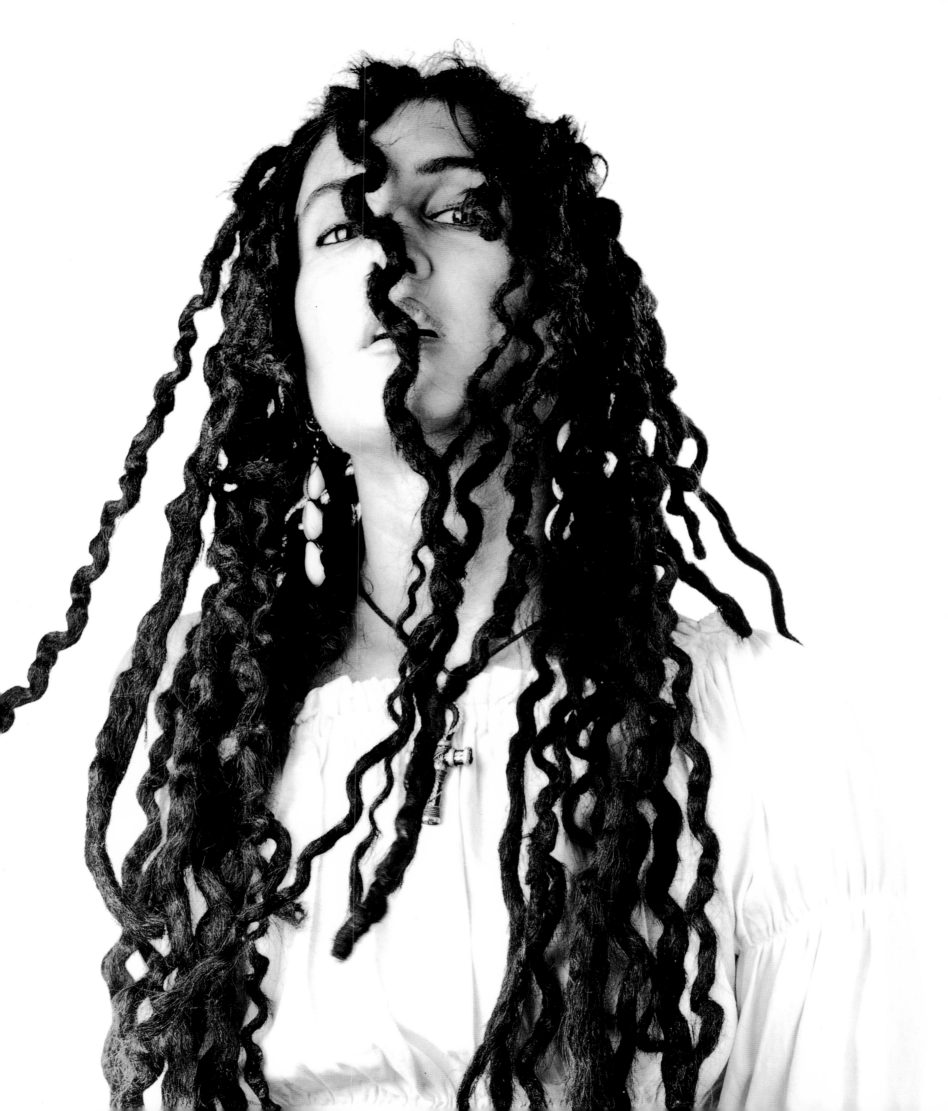

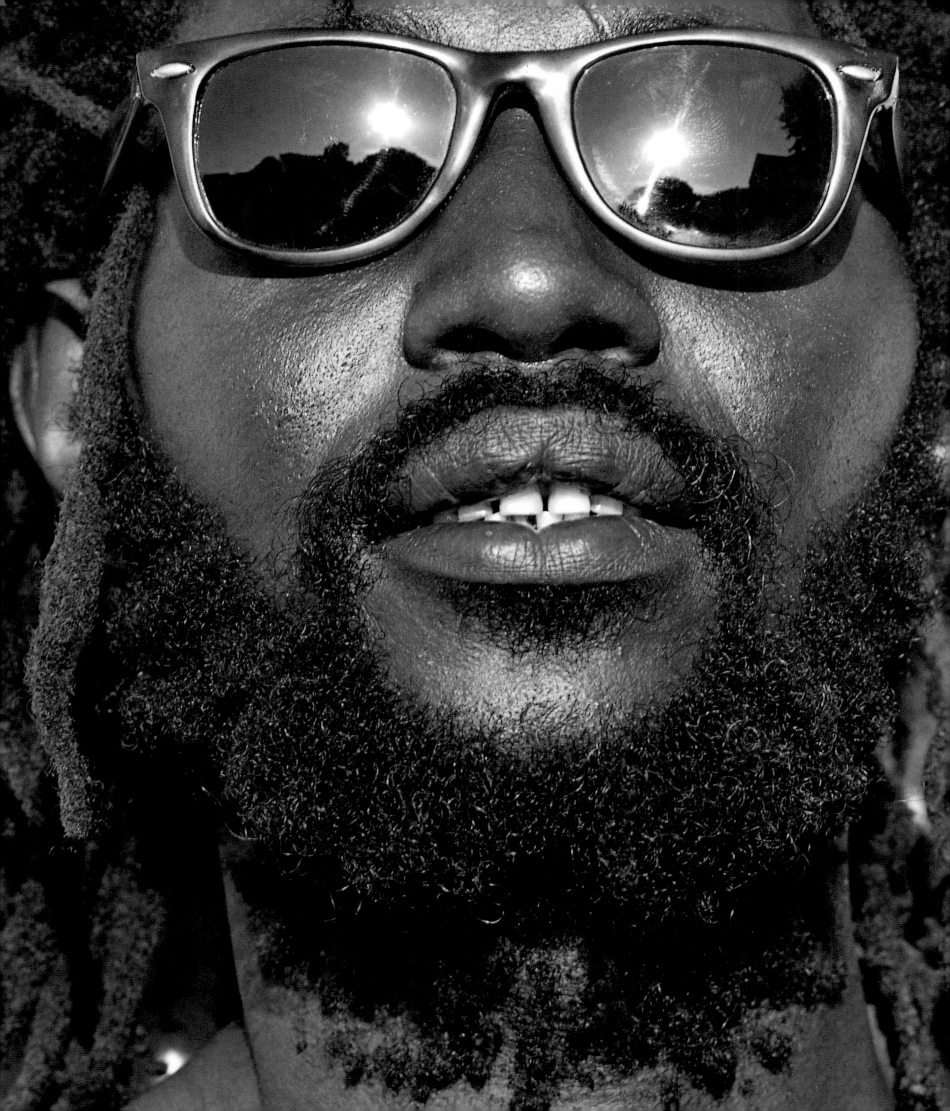

In supplication, the apostle Ibrahim Fall turned his hands toward the face of Cheik Amadou Bamba. The elder looked upon his disciple, then spit in his palms. So blessed, Fall ran his hands over his head, and vowed never to wash the offering from his hair. This is the origin of our ndiagne. I am a Baye Fall, a Black Muslim. I do not wear dreadlocks, I wear ndiagne. In English it means "strong hair."

At the time of French colonization, Cheik Amadou Bamba got a letter from the governor commanding his presence. All the spiritual guides went. The governor wanted to put an end to the native Senegalese religions. He declared that all who listened and obeyed would be set free, and any who did not would be taken inside the fort and killed. Of eighty-four spiritual guides, Amadou Bamba was the only one to say to the governor, "You are nothing. You are human, like me. These religions existed long before you, and I won't denounce mine."

Bamba was taken prisoner, and for seven years not a day passed when the governor didn't try to kill him. Bamba was held captive seven years, seven months, and seven days. Everything was in sevens. He left behind seven tons of spiritual writings.

His follower, Ibrahim Fall, was a man of action. He did not

bother with his hair. He is the first one we saw with ndiagne.

Now many people around the world lock their hair, not all for religious reasons. But we Baye Fall don't have the right to judge. Humility. It is our spiritual duty to be humble. And the Baye Fall and Rastafarian philosophies are not so different. The peace, love, respect—that's the same.

AMADOU

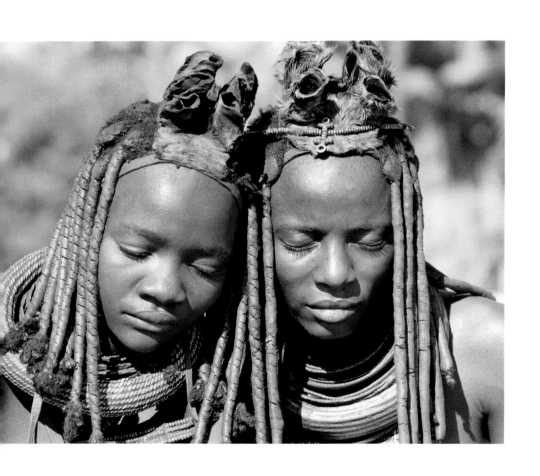
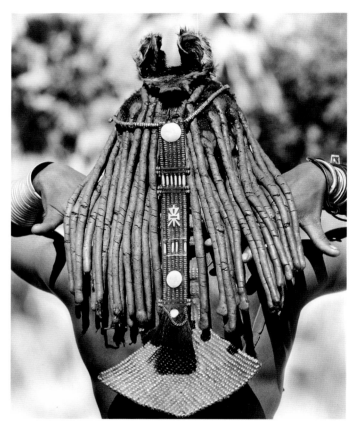

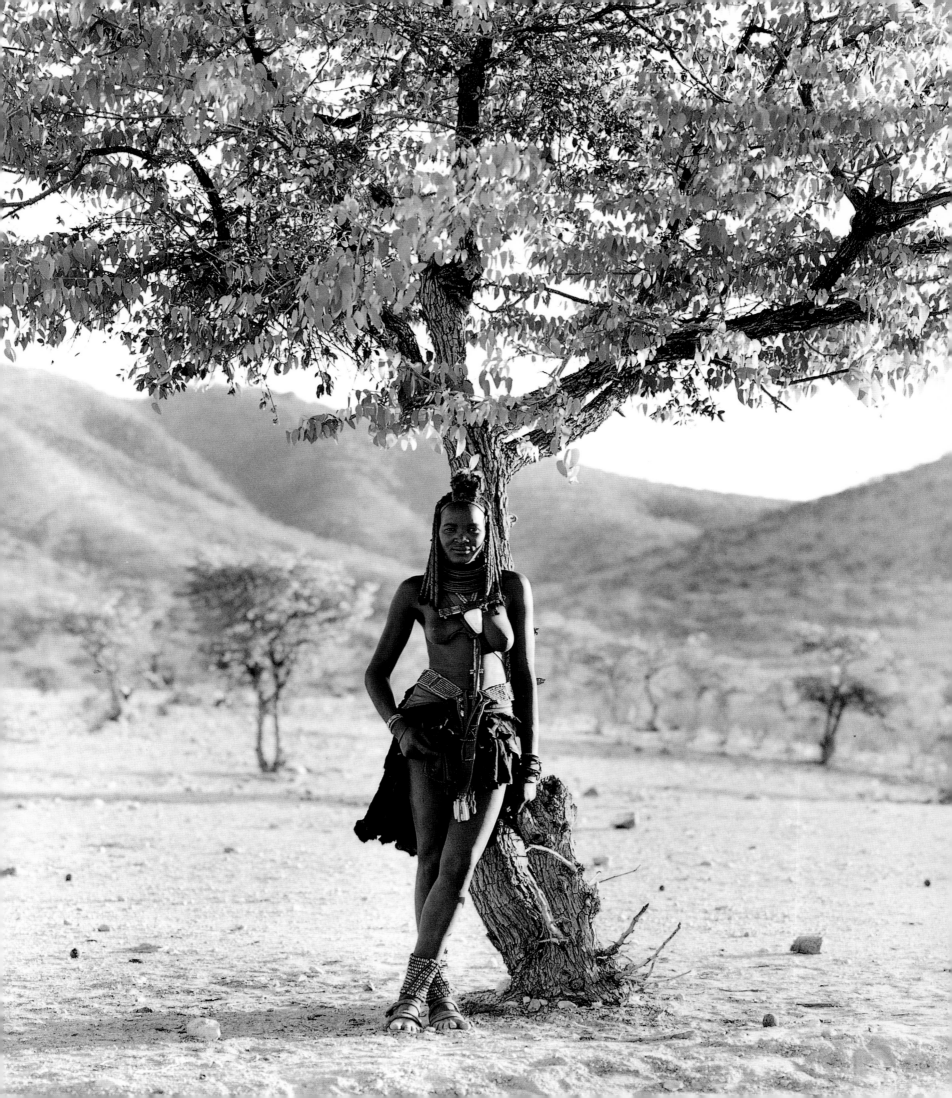

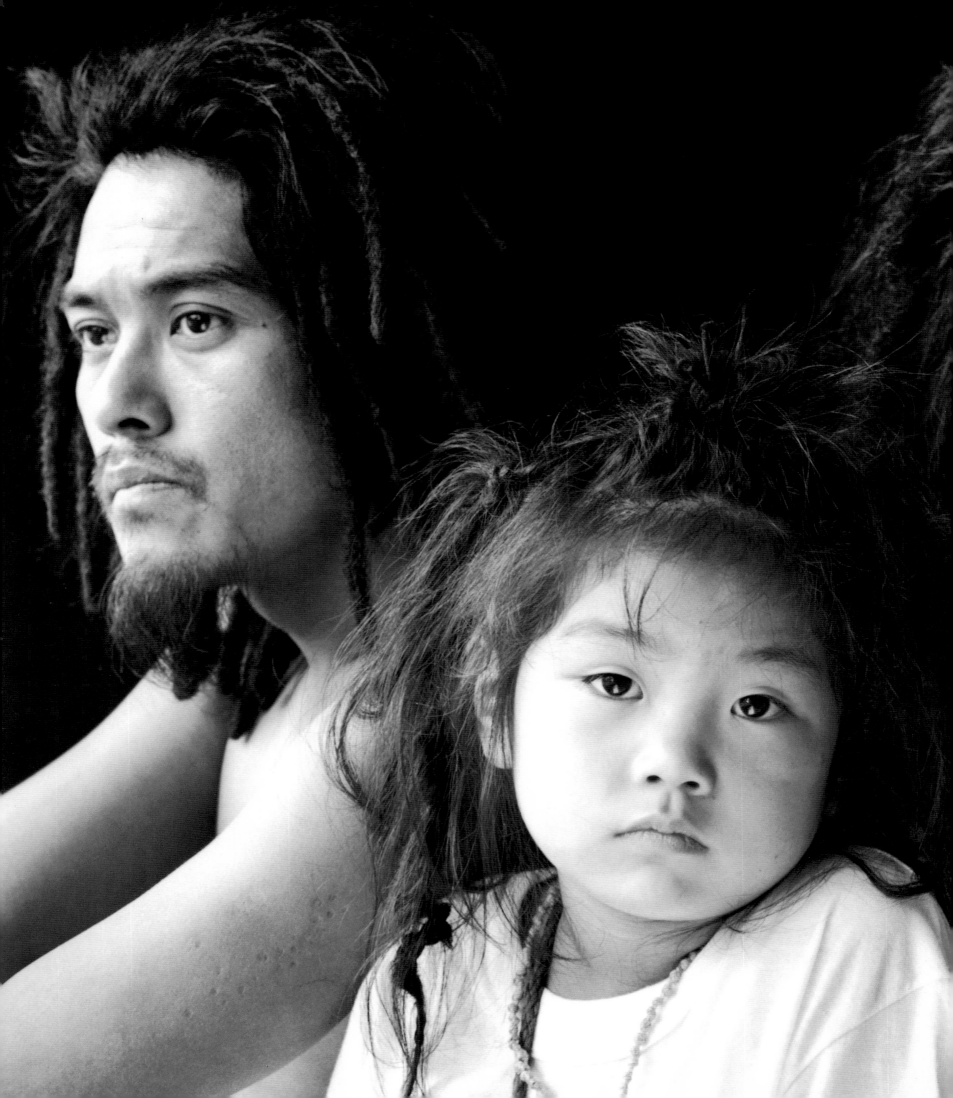

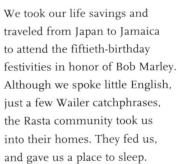

THE RASTA COMMUNITY TOOK US IN

We took our life savings and
traveled from Japan to Jamaica
to attend the fiftieth-birthday
festivities in honor of Bob Marley.
Although we spoke little English,
just a few Wailer catchphrases,
the Rasta community took us
into their homes. They fed us,
and gave us a place to sleep.

HIROYUKI SATO & FAMILY

FARMERS JAPAN

Him a wolf. The man who wears the locks not knowing the reasons is a wolf. He must expose himself. As a wolf in sheep's clothing. And him get a beating. For disregarding the covenant of Jah. Disrespecting the gift of Zion. He no enter the kingdom.

Me a sheep. My dreads show I a sheep for the most high, Haile Selassie. Dreads my cross to carry. When you see a man with dreadlocks, you see Selassie—him not carry them for fashion. Dreads represent the Creator, what I-and-I have gone through, connection with the Almighty.

So this fashion business, with some guy who come shave around the rim or something, he have to decide what the deal is. Because most I know that shave around the rim and have a little natty, if you tell them to grow it, them say, "Why, you know, mon, I can't humor that trim again."

It was never meant to be at first a fashion.

Livety. True livety. It is how I-and-I live. In and amongst I-and-I. It is what we have to go through, every nation, every peoples. Look inside yourself, see what your purpose on this Earth is. If the world lived that way, if the world lived like Rastafarians, there would be no crime. No war. No poverty. There is enough food on the Earth. You don't lack nothing.

No matter the color of a man's skin, what comes out makes him right or wrong. Not because him Black or White or him skin purple. I-and-I don't want no colorization. One blood, one peoples.

82

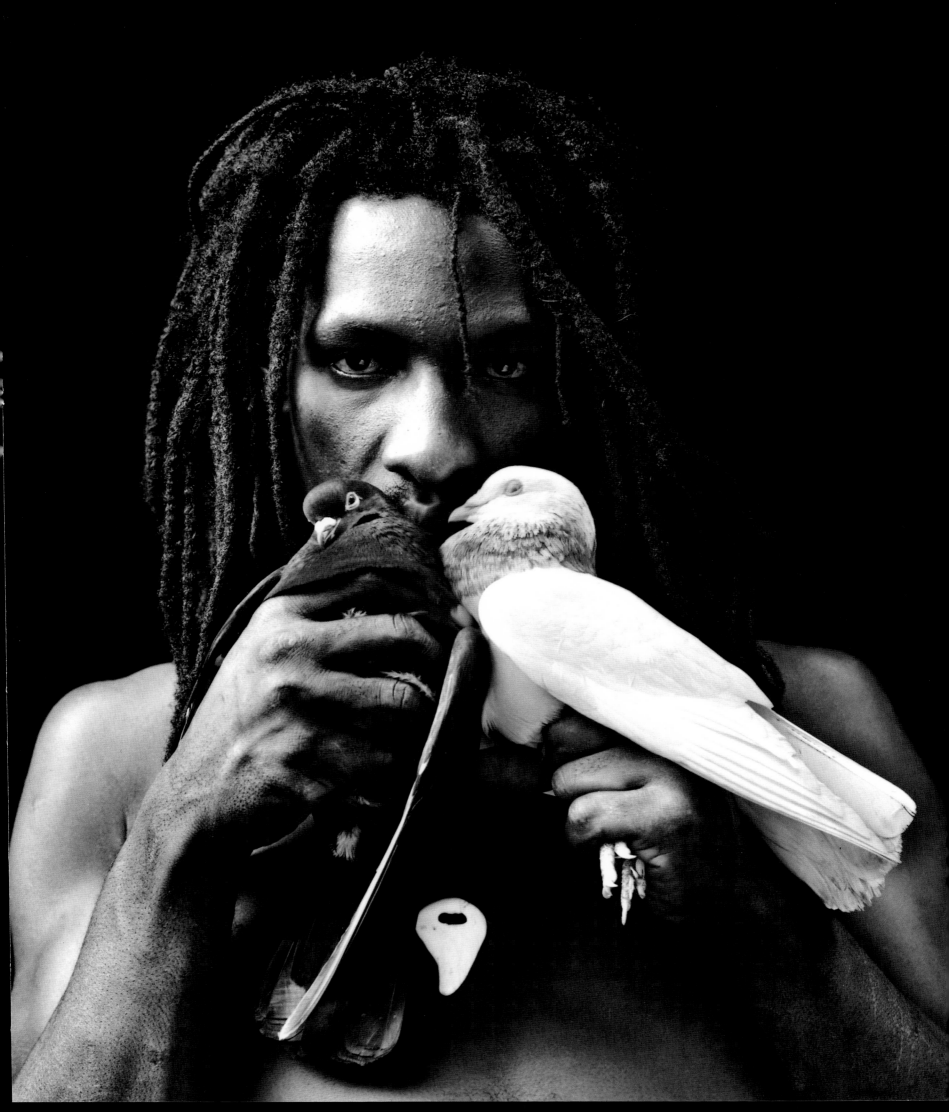

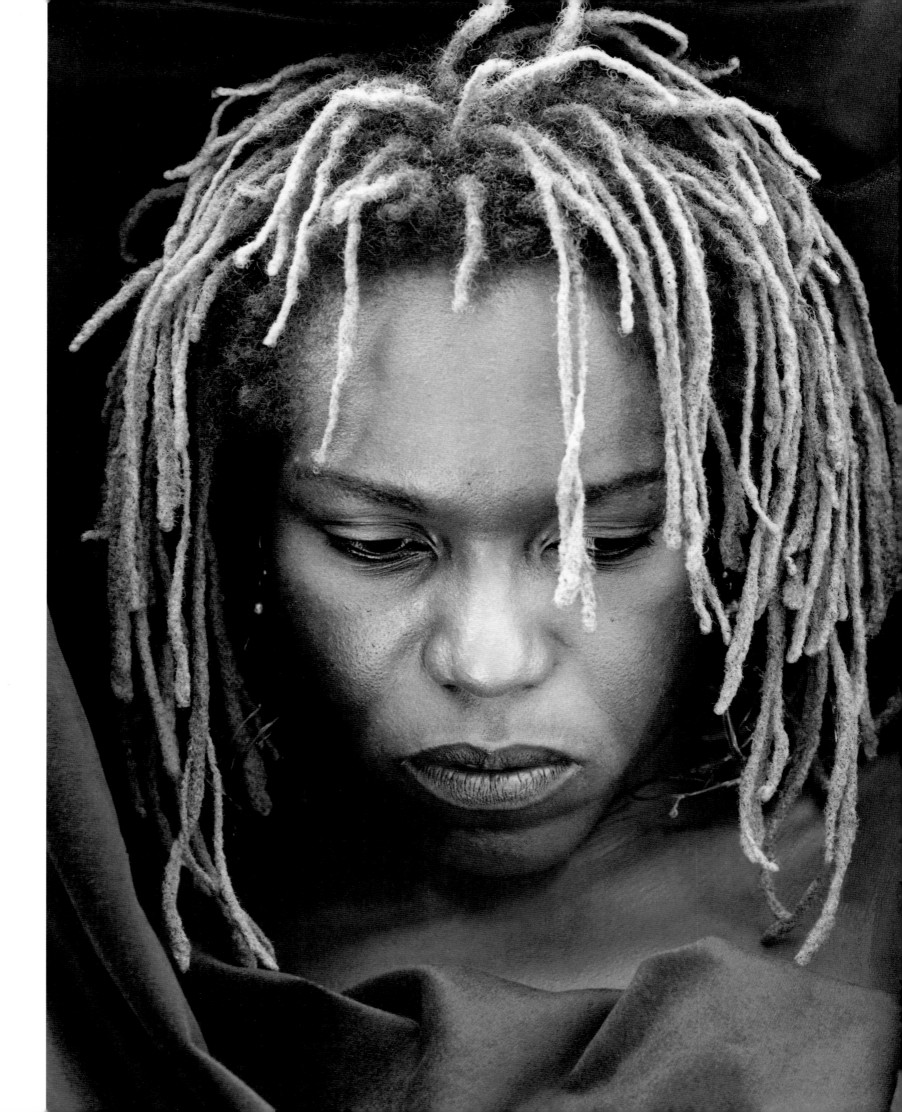

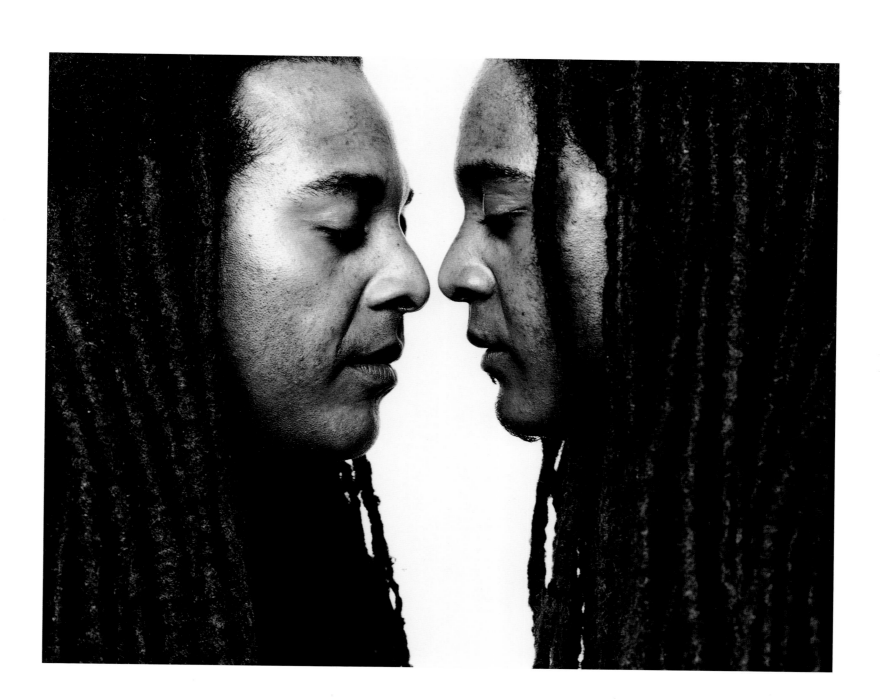

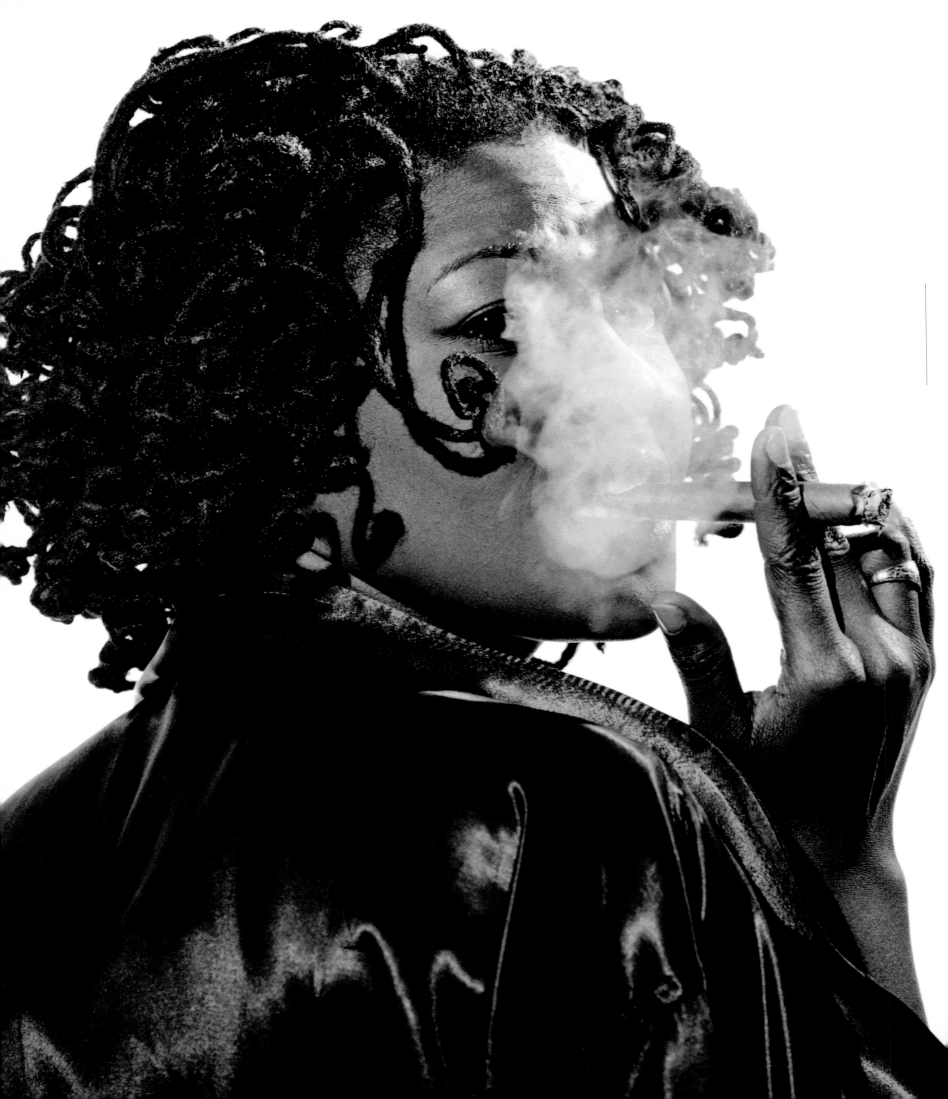

I had two choices: Go bald or grow locks. This was after years of putting chemicals in my hair, when I decided to go natural. It wasn't due to any particular influence or inspiration, it was more about my increasing self-awareness. Living my life in the most natural way meant letting my hair grow.

Through my dreadlocks, I've become more aware of my roots. I could say that, over the years, dreads have taught me many things about myself and my culture. People see me differently now, they listen more intently. I am taken more seriously and command more attention. Due in part to my dread-locks, I am seen as a person of substance and integrity.

GO BALD OR GROW LOCKS

HILDA THOMPSON

MARKET RESEARCHER NEW YORK CITY

DENTAL FLOSS, RUBBER BANDS:

Until I saw Bob Marley, I didn't even know what dreadlocks were. That was back in the seventies— even he had conventional hair in the beginning. I started my own dreads a couple of years ago. It was a lot of work, but it was worth it. I was entering these tattoo contests, and someone suggested I do something with my hair to enhance my pierced and tattooed visage.

It was either this or shave my head. And at my age, I'm not going to shave—it might never grow back.

I was born in Brooklyn and grew up in a conservative family. Until the end of high school, it was nothing but crew cuts. I began to grow my hair in 1967, but had to cut it off when I joined the navy. I grew it again in 1971, but went back into the military, the naval reserves,

in order to earn some money to pay for my tattoos. Considering the horseshit they put me through, it wasn't worth it. Anyway, not long after that, the piercing started.

I guess dreadlocks are the latest addition to my body transformation. I was tired of looking like every other middle-aged man with a ponytail. I used to have really long, red hair, but it's probably all gray by now. If I could ever wash all this wax out, I'd know for sure—I put beeswax in my hair, then take warm showers to soften it up and twist my locks. When it hardens, it holds the dreads together.

Beeswax really does attract bees, you know.

Dental floss, rubber bands: You wouldn't believe what's inside these locks. It's like orthopedics. It's like tying a stick to a tree. I put all sorts of things in my hair to thicken it and control the direction of growth.

Of course, Black people have the advantage of naturally kinky hair.

YOU WOULDN'T BELIEVE WHAT'S INSIDE THESE LOCKS

GEORGE BAUER

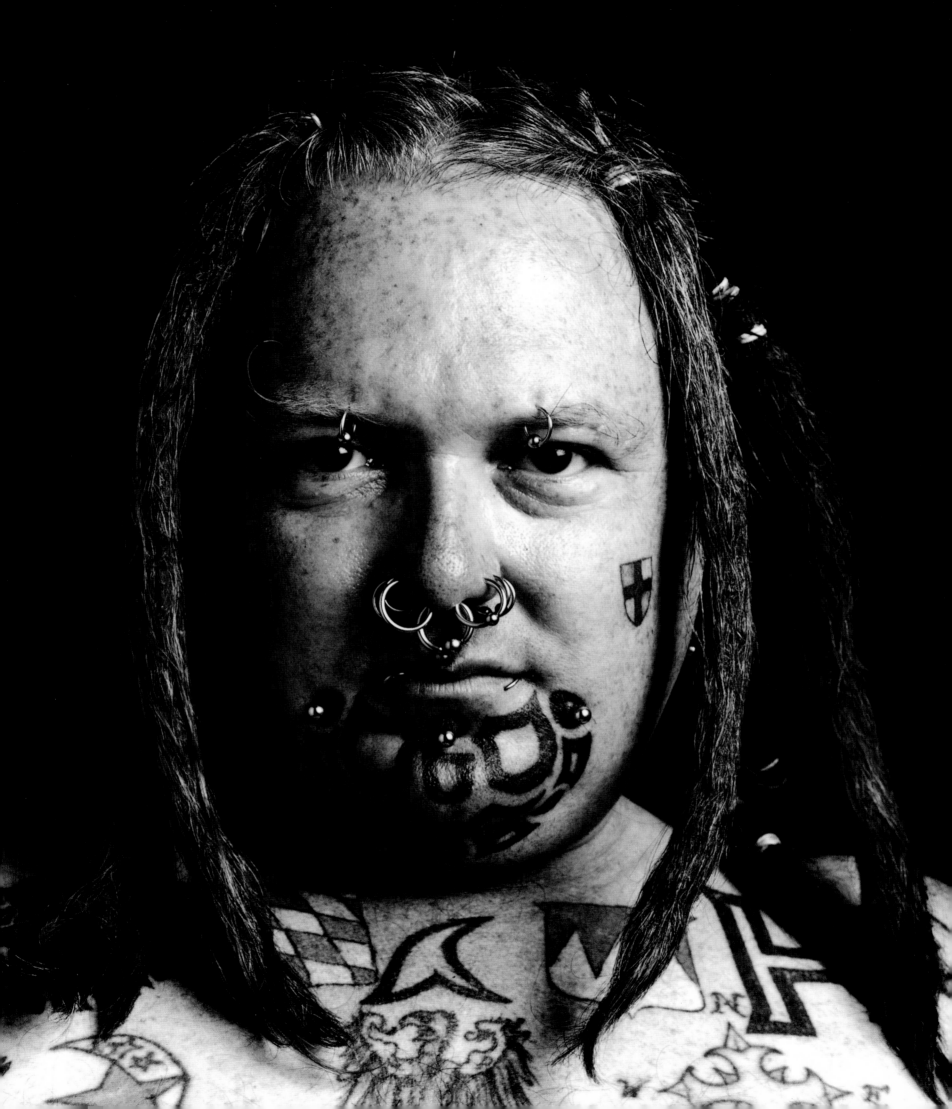

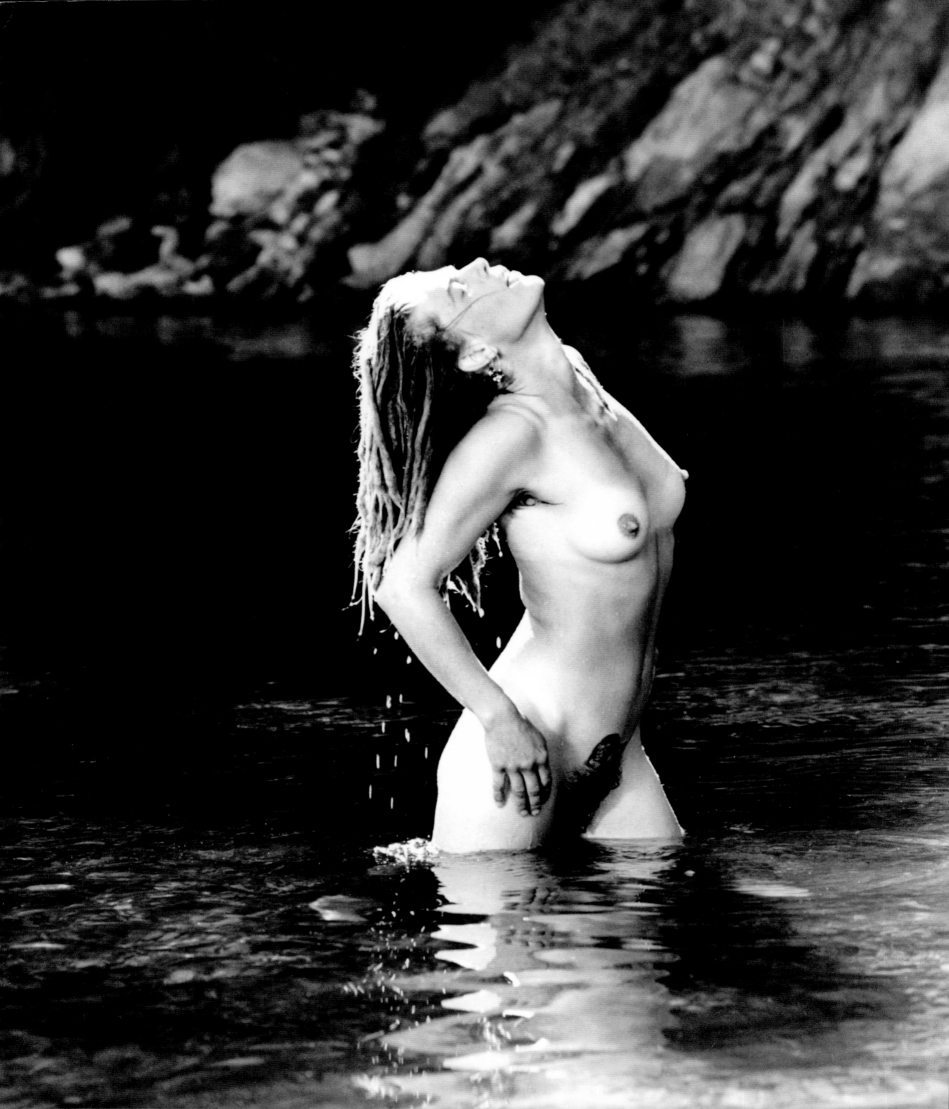

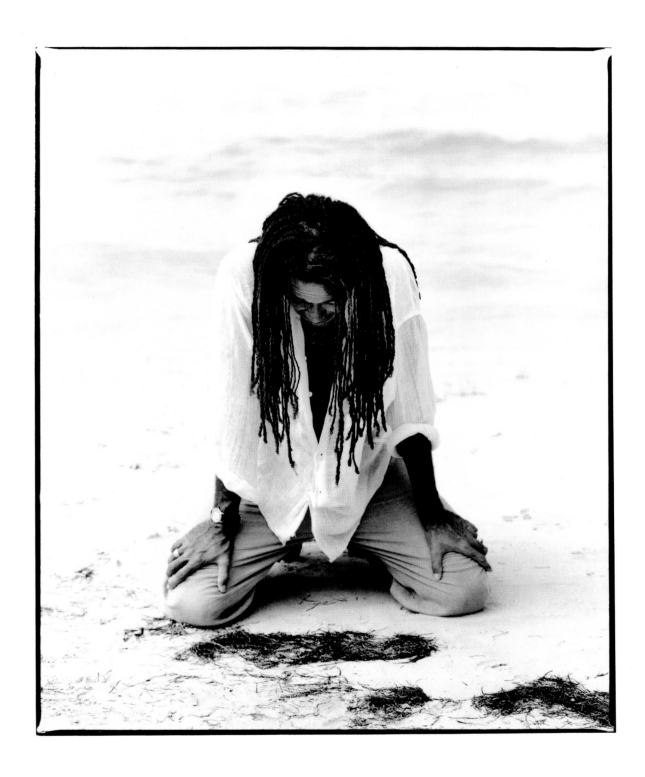

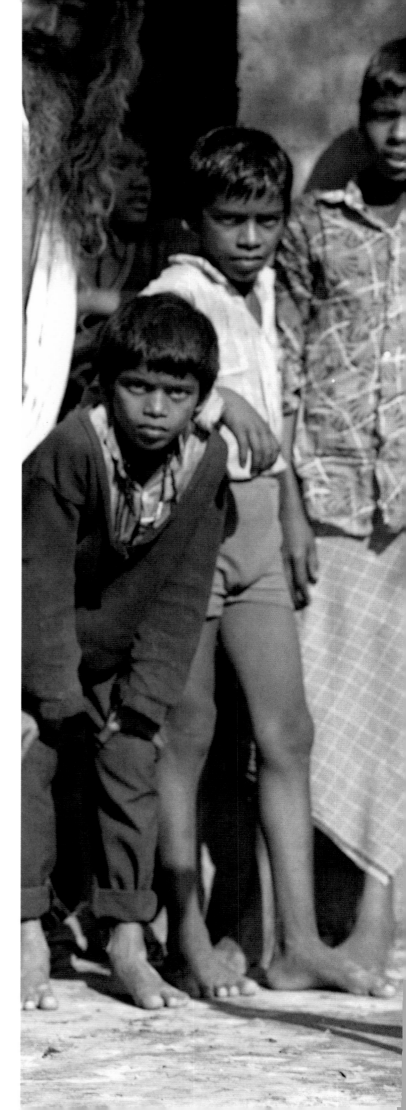

JATTA UNTIL DEATH

I do not spend my time thinking about jatta. I leave my hair in jatta until death.

When a sadhu dies, the people bring his body to the river. They surround him with stones and tie his hair to the rocks. They take him out in a boat and throw his body into the Ganges.

When a sadhu dies and goes to the burning ghats, he is pulled up to heaven by his jatta.

SRI SRI RAMNARAIN DAS

SADHU INDIA

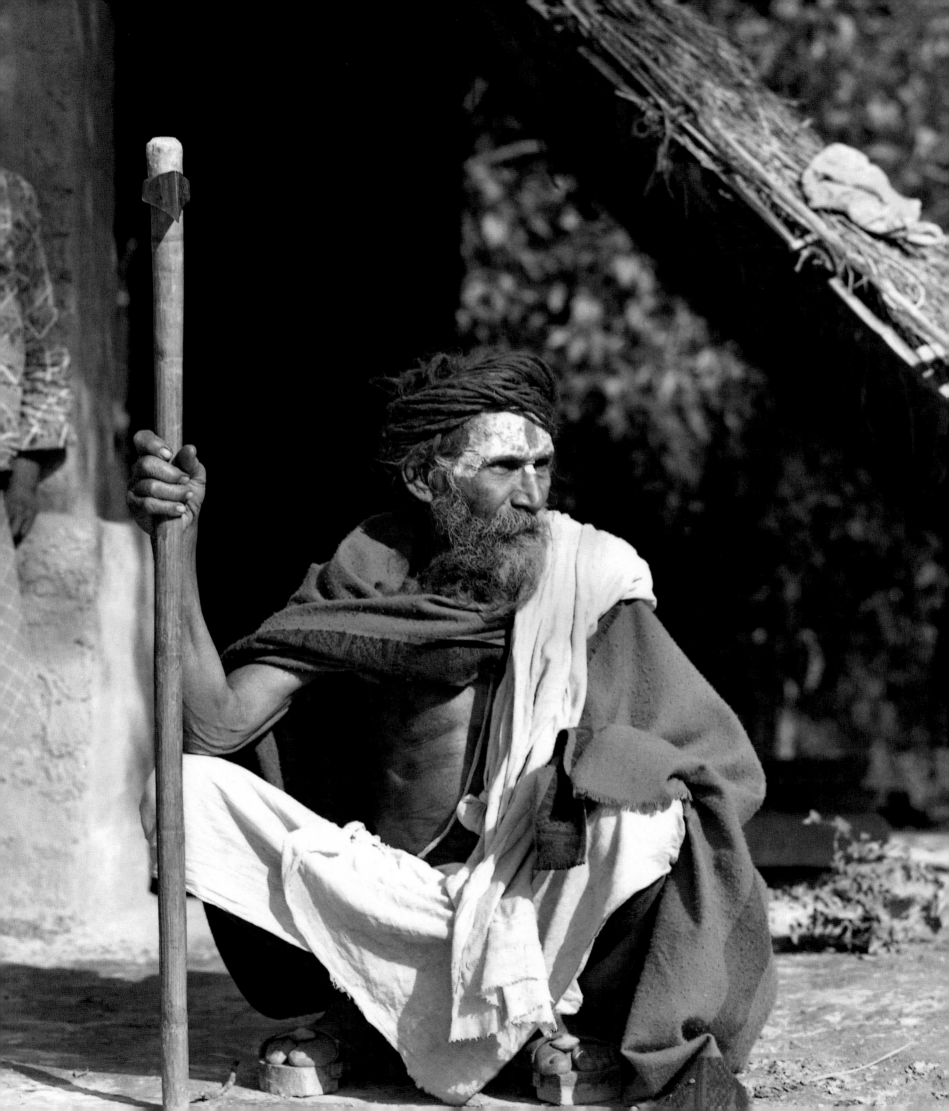

I locked my hair by accident. I used to wear my hair in a fade, a style I patterned after Grace Jones. She was one of the people I idolized as an innovative Black power figure in the music business. Then all of a sudden fades became the look of choice for the hip-hop generation. I was at least twenty years older than those kids, so I figured it was time to make a change. I just started to take my hair and twist it. After a number of months, I noticed one day while taking a shower that half my head was starting to lock.

As a musician, I always knew dreadlocks existed. I used to work with a lot of guys from Jamaica. But I admit I had no knowledge of the religious implications of dreads. The awareness came to me serendipitously. Because my hair started locking in an unorthodox way, I used to rip the sections apart to separate them, and because they were all different lengths, I used to cut them to even them out. One night I was in a club, tugging at my hair, and a Rasta came up to me and said, "You no cut your hair, mon, dat your antennae to God." Antennae to God? Brother, what you talking about?

To a Black man in America, hair always holds a lot of significance, positive or negative. Frankly speaking, I come from a family that has a history of intermarrying: In other words, they married lighter skinned people by design. It started with my great-grandmother, a well-educated woman who was half Native American in addition to being African and White. My grandmother was fair, and she instructed her children to marry paler skinned, finer haired, Caucasian-featured people. But my mother became pregnant when she lost her virginity to a very dark-skinned man from the West Indies, and here I am! I showed up in a family that had successfully been orchestrating the look and color of their offspring for a number of generations. Jokingly, they would say, "Look at that: One spot in the lot!" I was truly the black sheep.

As far as identifying with my hair is concerned, the most liberating time of my life was in the sixties, when I was able to grow a huge Afro, like Hendrix's. That's when I started to look at my hair as a source of self-identification. But even when I was really young, I used to idolize groups like the Temptations. With their big cuff links and ruffled shirts and processed hair, they looked like glorified pimps. I tried to pull off that look when I was a kid, and let me just say that my mother frowned upon it.

But my mother loves my dreadlocks.

The rest of my family reacted to my dreads the way they still react. My grandmother said, "My God, that's a pickaninny style! What are you doing wearing your hair like that?" She maintained her opinion to the day she died. My mother, however, was quite progressive and cool.

When I was contemplating cutting the dreads off and starting over again, like Lenny Kravitz, growing out a big Afro, as I was looking in the mirror, going to town with the scissors, I realized my dreads had become symbolic of my history, and I stopped in the middle of the haircut. I deal with Wall Street now, with millions of dollars, and for someone to think I was any less responsible because I had locks down my back, well, it pissed me off. Do dreads make me a less trustworthy person? Or less of an earner? I believe in tradition, I believe in the rules of decorum, so, what the hell, I'll put on a suit if the occasion calls for it. If they say you have to wear a tie to get into their restaurant, fine. But if they say you have to cut your hair to do business with them, not so fine.

MY MOTHER LOVES MY DREADLOCKS

NILE RODGERS

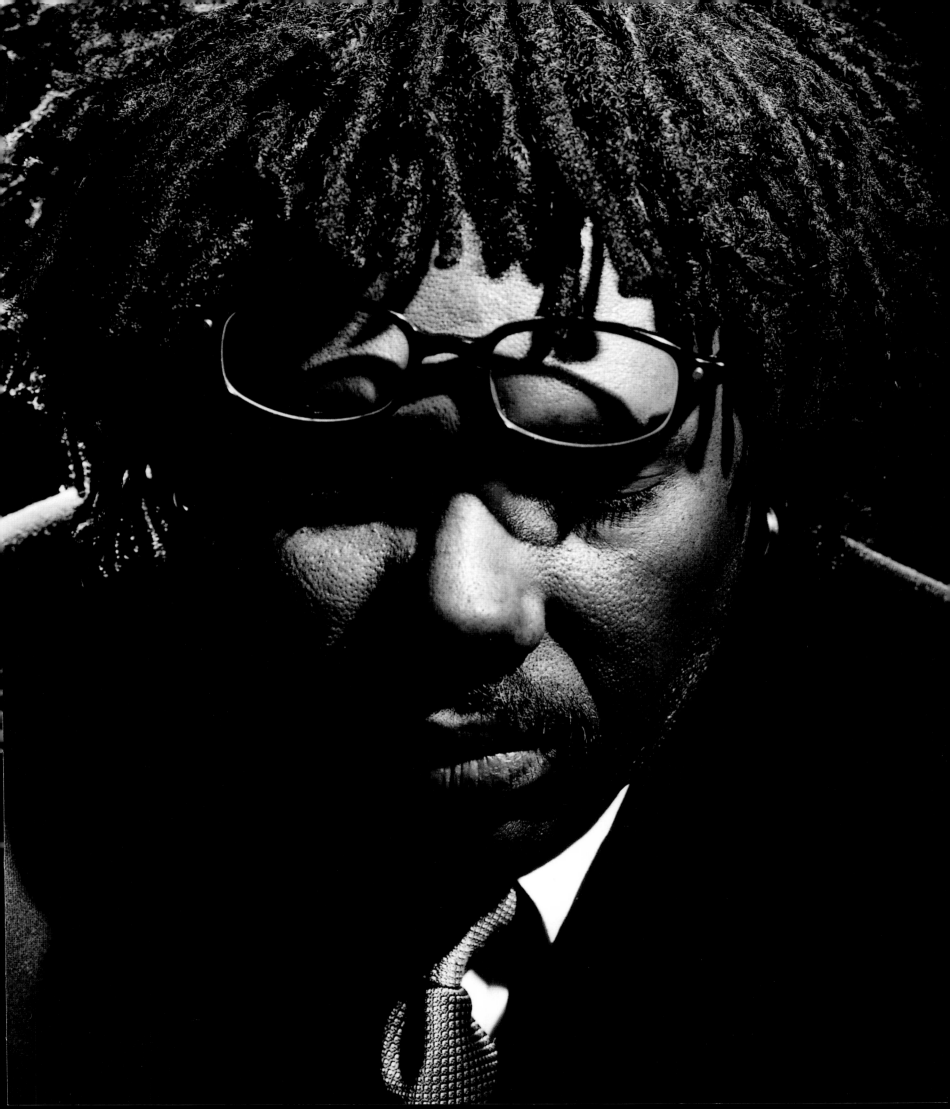

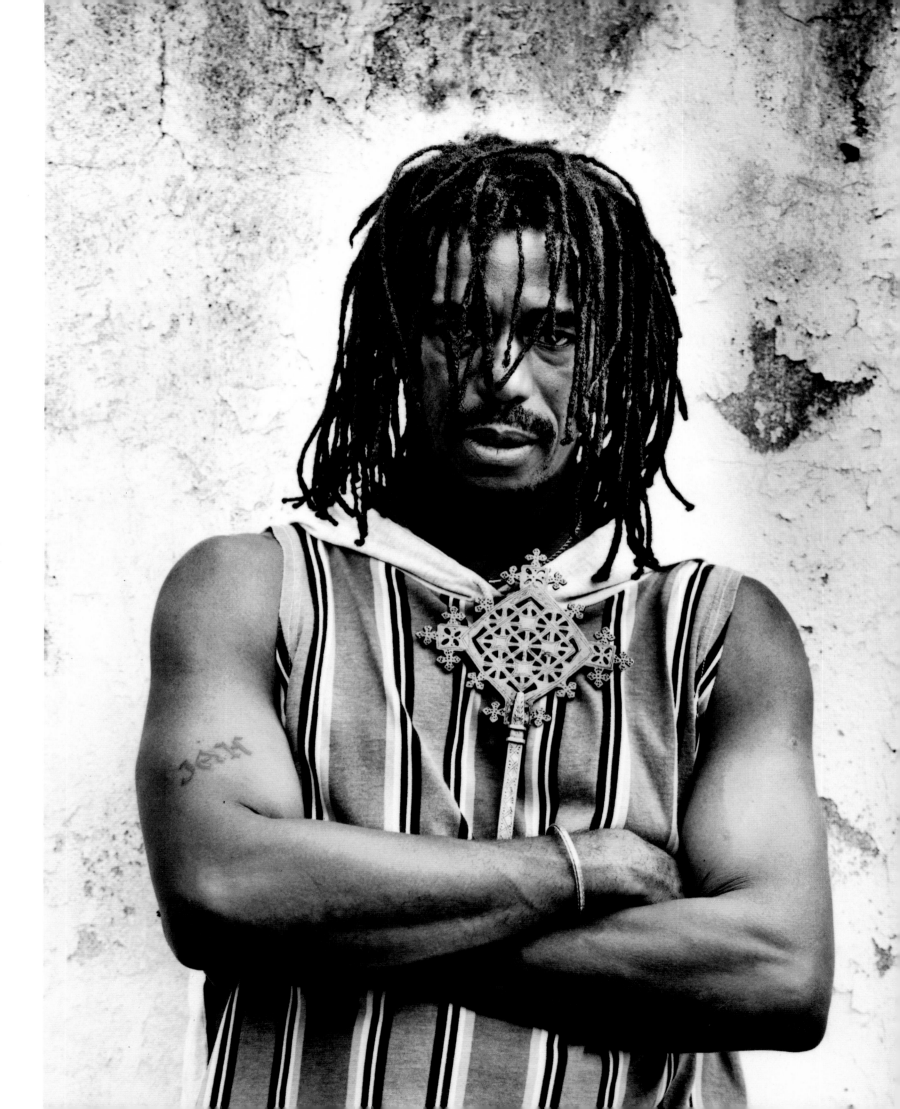

When I joined the Wailers was
when I was introduced to the phi-
losophy of Rastafarianism, and
that's when I began to carry dreads.
It's been nearly twenty years.

Some people wear dreads for
reasons of fashion, or of religion, or
of culture. For me, hair is just hair:
You can't judge a book by its cover.
I've never thought of my dreads as
making a specific statement. They're
just a natural, comfortable style.

In the early days of the Rasta-
farian uprising, Jamaicans wore
dreads because it was written in the
Bible. They paid dearly for their
convictions: Many were persecuted
and imprisoned simply because
they wore dreadlocks. Not everyone
who has dreads today realizes the
political history attached to them.

SIMPLY BECAUSE THEY WORE DREADS

"JUNIOR" MARVIN

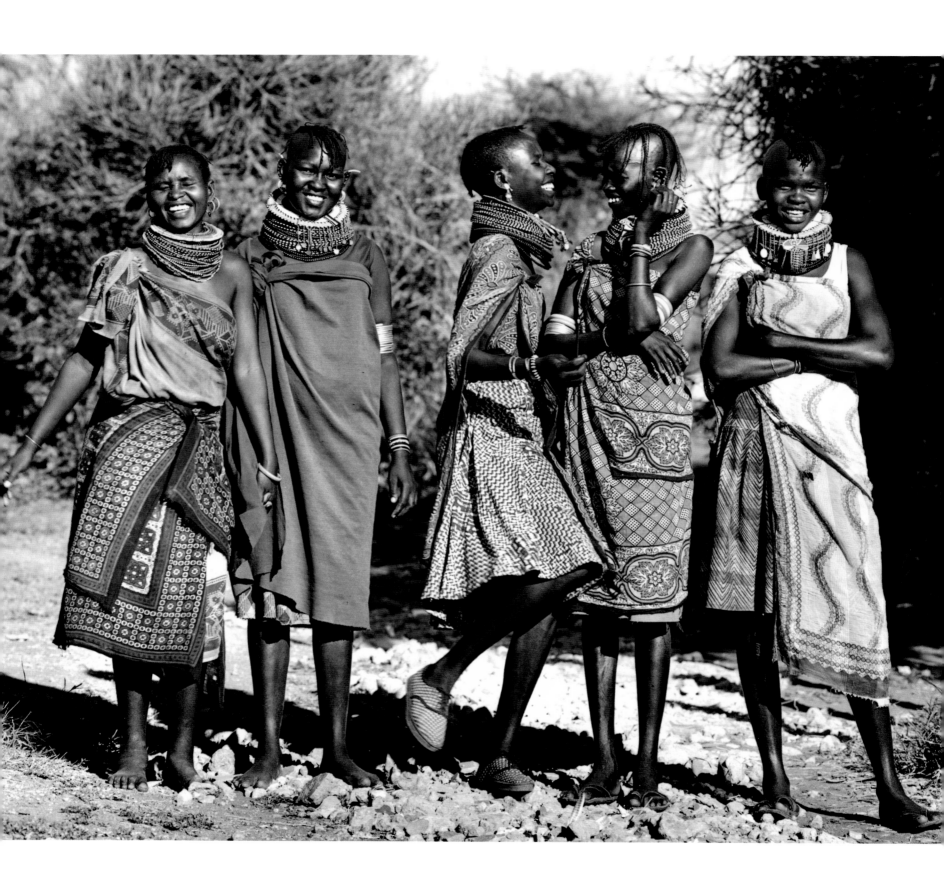

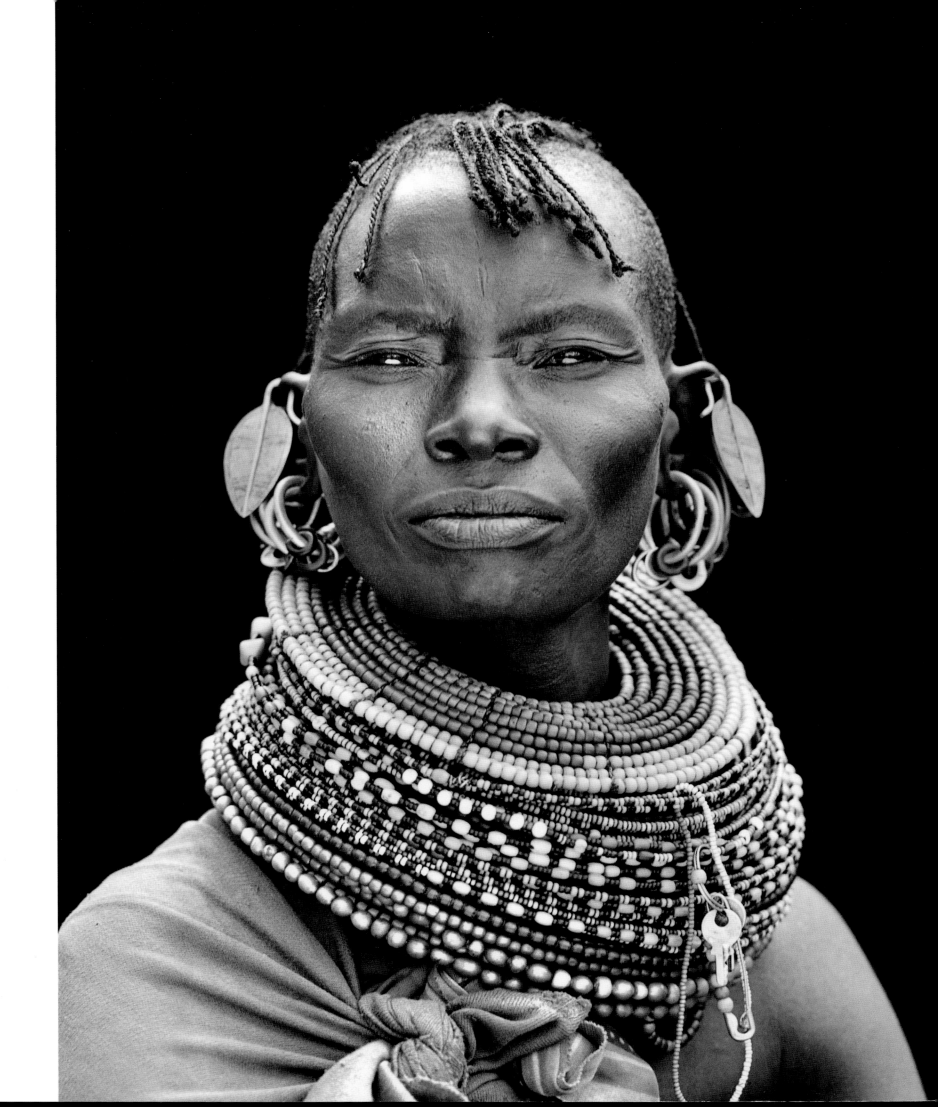

THE ROOTS OF RASTA HAVE BEEN WATERED DOWN

The fire and brimstone that Ras Tafari spoke of was never a physical state. It was always a spiritual uprising—a fire within, an awakening. In the past, no one wanted to deal with the Rasta. Why? Jamaican culture is based on European traditions. All things European were considered superior, and we as Jamaicans strove to meet those standards. At the time, no one wanted to hear about repatriation to Africa.

The positive cannot exist without the negative. The roots of Rasta have been watered down, to reach farther. That is why so many now wear dreads for fashion.

JANHOI JAJA

RASTA JAMAICA

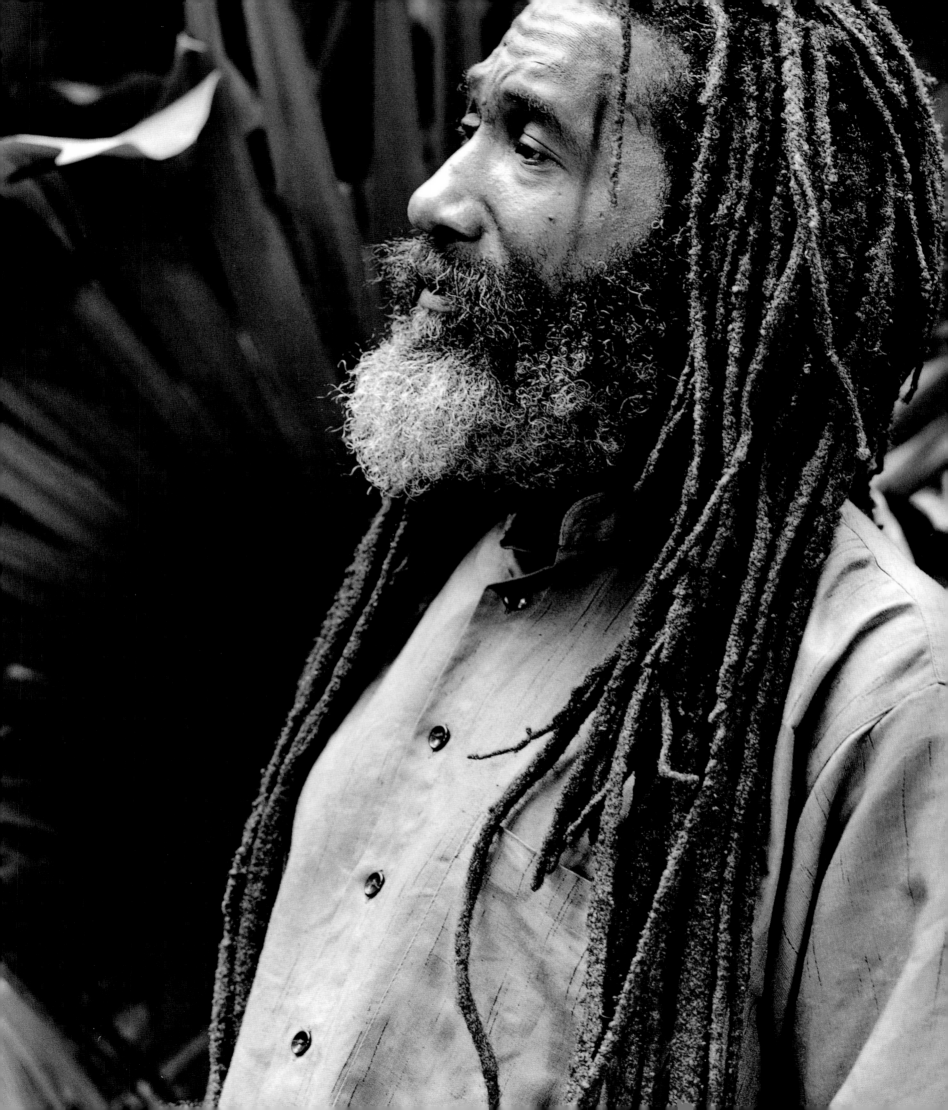

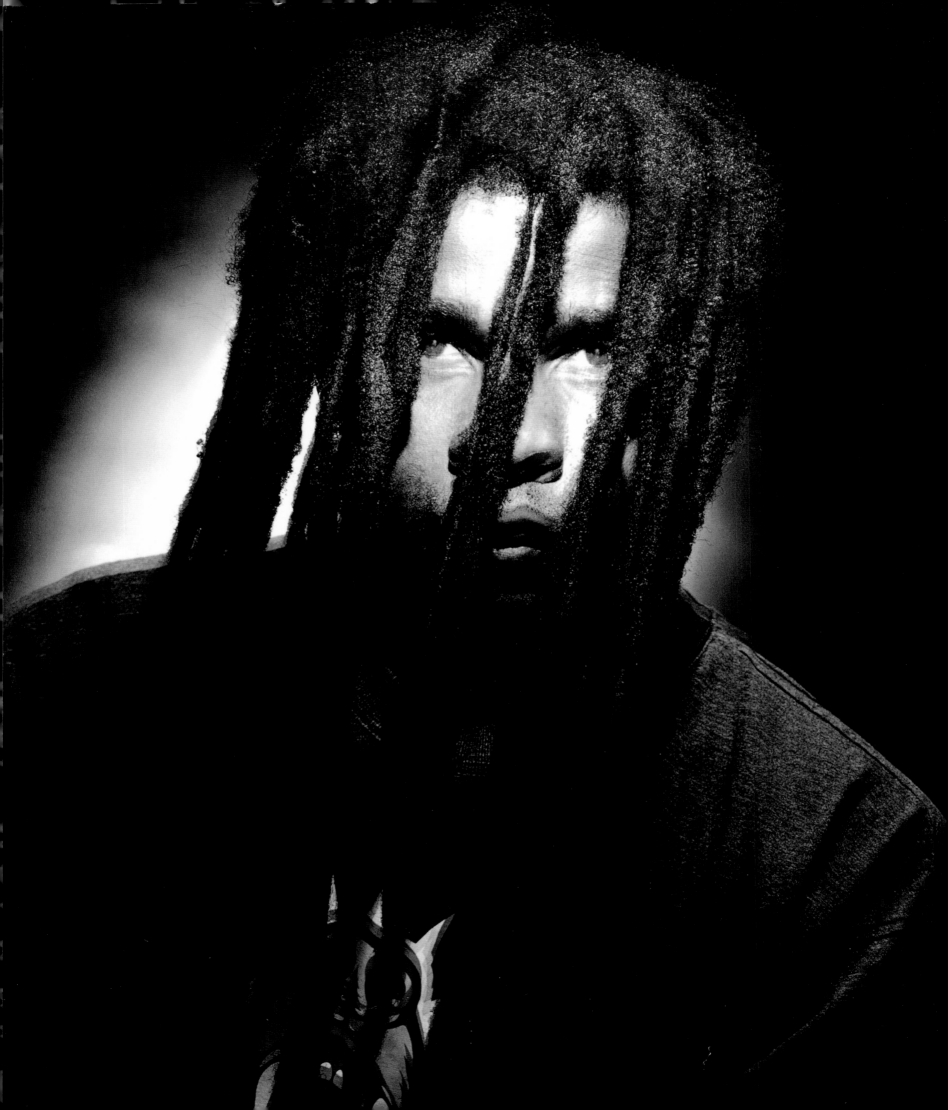

FASHION MAY BE MOMENTARY,

BUT STYLE AS AN EXPRESSION OF SELF

IS NEVER SHALLOW

I'd had an Afro. I'd had a fade. I'd had a brush cut. Then I met "Iron Mike."

Iron Mike was a carpenter and musician. He had a dread Mohawk—shaved on the sides, locks on top. I'd always thought dreadlocks were cool, but I associated them with Rastafarians and reggae music. I admire the Rastaman, but my roots are not Jamaican. My people come from Montserrat. There's an assumption that the Caribbean is monolithic. Actually, the islands are just as diverse as Africa in terms of different cultures and ethnicities—most of which do not embrace Rastafarianism. The Caribbean mentality can be quite conservative.

I'm an artist. I admit I wanted a look that conveyed my individuality, and, back in the eighties, I wasn't going to Jheri-Curl my hair like Michael Jackson. But an interest in style is not the equivalent of spiritual bankruptcy. Fashion may be momentary, but style as an expression of self is never shallow. Just as clergy members wear various ceremonial vestments, secular clothes can express states of spiritual being. Dreads were a way of embracing the evolving idea of myself.

At the time, I was living in Crown Heights, Brooklyn, where there was a large Caribbean community. Although the culture is certainly celebratory, it can also be narrow-minded. Plenty of people in the area had locks, but only Iron Mike, one other guy, and myself wore dread Mohawks. We took a lot of heat for being different. It's one thing if you have a big support system to back you up. When you stand alone, it's another story. Dreading my hair was a deep thing to do. The Brooklyn Rastafarians were not exactly accepting. At times it got almost abusive.

All that has changed now. I saw a woman the other day, dark-skinned with deep purple dreadlocks. She looked absolutely fabulous. Dreads have been commodified. They're everywhere. I've seen bank tellers, police officers, schoolteachers with dreadlocks.

But there's still something primal about locks. Early man must have had them. And dreads can be magnificent, intense. Plateaus of expression. I've seen dreads that look like capes or carpets, tree trunks or branches, unbelievable shapes. I think locks are one of the most abstract yet concrete human statements. And they evoke a tactile response. There's a fundamental curiosity. People want to feel them.

I've been dread for more than ten years. There are those who have been dread their entire lives. Obviously, dreads are a hairstyle to some, a lifestyle to others. But, as a philosophy, I suppose one can be dread without the locks.

VERNON REID

I was raised to be aware of and to respect my roots. Relaxing my hair was not an option. I have always worn my hair naturally, either loose or in braids. When I entered college, I grew dreadlocks: It was just an extension of what I'd been doing for years.

I'm not a Rasta, but dreads hold spiritual meaning for me in that they are an expression of my connection to and appreciation for my African heritage.

In New York, I don't usually get much of a reaction to my dreads—occasionally some gawking and ogling, general curiosity, mostly from White people who've never seen the style before. I'm

AMONG DREADS, THERE IS AN UNSPOKEN SOLIDARITY

reluctant to be treated like some sort of attraction, so I tend to ignore that kind of attention.

As for Whites with dreads, I try to evaluate the individual. Among dreads, even in a city like New York, there is an unspoken solidarity. If I pass someone on the street, and he or she affirms a connection with a nod or a look, that makes me feel okay. Without that sort of acknowledgment, well, I feel a little differently. It's one of two things: Either you've gone the distance, and educated yourself, or your dreads are just a fashion statement, and you're totally flighty.

KESIME BERNARD

GRAPHIC DESIGNER/WRITER NEW YORK CITY

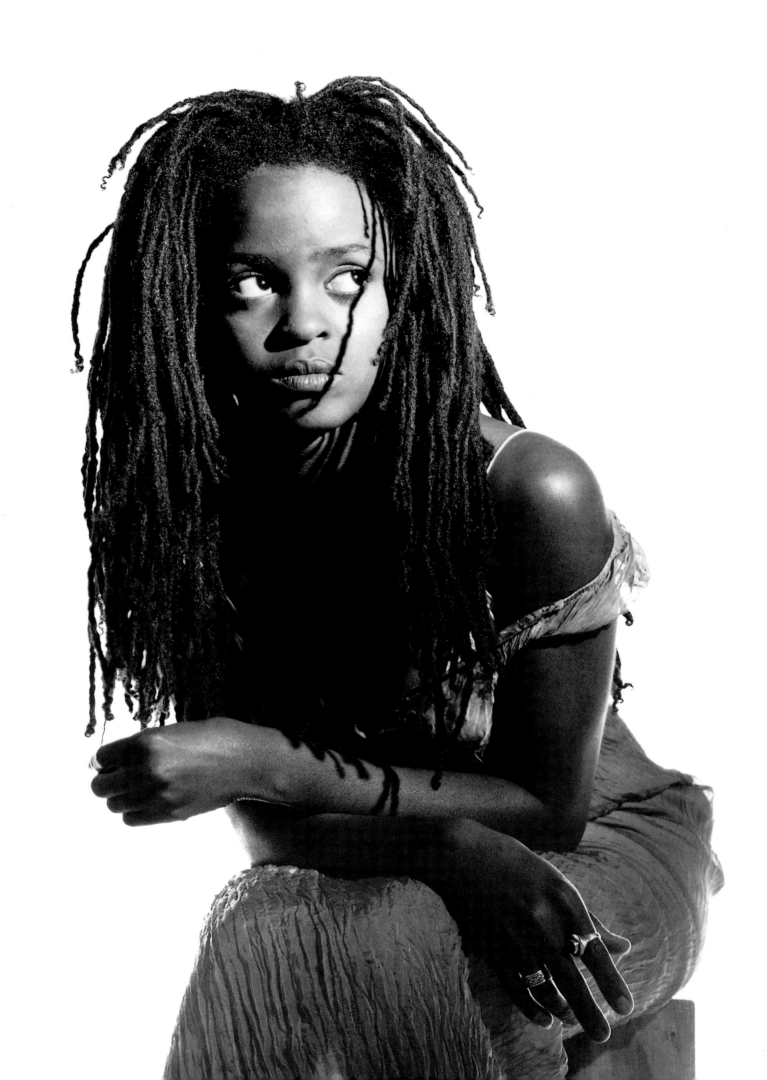

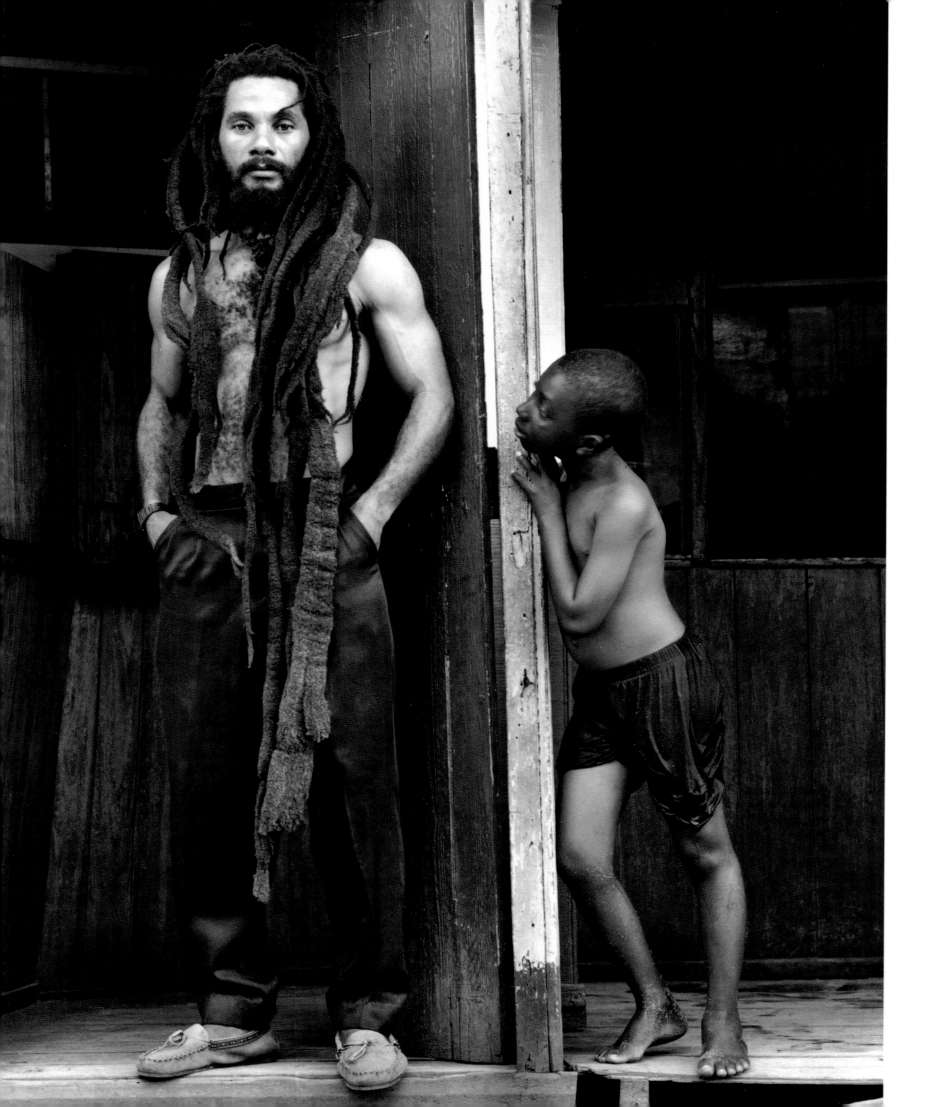

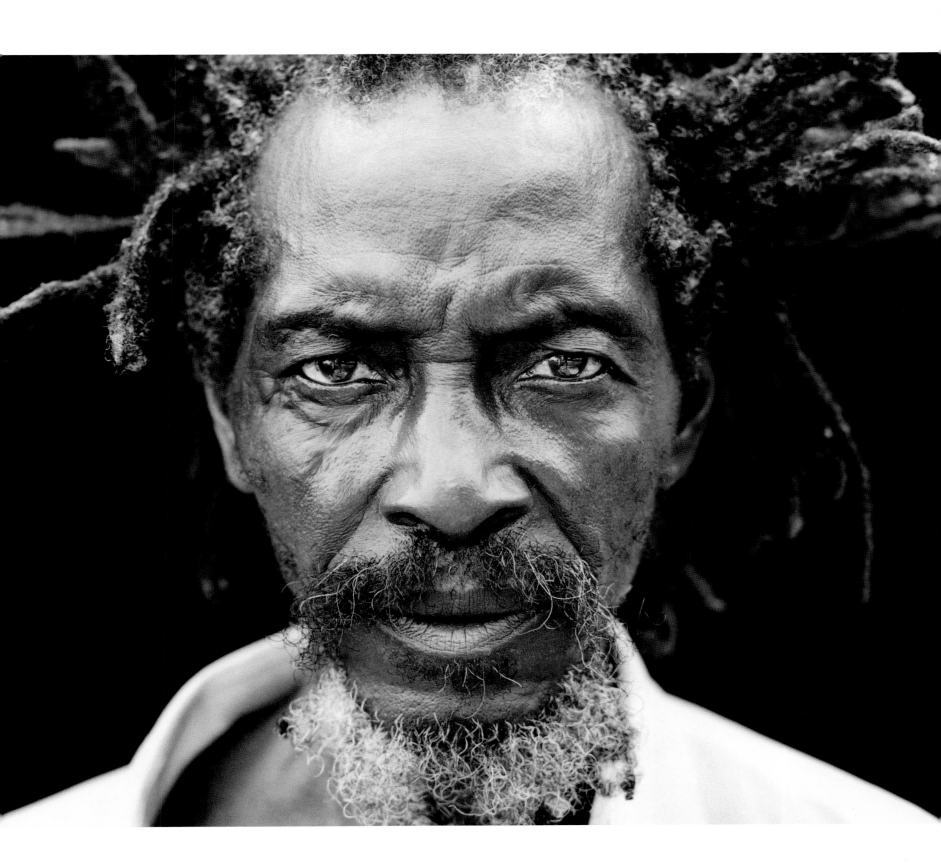

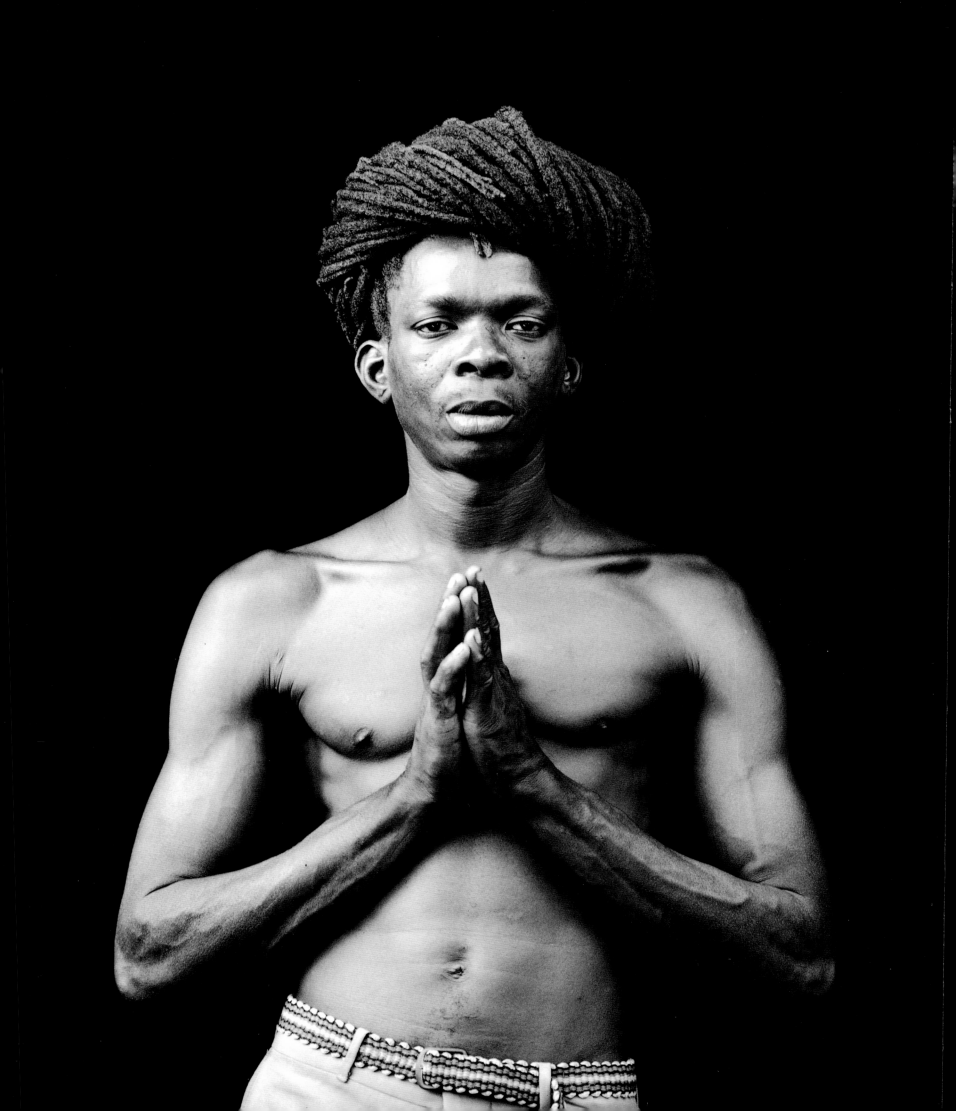

Brothers and sisters, this is what
it's all about: The power of
God to make it better. You hear
about the Pope, about organized
religion. Rasta is none of that.
Rasta is the chalice, praises to Jah.
Dreads are Jah antennae. I-and-I
a Rasta, straight out of creation.

DREADS ARE JAH ANTENNAE

GRANDVILLE "GRAVEL" REYNOLDS

RASTA JAMAICA

I was fourteen when I heard the call of Jah Rastafari. I had a vision, and the vision say to me, "A man shouldn't shave." Whole heap of tribulation and persecution follow.

In 1962, the police grab me off the street, throw me in a jeep, take me to prison. They try me in Spanish Town, the judge sentence me to nine months. He say, "Put him away, because his eyes red. He smoke a lot of ganja."

I get nine months prison in Spanish Town for my hair, I do six month, twenty-one days—and I serve them outside. The prison full, so every prisoner chained and cuffed to a big piece of iron, like a railroad track, in the yard. Twelve persons a piece. Six month, twenty-one days, chained outside. Rain come wet we, sun come dry we, dew come wet we. As the sun is my witness, I don't eat nothing. Everything them give was pork, and them know Rasta don't eat pork. Every morning, I drink four quart. I live six month, twenty-one days, on water. It was like I didn't have no stomach—when I walk, I float. I so thin, the director look on me and say, "Look like you a man of God."

Norman Washington Manley—the prime minister, a White Englishman—he take it upon himself to say, "A person live the life him want to live. Why we put these people in prison? Because them hair, what God give them? Them don't steal. Them don't kill." Him set 972 prisoners free: One Saturday morning him walk into the prison, go down to the office, and say to me, "What is your name?"

I say that my name is Joshua.

Him say, "What you charged for? Marijuana? Or your hair? Go through the gate."

These guys who say they Rasta—them don't go through nothing. I go through a lot of trouble. Back then, Rasta had to live in the bush. If you run, they shoot you down. There's a tree them call cherry—it grow big, it got three, four crotch you can sit in. I would hide in this tree. At night, I would tie my wrists around a branch with a piece of twine so I not fall out. When I sleep, I take a piece of carton box, put it in the middle; take a piece of zinc, put it on my face. My mother, she keep a pig, and she tie him near the tree. When she come to feed the pig, she leave some food for me.

Because I a Rasta, a guy cut me goats and throw out the parts. I confront the police super, but he pick up a bat to hit me. So when the son, Michael Manley, come to Lucea as prime minister in 1972, I 'front him in the courthouse. I the only Rastaman there. Michael Manley look my way and ask, "Yes, my brethren?"

I say, "Peace and love."

He shake my hand and say, "Speak your problem."

"I have no work, I have three boys to feed, and a man cut up my goats, cut me billy goat neck off."

Manley ask, "Did you go to the police station and make a report?"

I say, "Sure. They try to chase me away."

He ask me, "Who the person trying to chase you?" and I say, "The superintendant."

So he turn to the super and say, "This man, he a Rasta. Shake him hand. This man, he no need trim. He need justice."

The super shake my hand.

Mr. Michael turn to the MP and say, "By twenty-one days, give Joshua piece of land off the government—three-and-a-half acres." And the prime minister give me money to send the kids to school.

To be Rasta, you have to be called by the Creator. You can't just like the look. Why the Bible say that many are called, few are chosen? Wherever I go—New York, London, Kingston—I know them of clean heart. The criminal with long hair, I tell him he must trim, he is false prophet.

THIS MAN, HE NO NEED TRIM: HE NEED JUSTICE

110

JOSHUA McFARLANE

WOOD CARVER JAMAICA

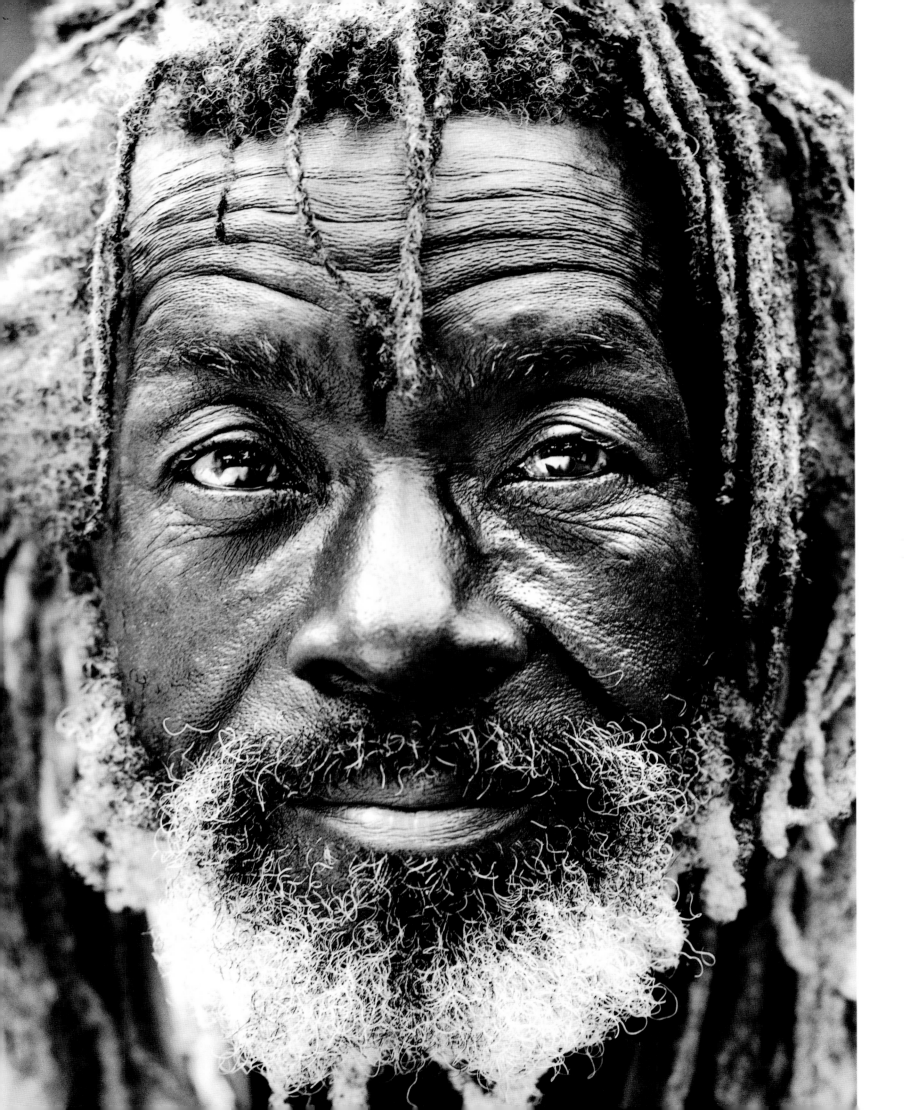

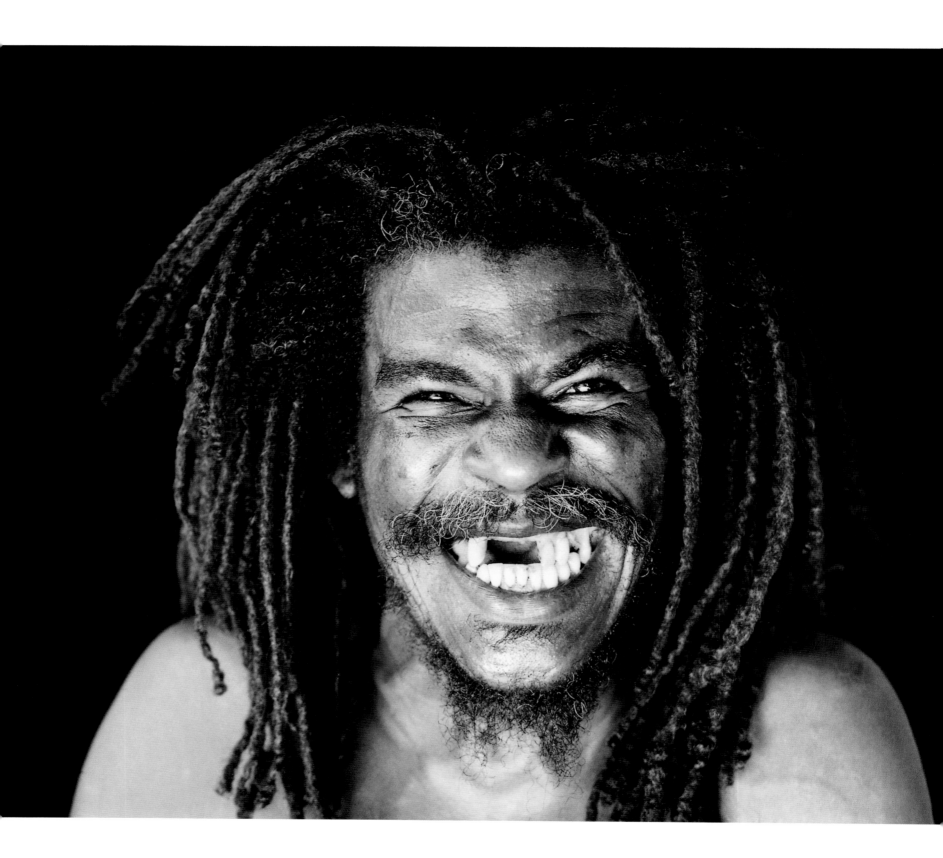

One-and-one living. Truthful living.
I carry dreads in direct obedience of
what is written, what has been put
down in words from God Almighty
to His people as a promise, as a
covenant between Him and those
who live right and natural-like.

It is clearly stated in the Bible
that the righteous are not to apply a
comb or razor to any part of the body.

ONE-AND-ONE LIVING, TRUTHFUL LIVING

For those who follow, all
oppression and persecution will
fall to the wayside. Freedom is
promised to the Rastaman.

Mine has been a journey in
search of natural living: natural
foods, natural work. My dreads help
me to recognize others on the same
path, and them to recognize me.
They are my antennae, receiving
the universality of all things.

PETER DESOUZA

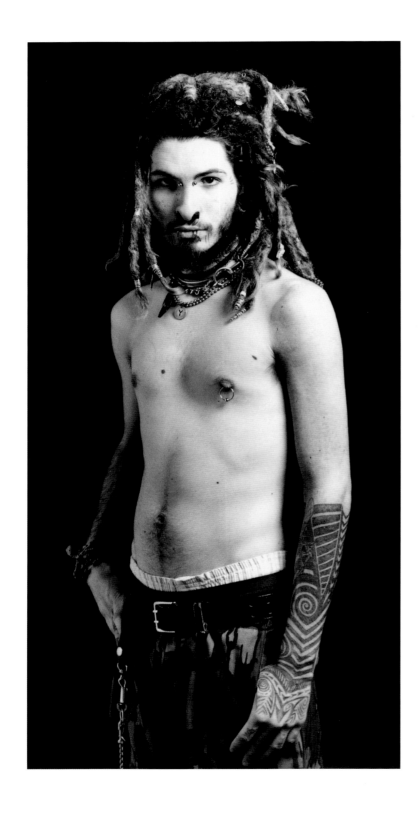

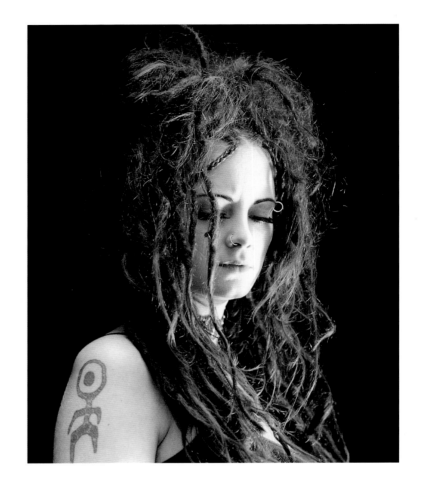

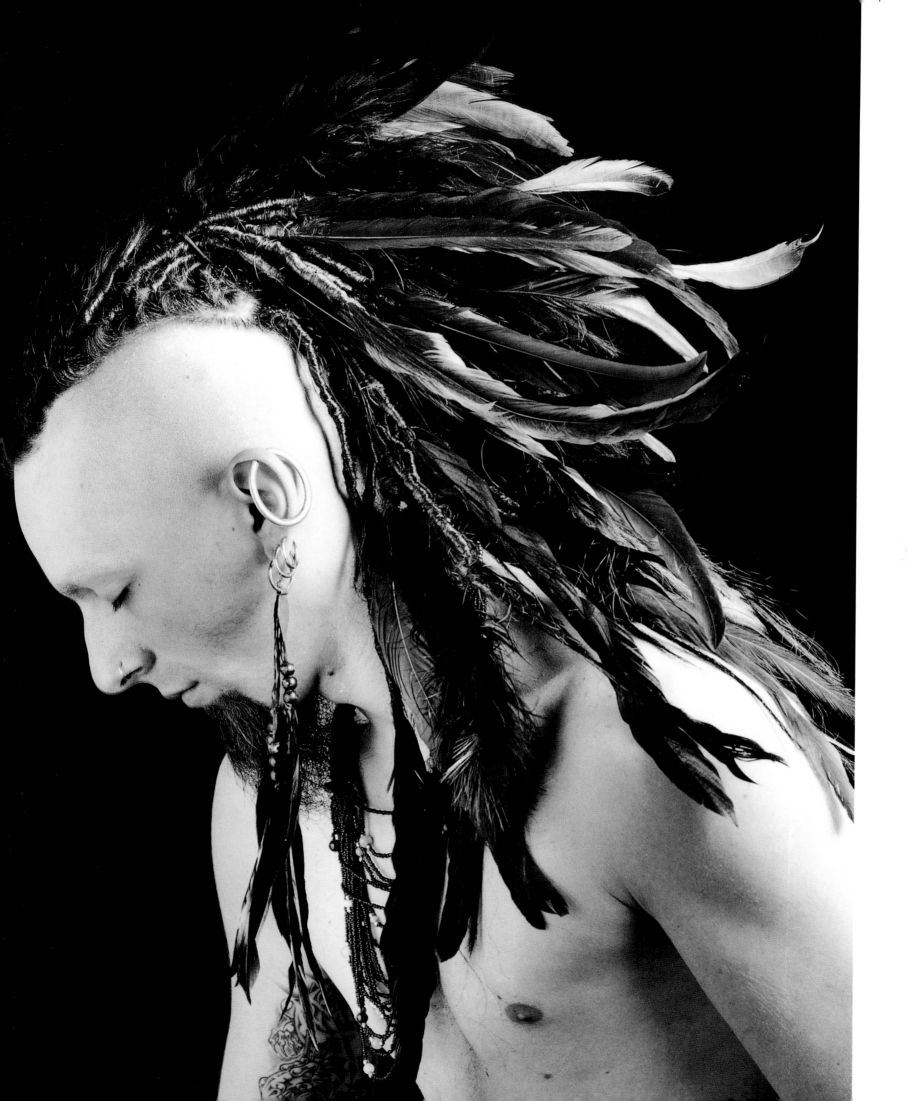

DREADS PREACH ONE LOVE, UNITY FOR ALL

Dreads as fashion? I don't fancy that. The man who wears dreads on top and shaves the sides makes a mockery of locks. But every man go his own way. Some act righteous by going to church. Some pure righteous. Some pure sinners who still go to church.

HENRY GORDON

STUDENT JAMAICA

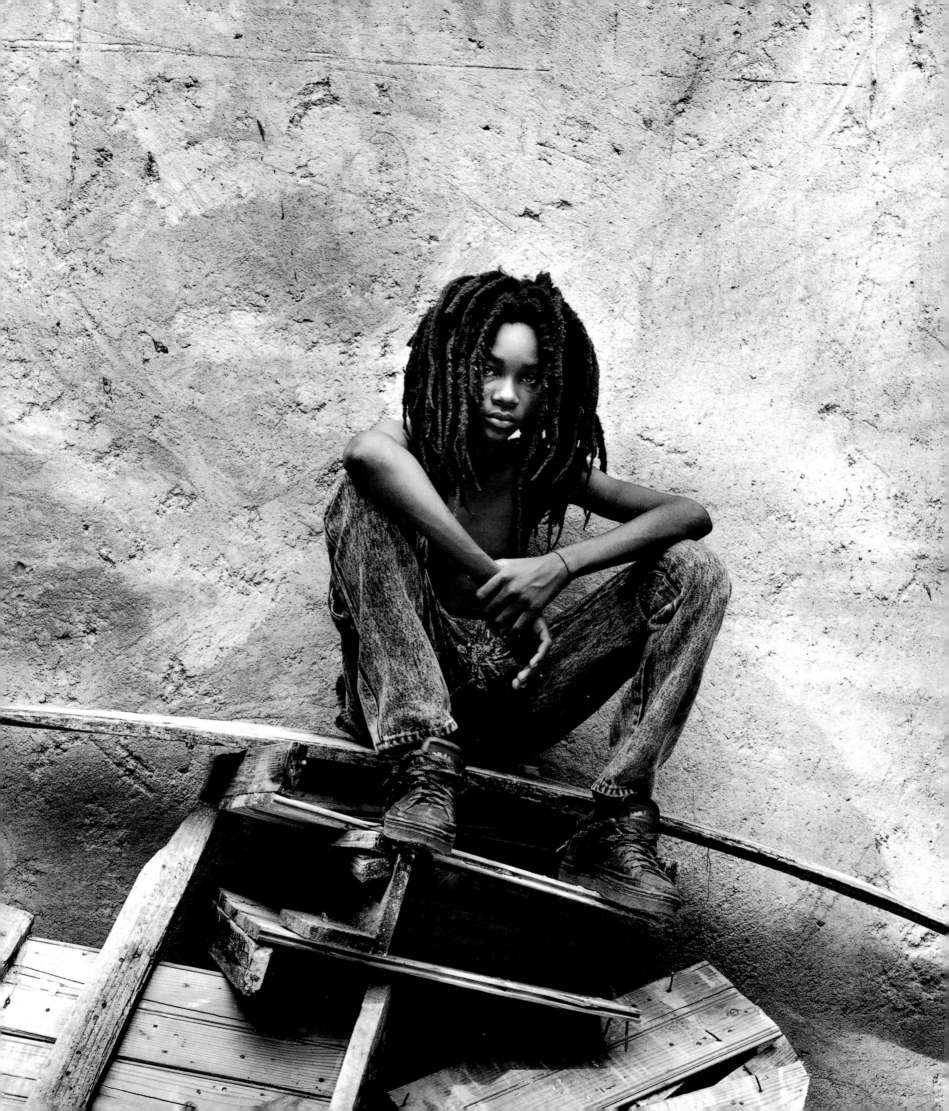

I didn't plan to have only one lock.
It just happened. The dreads started
to form about eleven years ago. I
was recuperating from a spinal
operation, my hair wasn't my top
priority, and I started to get buds.
I loved it, so I kept going.

When the dreads were about
six inches long, I impetuously cut
off a few in the front that were get-
ting in my eyes. Two led to three,
three led to four, and so on, until
only one remained. I really didn't
want to remove it, so I left it there,
alone, in the back, to grow.

Although I am influenced by
Rastafarian beliefs, I do not fully

follow them. I'm too much of an
individual. I don't like belonging
to any one group. But I see my
style as a tribute to Bob Marley,
his music and his work. This
solitary dreadlock stays with me
as a reminder.

I find that Marley and the
Rastafarian movement are misun-
derstood outside of Jamaica. There
are a lot of lock myths. People think
dreads are dirty, matted with mud.
But my dread acts as a conduit.
It draws people, like a divining rod.
It's an icebreaker. So I share my
experiences, and can contribute to
clearing up the misconceptions.

INANSI

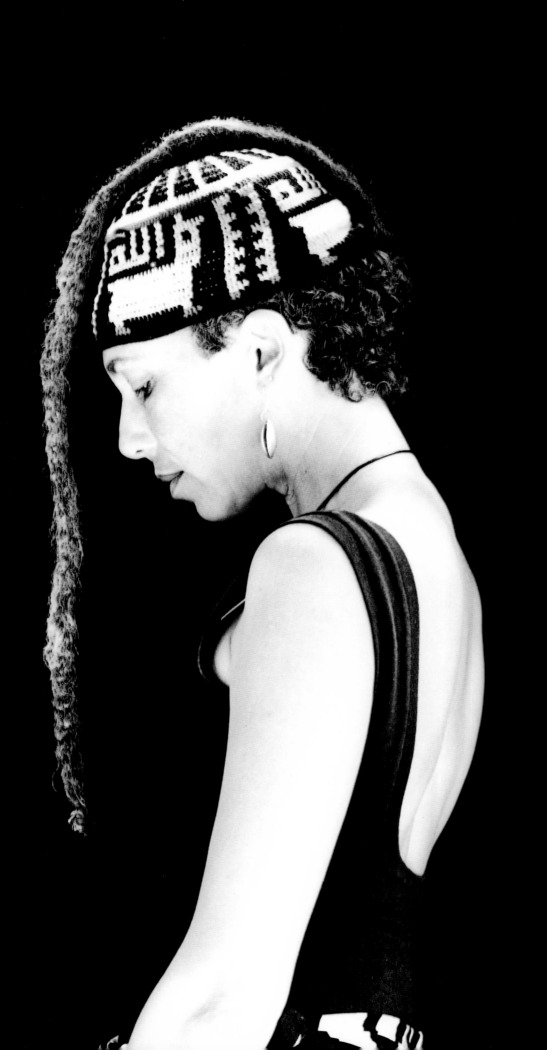

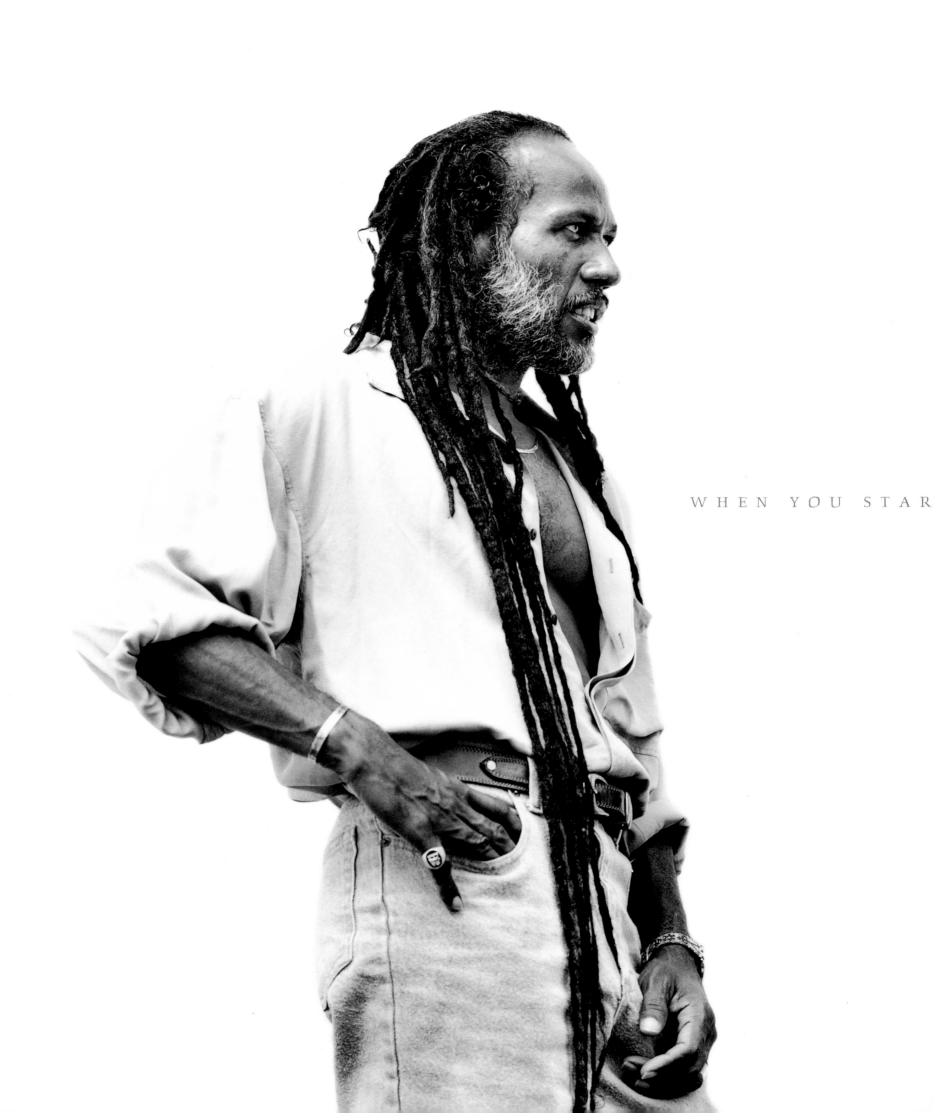

WHEN YOU STAR

My inspiration to dread was twofold: First, I was called to dread by my king, God, and leader, His Imperial Majesty Haile Selassie I; second, by Bob Marley. In about 1973, when I first saw Bob onstage, I saw a confident individual, believing in his God, his music, and his culture. There were similarities: We were both musicians—he was with the Wailers and I was with Third World—and we shared the same principles. Moreover, he was a fair-skinned Jamaican, like me. Naturally, I figured, if Bob can do it, why not I?

When you accept Rastafarianism and grow your locks, you find, afterward, a power speaks to you. That's what happened to me. One day I heard the voice of His Imperial

O GROW YOUR LOCKS,

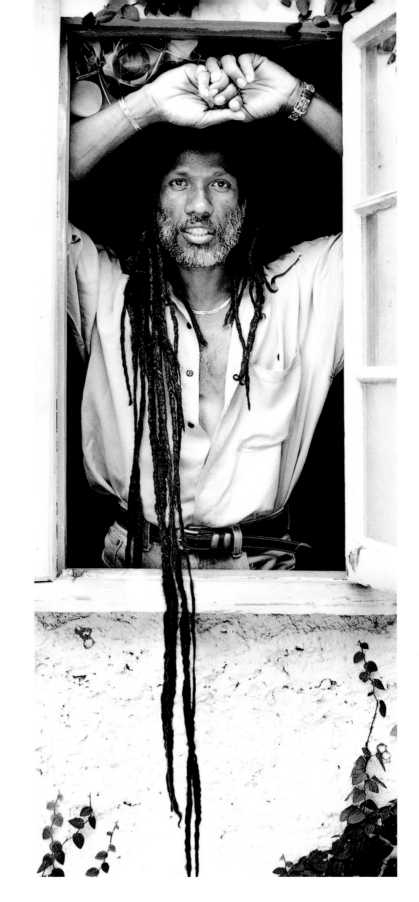

Majesty telling me I could either grow dreadlocks and accept the faith, or cut my hair. At first, we are all influenced by the fashionability of dreadlocks. But then the voice comes. Maybe not as quickly as it came to me, but it comes. There is a signal that starts you down the road of the religion, the spiritual path, or down the road of rejection. A desire to be stylish may initiate the process, but how the process will progress, where it will go, time will tell. If you are not strong in your commitment, eventually the system will break you, make you cut your hair.

Anyway, I love dreads, no matter how they're grown—thick, thin, round, flat, on the top of the head with the sides shaved, it's no matter to me. In fact, I think it's great, people living out what's in their souls.

A VOICE SPEAKS TO YOU

"CARROT" JARRETT

PERCUSSIONIST/RESTAURATEUR JAMAICA

121

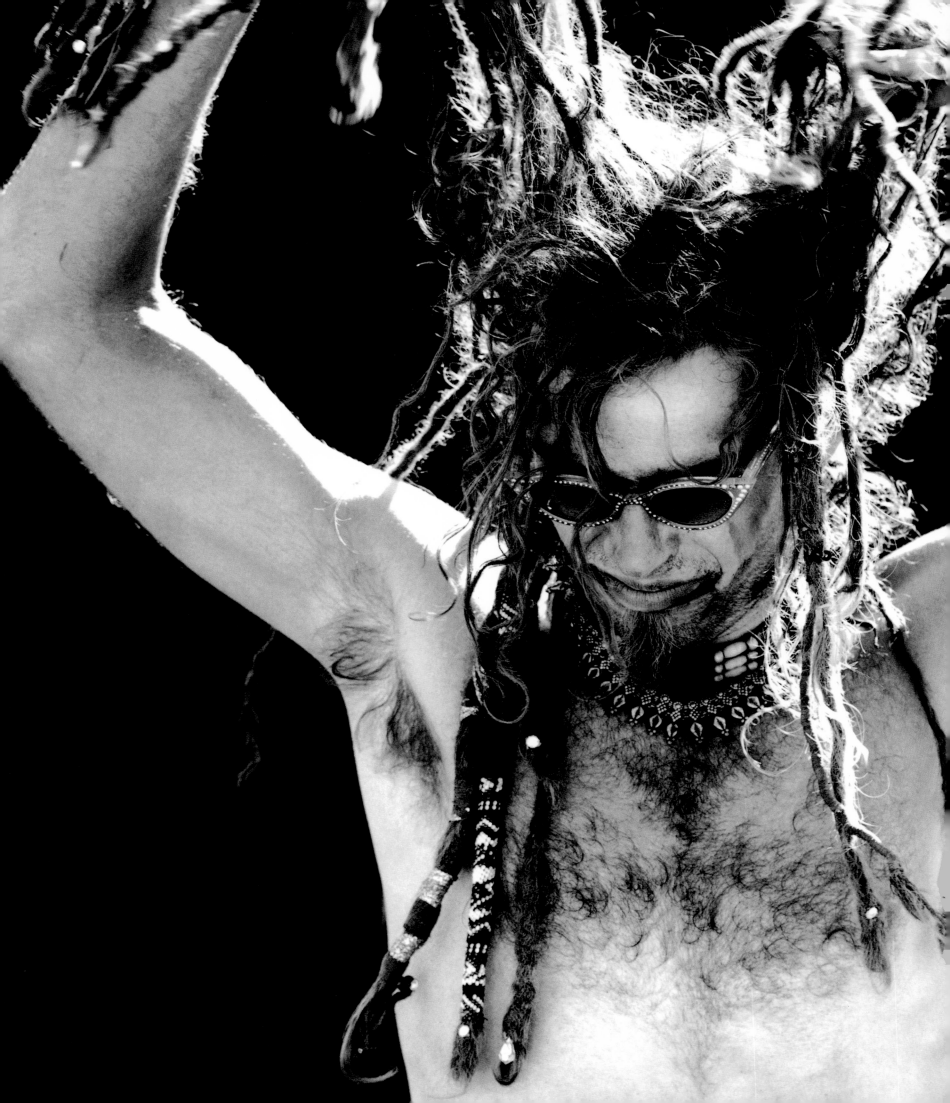

LOCKS GOT ME ON THE FREEDOM TRAIN

I locked my hair to get on the
freedom train, to live my life the
way I wanted to. I was also
influenced by my buddy James,
who had thrown away the comb
a long time ago. He was living
in a milk truck behind my house.
Now I'm living in a school bus.

 Sometimes my dreads
make people uncomfortable, some-
times comfortable. It depends on
where I am.

LARRY STEINER

POET WASHINGTON

I'D ALREADY DYED IT,

When I first considered locking my hair, a few questions came to mind. I figured I'd already dyed it, cut it, permed it. Why not dread it? I also saw in dreads an affirmation of my African culture. For me to be considered beautiful, it was no longer necessary to

CUT IT, PERMED IT.

subscribe to European notions. I could set my own standards.

The Rastafarians of Jamaica brought back the tradition of Africans locking their hair, so I would have to link the Rastafarian experience with the whole of

WHY NOT DREAD IT?

African history. Therefore, in Jamaica, one does not have to adhere to every tenet of Rastafarianism to appreciate its link to an African lineage. I do not consider myself a Rasta, but I respect their beliefs.

YESEMBIET

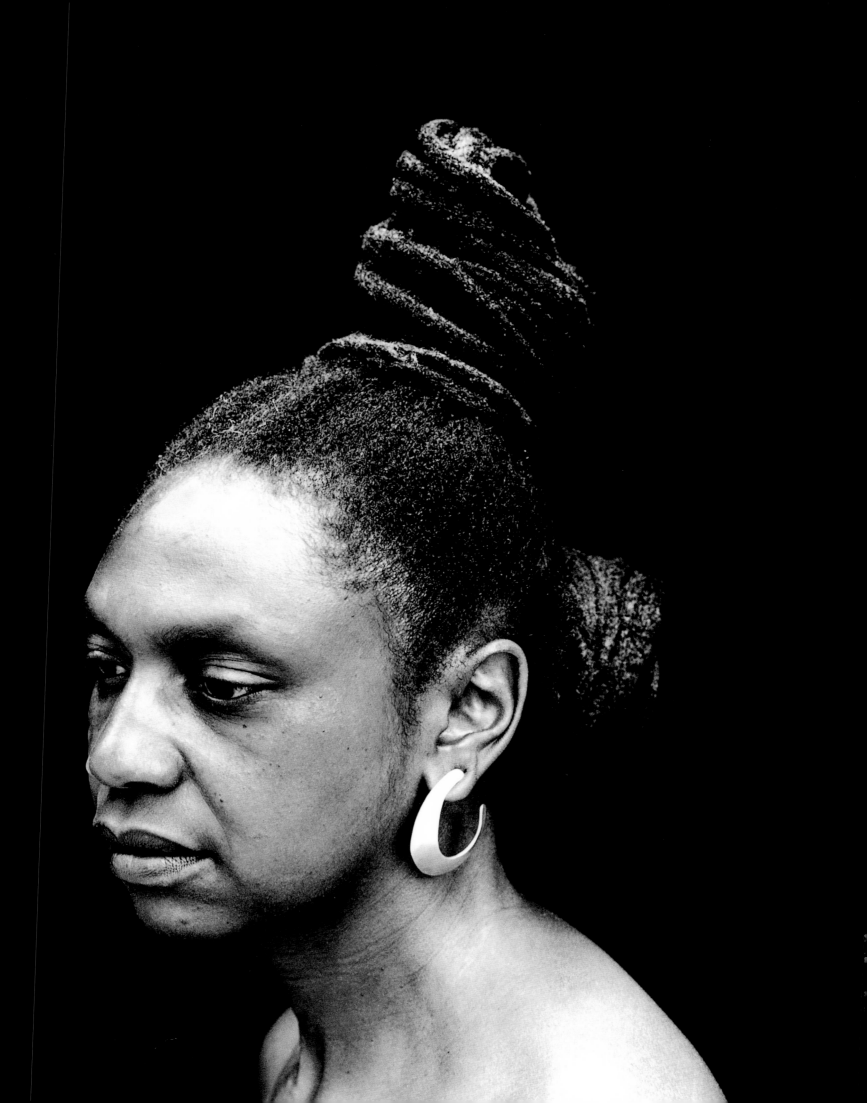

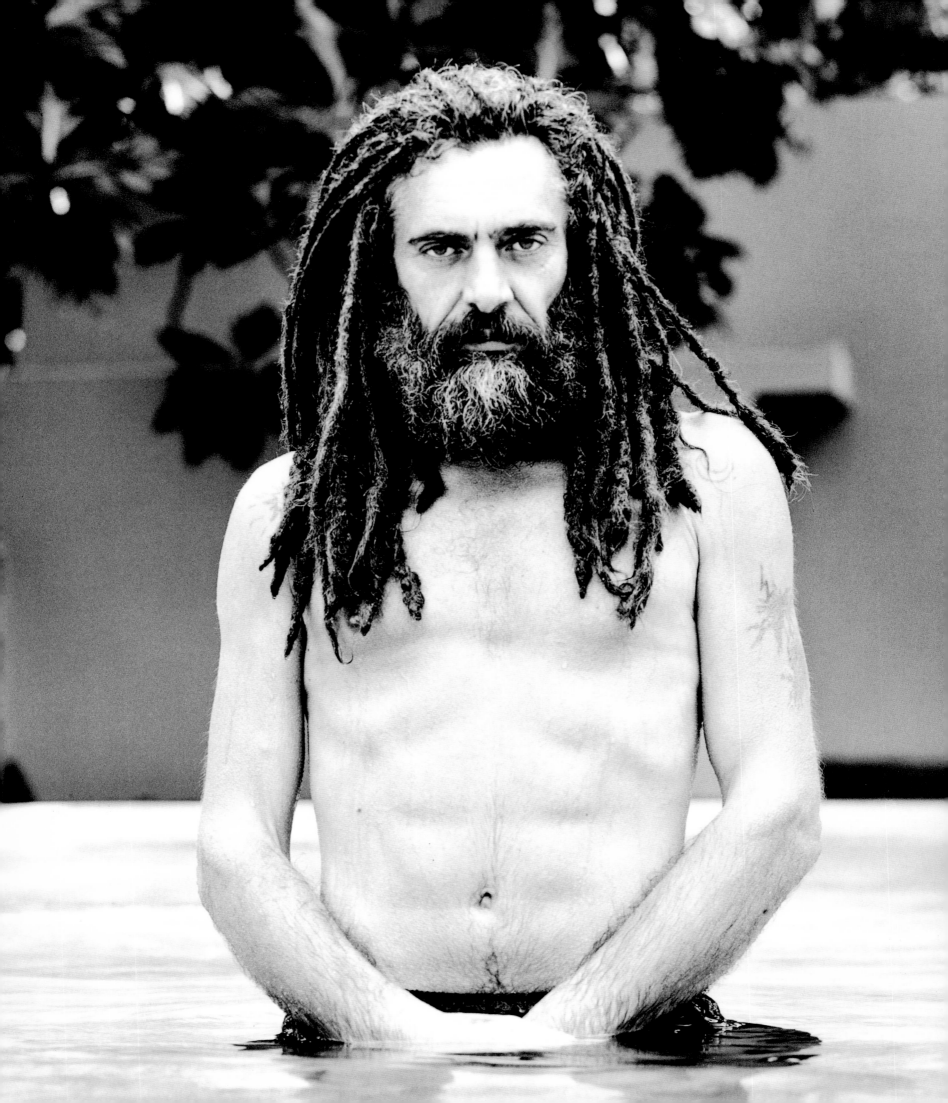

WHEN HUMANS ARE UNBALANCED,

My dreadlocks proclaim the fullness of creation. They are my freedom. Even if it has become fashionable to lock your hair, it still shows a form of spirituality. There's always meaning attached to the gesture. Anyway, I think spirituality has become fashionable. There is an absence of the sacred in our daily life, and people are striving to fill that void. Dreadlocks are nature speaking through humans. When humans are unbalanced, nature will exert herself. All we are is nature doing her own thing. Nobody is controlling us from outer space. It's just the human mind.

Speaking of nature, I also notice that anywhere you see herb, men"—have to lock their hair, which they call jatta, in order to replicate the image of Shiva. There are many different sects of sadhus in India: The Naga, for example, all lock their hair. Other men spend their lives conventionally, with wife, family, and job, until, at a certain age, their guru tells them they must abandon it all, detach themselves from their pasts and devote themselves to their god.

The first time I let my hair lock was in India in 1971. I remember being in Amsterdam in 1973. I was just about the strangest person there.

From beatnik to Rasta, I have been called a lot of names, but I don't adhere to any particular mind-set. I do consider my dreadlocks to be a symbol of general rebellion. My beard is, also. As a child, I was always traumatized when my mother took me to the barber's. Think about that: How many children, when very young, would resist the barber's chair? Many, yes? The child knows it is not natural to cut off hair.

NATURE WILL EXERT HERSELF

you see dreads. Locks are somehow related to that plant.

Ancient doctrines written in Sanskrit, the classical language of Hinduism, refer to Shiva as the god of creation. In some incarnation or another, Shiva has moved from India to Africa to Jamaica. The Hindu sadhus—it means "holy

VIDAL ANGEL

ARTIST JAMAICA

Frankly, I hardly know anything
about the history of dreadlocks.
I just know that, as of late,
we've been calling them locks.
The term "dread" seems to have
some negative connotation.
For me, dreadlocks were just a
way of embracing my beauty.

I got tired of perming my hair
and using all those chemicals on
my head. But my irritation went
beyond the tediousness and the
time consumption. Straightening
my hair was a way of conforming
to Caucasian society, and that's
just not my tribe. No matter how
hard I tried, I could never, ever

LOCKING MY HAIR LIBERATED ME

meet that standard. I finally
came to a place where I could
permit my hair to be natural.
Once I started locking my hair,
it was amazing. It liberated me.

The struggle of African-
Americans has always involved
appearance, has always been
about hair. When I first started
to see Rastafarians on the streets
of New York City, I was amazed.
It dawned on me that our hair
could actually grow that long.
Rastas inspired me to start
my own dreadlock journey. So
even if I still don't know the
full story of dreadlocks, in my
soul, I understand the source.

HAZELLE GOODMAN

ACTRESS/WRITER TRINIDAD

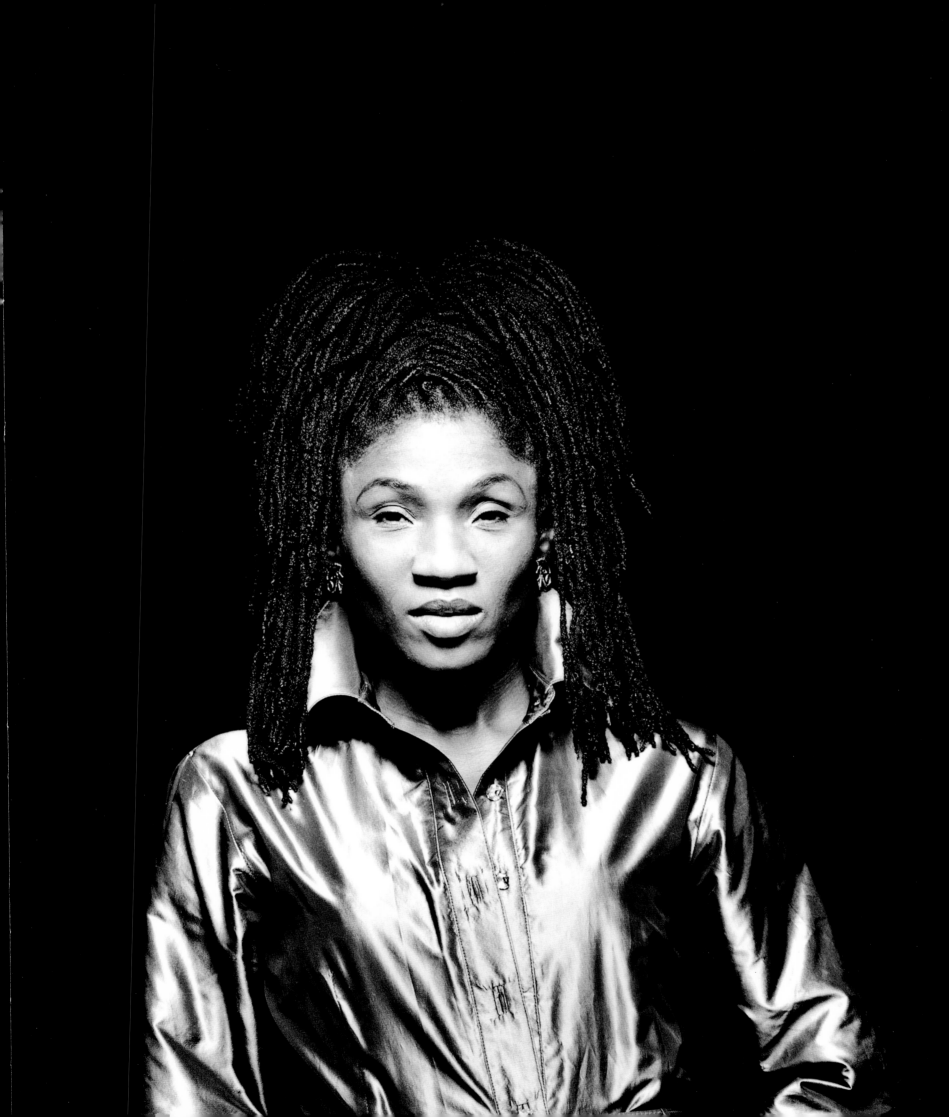

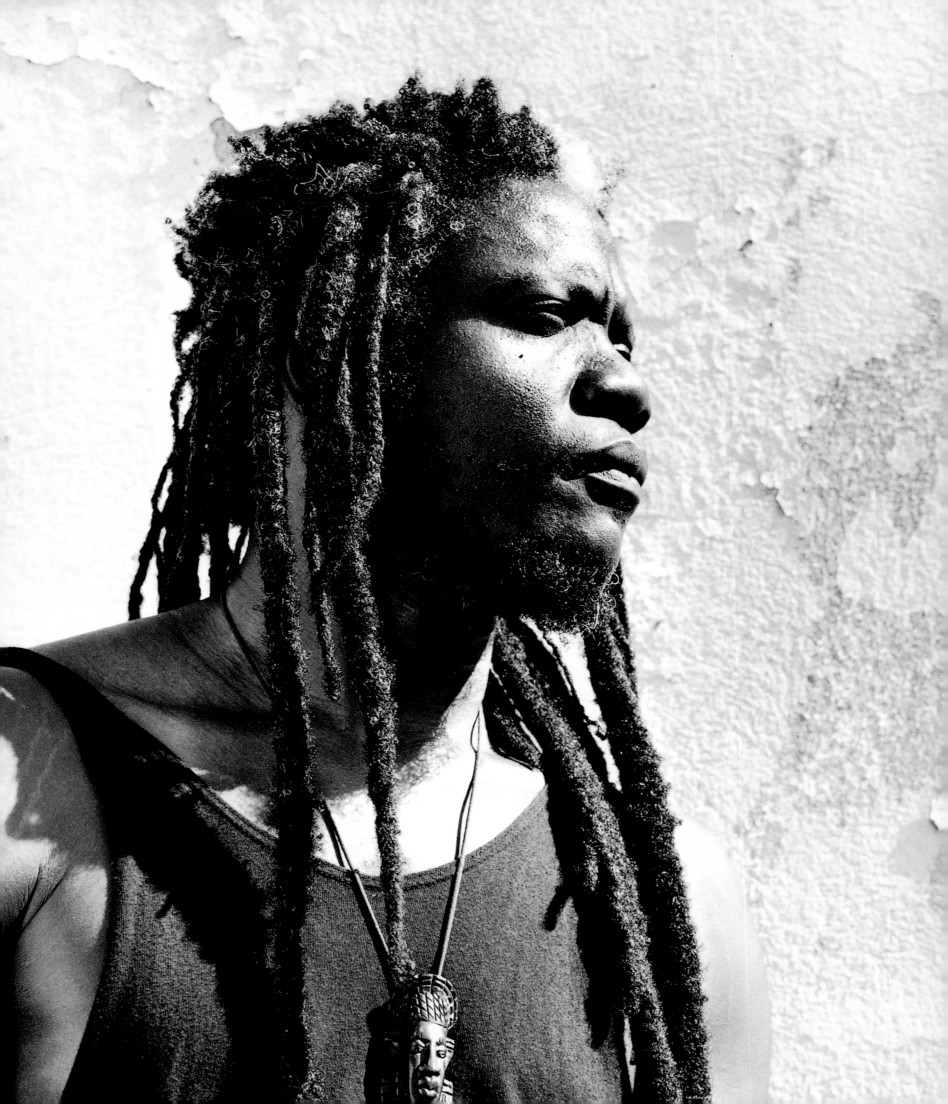

People say it is what is on the inside that's important. But what is inside must also appear outside. Dreadlocks are a part of that manifestation—the internal is revealed by the external.

Even when dreads are worn as a fashion, it doesn't disturb me. A

THE CULTURE OF RASTA IS NOT RASTA:

Black man who wears locks upon his head, regardless of his personal reasons, still shows a connection to Africa. For so long we were trained to accept European concepts of grooming and clothing. So a man don't have to have a spiritual connection to carry dreadlocks—and maybe it is his first step toward opening himself up, widening the scope of his understanding about Africa.

I am a Rastafarian, and my relation to my hair is spiritual. Originally, when Rastas first appeared in Jamaica, people were afraid of them—their hair was horrible, terrible, dreadful. The name "dreadlocks" has stuck with the Rasta ever since, because of soci-

ety's unwillingness to see locks as part of the whole of Afrocentric consciousness. But I am not a dread—I am a Rastaman. Many other African cultures carry locks— in Nigeria, Ghana, Egypt. The pharaohs wore them. Dreadlocks are not unique to Rastafarians, but Rastas are the ones who brought them out of Africa and to the rest of the world. And it is the doctrine of Ras Tafari, not reggae music, that is responsible for the spread of dreads. Most reggae musicians wear dreads because they embrace Rastafarianism. The culture of Rastafarianism influenced the music, not vice versa. Rastaman was here before reggae music.

tus quo, and so he was persecuted.

Today, people see dreads more; I don't know if they accept them more. Rather, there are more of us around to blame! I believe Haile Selassie is God; the majority does not subscribe to that belief. Man will display the red, gold, and green, he will play the reggae music, but when you tell him Selassie is God, he protests "No!" Yet that is the foundation of Rastafarianism—if you do not accept Haile Selassie as God, then you are not Rasta. The culture of Rasta is not Rasta: The theology of Rasta is Rasta. Accepting the culture and not accepting the theology is not accepting Rastafarianism at all.

THE THEOLOGY OF RASTA IS RASTA

Rasta began in Jamaica in the twenties and thirties. According to the pervasive British colonial mentality of the day, hair had to be properly groomed. The dreadlocked Rasta was seen as a nonconformist, a societal outcast, a threat to the sta-

MUTABARUKA

POET JAMAICA

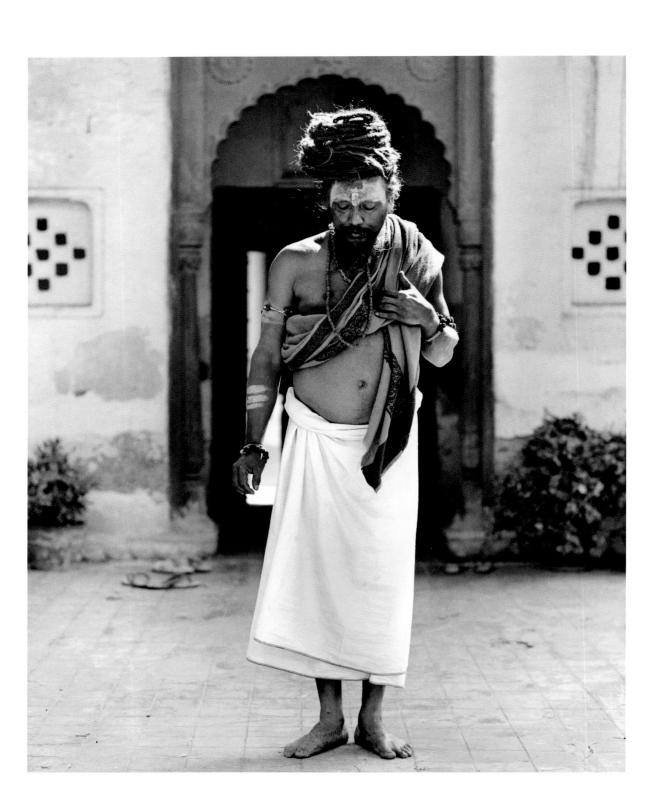

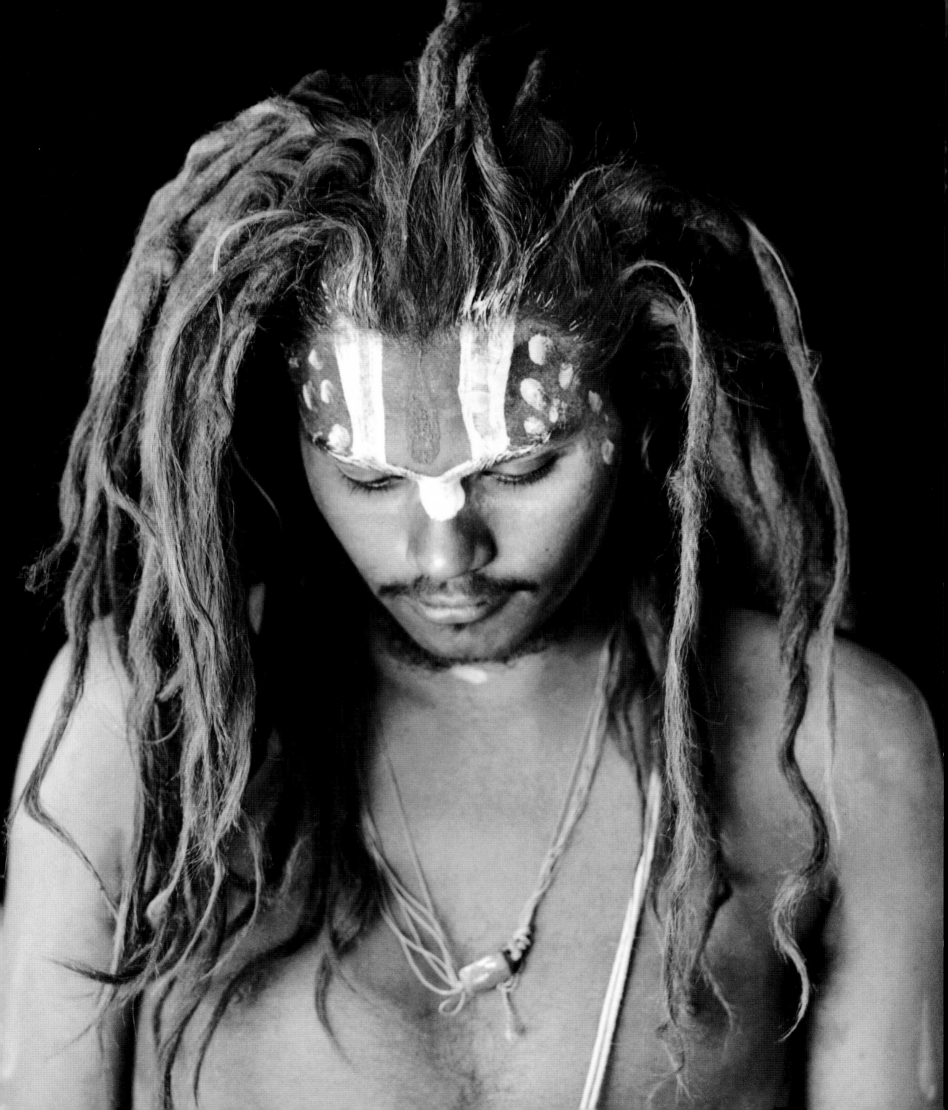

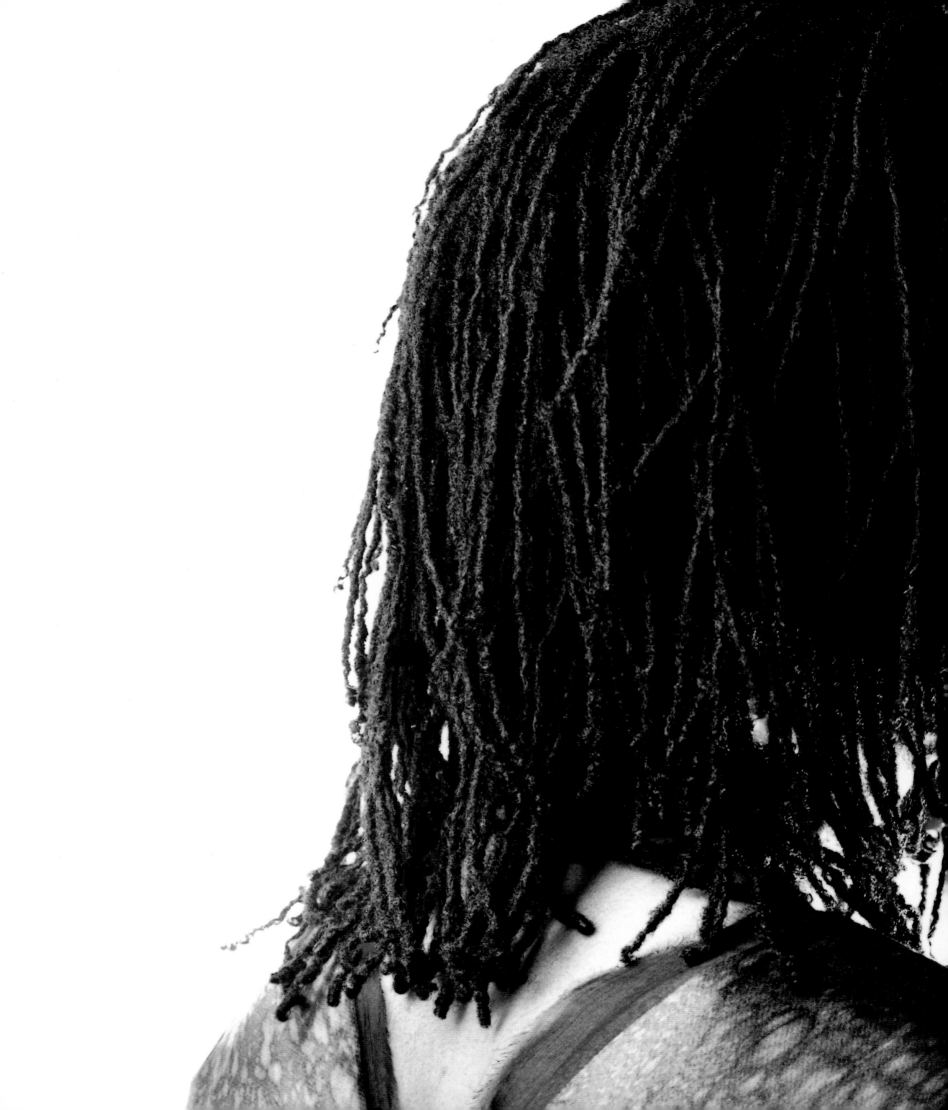

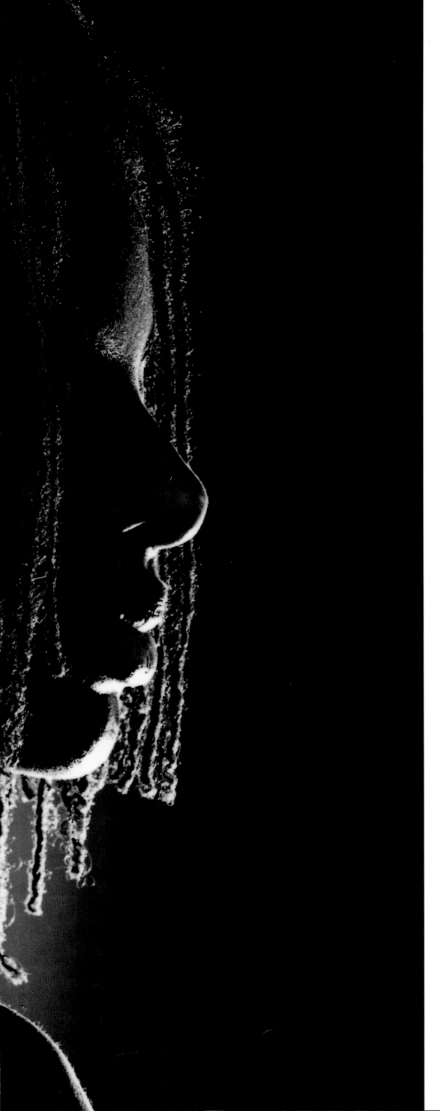

IT STOPS HERE,

Blonde hair, pale skin, blue eyes:
Without them, one was consid-
ered ugly. Such attitudes prevailed
in my mother's time, in her
mother's time. They still exist
today, but it stops here, with
my generation, with me.

WITH MY GENERATION,

It's only recently that Black
beauty has gained any recognition.
Dreadlocks express my
faith in myself and my culture.
They are the pathway to a natural
and spiritual life.

WITH ME

JACQUELINE "SETRA" COLLINS

SINGER NEW YORK CITY

The external versus the internal: I'm someone who has always had a strange battle going on with her body. I suffer from skin allergies and asthma. To get along with my friends and feel comfortable in the world, I tried to cover up my so-called physical flaws. I had a lot of fun experimenting with my look, and eventually I gave in to nature. My dreads happened by accident. My hair is kinky and dry, it started to tangle, and instead of trying to fight it, I let it go. I figured I'd end up with one or two locks, but they took over my whole head.

I don't think I could ever cut them now. I've grown attached to them. (They've grown attached to me!) When you stop trying to control certain superficial elements of your appearance, it's incredibly liberating, it puts you in touch with what's real.

A tree twists and turns. It exhibits its history, how it has grown, been shaped by the elements, maybe even struck by lightning. Some think the tree is a symbol of the soul, representing the rough journey of life. My dreads hold the same meaning for me. I think of them as battle scars, as war wounds.

Still, ultimately, hair is hair. You can't definitively judge a person by it. I admit it can be frustrating, now that dreads are in vogue, to be asked about mine all the time, because the whole point of letting my head lock was so that I wouldn't have to think about it. It was a matter of self-acceptance, not self-promotion.

My mother was an art teacher, and thanks to her I was never afraid of foreign cultures—Jamaican, Japanese, Native American. Every indigenous society has its rites of adornment, often in emulation of nature. Hindu ascetics and Jamaican Rastafarians lock their hair for religious reasons. It's interesting how hairstyles have been linked to spiritual sects, from Hasidic ringlets to monastic shaved heads. There's something wild about hair that compels people to contain it, cut it, cover it. Hair is just dead waste coming out of your head, but at the same time it symbolizes all kinds of things to all kinds of people.

I dyed my dreads red for a while, and the reaction was not good. Whether it was the red or the dreads, I don't know, but now that my hair is blonde, people feel less threatened by it. I guess blonde, even dreadlocked blonde, is still iconic in American culture.

Once, I was in Tennessee, eating at an all-night restaurant. A cowboy walked up to me and called me White trash. How crude. Here he was, all dressed up in his cowboy gear, his uniform of choice, and a song called "I'm a Redneck" was playing on the radio. It fit together quite nicely. But overall, people have been more or less tolerant, if not positive. Maybe they've already been exposed to dreadlocks. Maybe they think that, if we didn't have at least a few expressive individuals around, then we'd all be Republicans. Or rednecks.

KARYN CRISIS

MUSICIAN NEW YORK CITY

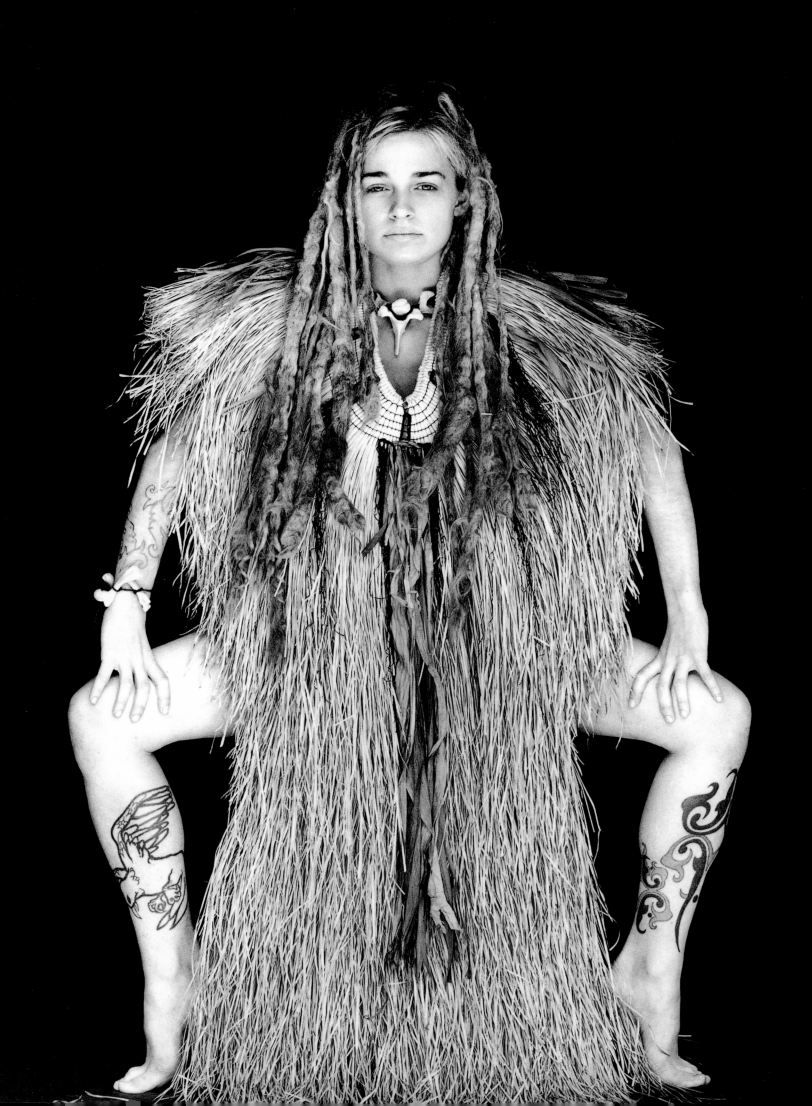

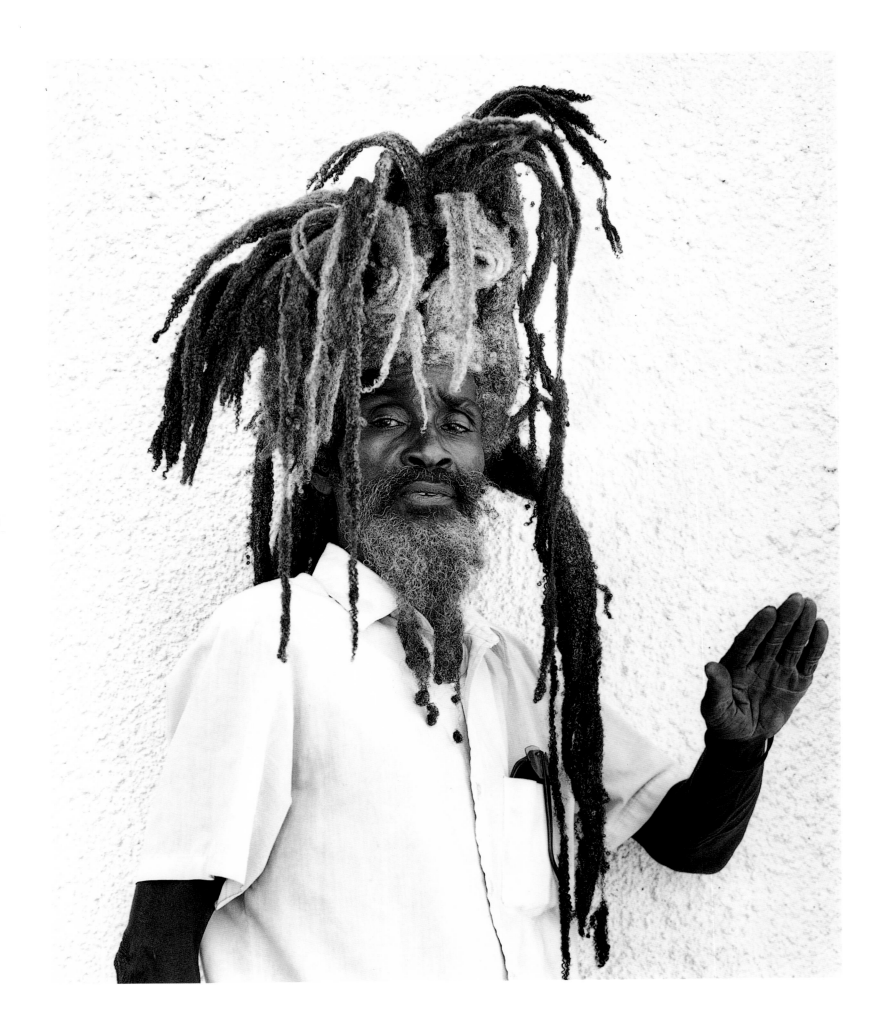

Dreadlocks are part of my instruc-
tions, part of my commandments
from the Almighty. In the Book of
Numbers, the Lord speaks to Moses:
"Until the day be fulfilled when the
vow of separation is complete, there
shall come no razor upon his head.
He shall be holy, and let the locks
of his hair grow." Rastas are the
keepers of this covenant in Jamaica.

We just want to go home,
somehow, to Zion. Next door to
where I live, there is a German
youth, about nineteen. He is in
Kingston for the music, Bob
Marley's music. He is as white as
a sheet of paper. He's White,
him hair all white. Him over-stand
everything. Him have a lot of
records going back to Germany—
him sending the message to his

home, you see? All Rastas want is
to go home ourselves.

Rastafarianism is word power.
In words we have seen the power
of creation. One is not op-pressed,
but down-pressed. We do not have
under-standing: With wisdom
comes over-standing. The emphasis
is on the positive.

I've been a Rasta for fifty years,
since the earliest days of the move-
ment. I've seen a lot of persecution.
But you can't tell a true Rasta
by dreads alone. How you going to
know the wolf? Not by his locks.
You going to have to test him. By
his heart and works, by his truth,
you shall know him.

D. HARRIS

DIRECTOR OF THE OFFICE OF PAN-AFRICANISM JAMAICA

Like many women of color, particularly women of African ancestry, I was raised to hate my hair. My mother had loose curls, but mine were much tighter, kinkier. On a daily basis, she loudly lamented the fact that my hair wasn't straighter. As a child, I was regularly subjected to burning hot combs. My hair was thick, and my mother was impatient. She'd try to untangle it while it was still wet, and the steam from the comb would scald my scalp. I understand why my mother acted the way she did, but it's still a sad memory for me.

It was oppression of the most mundane, insidious sort. Going out, we were always worried about whether we would sweat, whether it would be humid or would rain—all factors that would unleash the beast that was our frizzy hair.

I wanted to be free of all that. I didn't want to care so much about my hair—although I know it sounds like a contradictory statement now that I have dreadlocks down to my ankles.

For a while, I had my hair braided, but it hurt my scalp. I cut my hair short, but it grew back so quickly that maintaining it became too much of a preoccupation. A couple of my friends had locked their hair, and they encouraged me, although I must say that in 1981, when I cut my hair off completely to begin my dreads, it simply was not being done.

At first, the locks wouldn't take. I'd twist them, pin them, prod them, but they'd spring right back out in Shirley Temple curls. So I sort of gave up, let it be, stopped combing my hair altogether. And after a year, it began to lock. It was as if it had a life of its own, just waiting to be born. It took on structure, form. It was then I began to understand that dreadlocking was about energy. It was about nature, and nature has its own logic. My body had its energy also, and a relationship to the energy around it. My body started to create art out of its own internal rhythms.

That was nearly twenty years ago. Although ethnicity has since become more accepted, at the time, people of color looked to each other for affirmation. If we felt we weren't appropriately assimilating ourselves, we didn't want to do anything that would further set us apart. When Black people in particular saw me with my dreads, they were extremely antagonistic. Not only did I not meet the European standards of grooming and beauty, I was willfully rejecting them. In doing so, I was perceived as a threat to their own precarious status. I was single-handedly destroying the hard-won, honest reputations of my entire race. I was making everyone else look bad.

Once my locks grew longer, the reactions were less hostile. For some reason, shorter locked hair seemed to disturb people more. Maybe it has something to do with gender: Longer hair is considered more feminine. Of course, dreadlocks in general became more acceptable when a few prominent Blacks began to wear them—actors, artists, authors.

I recently visited Ghana, where all the women had extensions. I did not see one Ghanaian woman with dreadlocks, and only a couple of the men had them. So are people there still dealing with the effects of colonialism? I don't know.

My dreadlocks have as much to do with my biology as my ethnicity. It's genetic: This is how my hair is, and locks free me from the losing fight to tame the life out of it.

DAVINE DEL VALLE

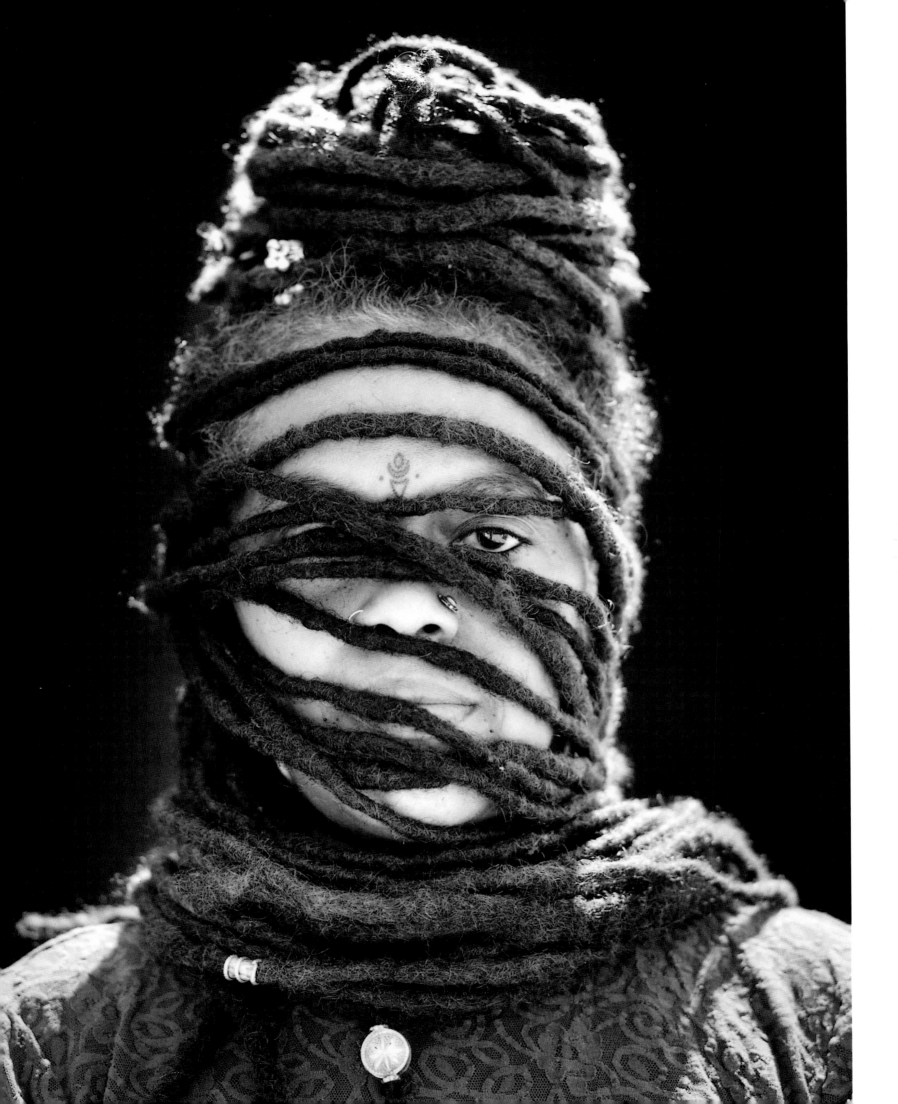

A C K N O W L E D G M E N T S

The authors wish to express their gratitude to the many people around the world who generously contributed their knowledge, stories, language, and faces—your spirit is the essence of this book—and to acknowledge in particular:

Tom Hoops, Desi Smith, "Junior" Marvin, Peter Desouza, Jackie Cowen, Vidal Angel, Fannette Johnson, Lynn White, Ilene Kristen, Susan Baker, Ralph DeMatthews, Bruce Rosenblum, Sophia Durbetaki, David Thorpe, Lauren Pipcorn, Roberta Raeburne Fotographia, Marina Keijzer, Guy Wilson, Bonni & Nicki, Hira Nam Jah, Patrick Bonnmarito, Margaret Slater, Henny Victor, Big Five Tours, Ann Bramson, Nancy Murray, Tricia Boczkowski, Elizabeth Hermann, Susi Oberhelman, and Alice Walker.

A very special thanks to writer and editor Siobhán McGowan.

Hairstyling on pages 6, 30, 40, 41, 54, 60, 75, 86, 105, 129 courtesy of Derrick Scurry & Hairobics.

Styling on pages 6, 30, 41, 54, 60, 75, 105 courtesy of Cornelius Freeman; wardrobe courtesy of Showroom 7; Rubin-Chappelle; Exodus; Tracy Reese; Mao; Quinto & Quinto.

Makeup on pages 6, 30, 40, 41, 54, 60, 75, 86, 105, 129 courtesy of Chanel Dorsette.